ARTISTS IN THEIR STUDIOS

ARTISTS IN THEIR STUDIOS

IMAGES FROM THE SMITHSONIAN'S ARCHIVES OF AMERICAN ART

LIZA KIRWIN WITH JOAN LORD

COLLINS|DESIGN

An Imprint of HarperCollins*Publishers*

CONTENTS

FOREWORD

For centuries, artists' studios have occupied a place of romance and mystery in the popular imagination. As fictionalized in literature, opera, and film, the artist's studio has been variously portrayed as both a den of debauchery and a chapel of divine inspiration, the backdrop for lively social interaction and a place of overwhelming solitude. But as most of the images in this volume demonstrate, the studio is first and foremost the site of artistic labor.

In this fascinating survey of photographs, carefully culled from the thousands of such images housed in the collections of the Smithsonian's Archives of American Art, we are afforded an insider's view of artists at work in settings both splendid and humble. These artistic mise-en-scènes are rich with information, revealing everything from economic status to the details of the artistic process.

The photographs and related documents reproduced here are just a few of the more than 16 million items collected by the Archives of American Art over the course of its 53-year history. Established in 1954 with the mission to collect, preserve, and make available the primary material documenting the history of the visual arts in America, the Archives continues to have a defining effect on the scope and direction of American art scholarship. Our collections of photographs, letters, sketchbooks, diaries, unpublished writings, financial records, and other forms of archival material are an unparalleled resource for the study and deeper understanding of our nation's artistic legacy.

Liza Kirwin, the Archives' curator of manuscripts, is to be commended for her sensitive and careful selection of the material included in this book. Liza's long association with this organization has provided her with in-depth knowledge of its holdings. Her eye for detail and nuance has ensured a visually compelling book, while her thoughtful text provides a rich intellectual framework that enhances our appreciation of these images. In this project, as in so many others, Liza has been admirably supported by Joan Lord, curatorial assistant.

Projects of this kind invariably rely on the enthusiastic assistance of many people. I am deeply grateful to many of our Smithsonian colleagues who have so generously lent their expertise toward this volume's realization, particularly William McNaught, former director of the Archives' New York Research Center, who had the idea to publish a collection of photographs of artists in their studios some 20 years ago; Richard J. Wattenmaker, former director of the Archives of American Art; former research fellow Kelly Quinn and current research fellow Jonathan Katz;

Cynthia J. Mills, executive editor of the *American Art Journal*, Smithsonian American Art Museum; Joann G. Moser, senior curator of graphic arts, Smithsonian American Art Museum; Judith K. Zilczer, curator emerita, Hirshhorn Museum and Sculpture Garden; and Jane Milosch, curator, Smithsonian American Art Museum, Renwick Gallery. We are thankful for the work of our industrious interns Staci Steinberger and Emily Cogswell, whose research has enlivened many of the book's captions. We appreciate Marv Hoffmeier's technical expertise with digital imaging, Laura MacCarthy and Erin Corley's first-rate research assistance, and Rosemary Regan's sound editing advice.

We are grateful to the many individuals who provided information and granted permissions to publish items from the Archives, including Julie Aronson, curator of American painting and sculpture, Cincinnati Art Museum; Marilyn Auer; Will Barnet; Clare Bell, Roy Lichtenstein Foundation; Avis Berman; Peter Capurso; Irene Casali, Archivo Ugo Mulas; Center for Creative Photography at the University of Arizona; Arnold Chanin; William P. Daley; Corinne Dean, library assistant, Cincinnati Art Museum; André Emmerich; Peter A. Engstrom; Helen Frankenthaler; Steve Friedman; General Mills, Inc.; Mimi Gross; Helen A. Harrison, Pollock-Krasner House & Study Center; Elizabeth Helm, office manager and circulation director, National Sculpture Society; Susan Larsen; Mimi Muray Levitt; Virginia R. Liles; Fred W. McDarrah; Juliann McDonough, curatorial associate, Addison Gallery of American Art; Frederick C. Moffat, professor, University of Tennessee; Inge Morath Foundation; Peter Namuth; Liz Gill Neilson, LeRoy Neiman Archive; Mary Panzer; Renate Reiss; Ingrid Schaffner, senior curator, Institute of Contemporary Art; Lenore Seroka; Christy Singleton, Beverly Pepper studio; Laurie Snyder and John Wood; Arden Sugarman; David Soyer; Saul Steinberg Foundation; Beth Zopf, Chuck Close studio; and Rosalind Turner Zuses and Howard Zuses.

We also thank Elizabeth Viscott Sullivan, our editor at Collins Design, for her direction and enthusiasm for this project.

Finally, our thanks to the countless artists, collectors, critics, dealers, and arts organizations who over the years have so generously donated their papers to the Archives of American Art. It is their legacy that is celebrated not only in this book, but in all we do.

—JOHN W. SMITH, Director, Archives of American Art

INTRODUCTION

On New Year's Day 1899, Alson Skinner Clark, an American art student in Paris, visited the studio of his teacher James McNeill Whistler. He described the event in a letter to a friend: "Whistler invited the class up to his studio. We all went and his valet let us in and we each shook Jimmy by the hand. . . . He gave us all the champagne we could drink. . . . His studio is as big as the whole attic and is fine. He has a beautiful screen . . . it is sort of a Japanese water scene with a big bridge or something on it and is fine in colour. His studio is very dimly lit, the walls are of a warm dark pink. There are all kinds of balconies in it but not one picture is to be seen anywhere, all are turned toward the wall. He wears a little monocle and always keeps putting it in and recovering it."

With this book, I would like to hand you an imaginary glass of champagne and set you on a tour of the extraordinary work spaces of American artists. From the sumptuously furnished studios of the late nineteenth century to the austere workrooms of the present day, studio spaces have played a dynamic role in the history of American art—not simply reflecting aesthetic visions, but informing them. This look at artists in their studios, through photographs and documents from the Smithsonian's Archives of American Art, offers a behind-the-scenes view into the lives of American artists—their methods and materials, aesthetic influences, artistic personae, and social worlds.

Studios are intimate places, chambers of the imagination where artists realize their most personal expressions. The public is not always invited in. Carl Milles was particularly fussy about anyone seeing his work space. When he was the sculptor in residence at Cranbrook Academy of Art, he wrote to the founder of the school, Henry Booth, "I know that you visited my studio the 23rd of September without asking me. Please do not do that . . . I lose all inspiration if strangers can go in that way."[1] Ceramic artist William P. Daley spoke of his studio as both a "celestial" and a "psychic" space and said, "I very seldom let anybody see my work space." For Daley the studio was personal, not for "tourists." He added, "I think of it just like a bedroom."[2]

Sometimes the spaces themselves took on a charged atmosphere, magically imbued with the creative spirit of previous occupants. Erle Loran soaked up Cézanne's style while working in Cézanne's studio in Aix-en-Provence, and when Hananiah Harari took over Chaim Soutine's studio in Cagnes-sur-Mer with sculptor Herzl Emanuel in 1934, Harari painted one of his most inspired works, *Soutine's Studio*.

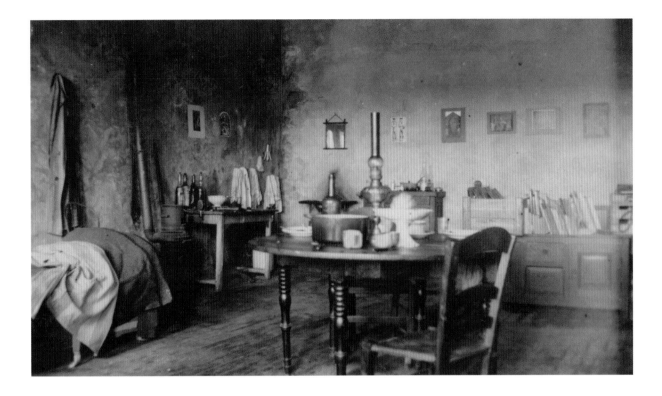

The studio that painter Hananiah Harari (1912–2000) shared with sculptor Herzl Emanuel (1914–2002) in Cagnes-sur-Mer, France, for several months in 1934. It had once been the studio of painter Chaim Soutine (1893–1943). Photographer unknown. Hananiah Harari papers, 1939–1983.

Space is an important factor in the production of art. In 1960, Al Held took over Sam Francis's New York studio at 940 Broadway and was in awe of the space: "…it was one of those spaces that I wasn't accustomed to, beautiful big space, it must have been about forty or fifty feet by a hundred…about sixteen feet high." The scale of his paintings, as well as his creative ambition, expanded: "I immediately switched to canvas and, of course, enlarged the scale to fit the environment. And they got to be big paintings." Al Held never looked back.[3] In later years he converted an enormous dairy barn in the Catskill Mountains into a studio and continued to push the physical limits of scale as well as the pictorial illusion of space in his paintings.

For some artists, the studio window provided a visual frame for the works that were created there. This was the case with Frederic Edwin Church and the landscape studies he made from the studio window of Olana, his magnificent house on the Hudson River. In 1871 he wrote to fellow painter Martin Johnson Heade, "I am painting on a big Parthenon—and three tropical pictures—and make a study from my studio window of a sunset or twilight nearly every day."[4] A century later, on the West Coast, Richard Diebenkorn, looking at and through the windows of his studio in Santa Monica, California, composed his *Ocean Park* series—the mullions suggesting painterly blocks of color.

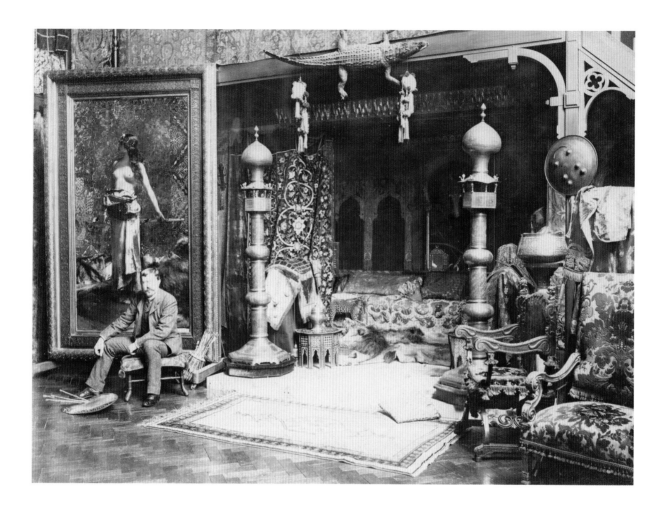

French painter Jean-Joseph Benjamin-Constant (1845–1902) in his studio in the rue Pigalle, Paris, ca. 1890. Photographer unknown. Artists in their Paris studios, 1880–1890.

Artists create their own ambience. In the late nineteenth century, Americans who were studying abroad and developing their own identities as professional artists looked to their teachers for guidance. The exotic studios of French painters such as Jean-Léon Gérôme (1824–1904), who taught at the École des Beaux-Arts, and Jean-Joseph Benjamin-Constant (1845–1902), at the Académie Julian, were the material proof of their aesthetic sophistication and financial success. Both created Orientalist havens that were fonts of inspiration. In the photograph on this page, Constant sits amid the luxuries from his travels—intricate oriental rugs, details of Moorish architecture, curious objets d'art, a lion skin, a stuffed ocelot, and a crocodile hung overhead. He had transformed his studio into a Moroccan interior.

It's no surprise that when artists returned from Europe and established their studios, they patterned them after ones they had seen in Europe. Later in the twentieth century, lavish studios in the style of William Merritt Chase gave way to more

workmanlike spaces. Paint-spattered jeans replaced smocks and suits, and an orderly arrangement of pigments on a palette turned into tables covered with tubes and cans.

While this book includes images of some of the most famous purpose-built studios, artists more often had to adapt buildings for their use. Helen Frankenthaler and Roy Lichtenstein converted garages into studios; George Gray Barnard's studio was once a stable; Arthur Wesley Dow used an old store; and Agnes Pelton set up shop in a windmill. They took available space and made it work.

The photographs and other documents in this book are arranged around four themes. The first, "artists abroad," shows American artists in their European studios. From about 1850 to 1950, American painters and sculptors flocked to the art capitals of Europe—Rome, Florence, Munich, Paris, and London—to study and work. Some, like William Wetmore Story, Hiram Powers, James McNeill Whistler,

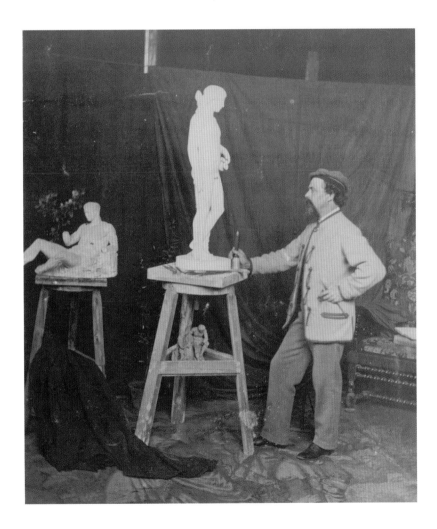

William Wetmore Story (1819–1895) in his studio at the Palazzo Barbarini, Rome, 1865. Photographer unknown. John Neal Tilton scrapbook, ca. 1860–1880.

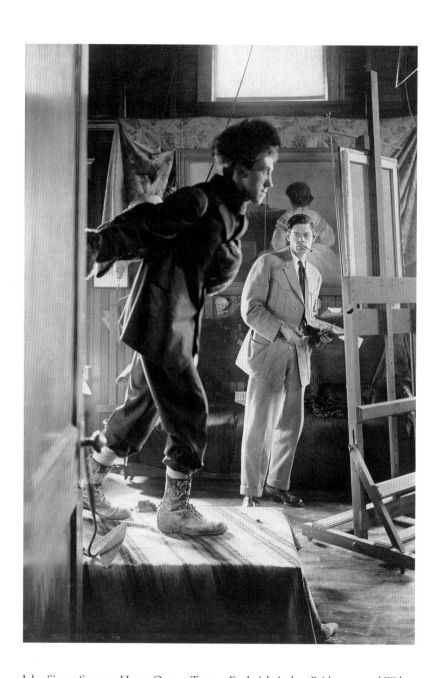

Charles Shepard Chapman (1879–1962) in his studio with a model, ca 1920. Photographer unknown. Charles Scribner's Sons Art Reference Department records, ca. 1865–1957.

John Singer Sargent, Henry Ossawa Tanner, Frederick Arthur Bridgman, and Walter Gay, established their permanent residence there. Story's studio in the Palazzo Barbarini in Rome was a gathering place for American travelers. A small photograph of him in his studio, dated 1865, is one of the Archives' earliest images of an artist in his studio (see page 11). Story stands in profile, tools in hand, looking at his marble statue of *Bacchus* (1863) on a modeling stand. His classical inspiration, a copy

of a figure from the Parthenon, is at the left. In Paris, Tanner, an African-American, found freedom from racial prejudice, and Whistler and Sargent enjoyed international acclaim and patronage. Each of these artists maximized their potential by establishing studios abroad.

The second theme of this collection, "artists and their models," pays tribute to the anonymous men and women who held long poses in cold studios, often naked. The heyday of artistic modeling began in the 1870s, stimulated by a concern for realism, and continued through the first half of the twentieth century. Sometimes models were nothing more than human clothes hangers to show the arrangement and contours of costumes—as was the case with Charles Shepard Chapman's model (opposite), for an illustration in *Scribner's* magazine. Dressed in a fur cap and heavy wool, the model strides across an imaginary tundra, while Chapman captures the action on canvas.

Around 1851, when Emanuel Leutze was painting his famous *Washington Crossing the Delaware*, he pressed Worthington Whittredge, then an art student in Düsseldorf, into service. Whittredge posed as a steersman with an oar and again as Washington himself. In his manuscript account, Whittredge described the ordeal: "I stood two hours without moving for the cloak of the Washington to be painted at a single sitting so that the folds might be caught as they were first arranged. Clad in Washington's full uniform, his heavy chapeau and all, Spy glass in one hand and the other on my knee I stood and was nearly dead when the operation was over. . . . This was all because no German model could be found anywhere who could fill Washington's clothes"[5]

Moses Soyer's wife, Ida, a dancer, often posed for his paintings. Soyer also invited interesting people from the streets of New York to pose. One such character, a homeless man, enjoyed the experience so much that he became a permanent fixture in Soyer's studio—which leads to the third theme in this book, "the studio as a social space." Studios are often big spaces, perfect for parties, concerts, dinners, dances, poker games, and other activities. Studio buildings, such as the Sherwood Building, the Tenth Street Studio Building, and 33 West Sixty-seventh Street, encouraged communal affairs. Sculptor Bessie Potter Vonnoh held regular dance parties in her studio, and Charles Keck gave lavish dinners in his. In 1933 Keck invited 20 gentlemen for steaks and steins of beer in his studio at 40 West Tenth Street in New York City. The guests included John J. Raskob, builder of the Empire State Building; art deco architect John B. Peterkin; and Charles Edison, the future governor of New Jersey and the son of Thomas Edison. Though the occasion is unknown, this dinner included musical entertainment and carefully arranged centerpieces of "white narcissus, mignonette, sweet peas, freesia, anemones, asparagus

fern in red and white scheme." Keck may have used such events in his studio to win friends in high places who might influence future sculpture commissions.

Perhaps less calculating, sculptor Robert Boardman Howard in San Francisco had parties all the time. His papers in the Archives hold stacks of handmade studio party invitations, advising guests to wear old clothes.

The fourth theme, "artists at work," pervades this book but is most clearly expressed in the last chapter. One wonders why these photographs were taken—perhaps for publicity or to illustrate publications. Art dealer André Emmerich took hundreds of photographs of the artists he represented and often used the images in his exhibition catalogues. These photographs show works in progress or the process of production. They also help define an artistic persona. Without a doubt, Robert Rauschenberg participated in the construction of the "artist at work" image when Henri Cartier-Bresson artfully photographed him with a dry squeegee balanced on his knees, poised over the silkscreen as if pulling paint onto the Plexiglas below.

Art making is physical labor. Numerous photographs (by Hans Namuth, Rudy Burckhardt, Wilfred Zogbaum, and others) of Jackson Pollock at work and posing in his studio immortalized the artist while promoting a new image of "The Great American Painter"—masculine, impetuous, and physically engaged in the creative act. The image continues to inform our construction of the artistic persona. In 1950, when Rudy Burckhardt arrived at the Springs, Long Island, to photograph Pollock painting for *Artnews*, he found that Pollock had already finished his painting (*No. 32*) and was not willing to add one more drip. Instead Pollock pretended to paint. Arm outstretched as if drizzling, a paint can in his left hand, he leans into the canvas, holding perfectly still for the camera and the photograph's promise of publicity.[6]

It is more likely that Beverly Pepper actually *is* welding in her studio in Italy, since the sparks are flying. Known for her site-specific, monumental outdoor sculpture, Pepper divides her time between studios in New York City and Todi, Italy. Crouching low to the flame, in her jeans and work boots, Pepper is the picture of a woman who knows and respects her materials.

The clothes, the pose, and the objects at hand define the artist. Grant Wood almost always posed in overalls to underscore his Midwestern sensibilities, while William Merritt Chase, sophisticated cosmopolitan, wore elegant suits. Artists held the tools of the trade—palette and brushes, chisels and clay—to identify themselves as painters or sculptors.

The photographs and documents in this book range from the 1840s to the 1990s and include a variety of items, from albumen silver-print *cartes de visite* to letters, diaries, draft writings, and rare printed material. These images enrich our

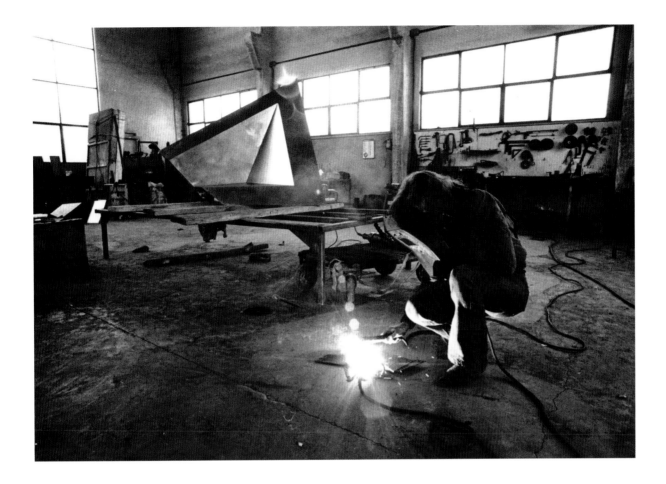

understanding of the artist's biography, providing clues to works in progress and the creative process. They also tell us what an artist looked like at a particular moment. They give us information about their social and economic circumstances. They remind us that making art is a physical activity and often a solitary pursuit.

Solitary, perhaps...but these photographs welcome us in. So step through the door, feel the energy, breathe in the smell of paint—or clay, or marble dust—and begin your visit to these artists in their studios.

Beverly Pepper (b. 1924) welding in her studio in Todi, Italy, ca. 1975. Her sculpture *Pi* (1974–75) is on the platform. Photograph by Dan Budnick. André Emmerich Gallery records and André Emmerich papers, ca. 1954–1999. © Dan Budnick.

1. Letter from Carl Milles to Henry Booth. Archives of American Art.
2. Interview of William P. Daley conducted by Helen W. Drutt English for the Archives of American Art, 7 August and 2 December 2004.
3. Interview of Al Held conducted by Paul Cummings for the Archives of American Art, 19 November 1975 to 8 January 1976.
4. Frederic Edwin Church to Martin Johnson Heade, 8 February 1871. Martin Johnson Heade papers, 1853–1900. Archives of American Art.
5. Worthington Whittredge handwritten memoir, p. 36 [51]. Worthington Whittredge papers, 1836–1932. Archives of American Art.
6. Rudy Burckhardt's photographs were intended for Robert Goodnough's article "Pollock Paints a Picture" in *Artnews* (May 1951), but because Pollock was faking it, Burckhardt's photographs were not used. Instead, Hans Namuth's photographs of Pollock painting illustrated the article.

I

ARTISTS ABROAD

HIRAM POWERS

(1805–1873)

One of the most successful sculptors of the nineteenth century, Powers specialized in portrait busts and idealized figures, such as Proserpine, goddess of the underworld and a symbol of seasonal change.

In 1837 Powers settled in Florence, Italy. In his Studio memorandum, he recorded his business transactions, visitors to his studio, his children's births and illnesses, and the occurrence of earthquakes and comets. *Proserpine* was his most popular ideal bust. On 14 May 1843 he wrote: "Should any 'mishap' render it necessary for others to attend to my affairs, I wish if possible that my three statues and the bust of *Proserpine* be finished by Remigio [Romigo Peschi, Powers's chief workman] in the best marble and exhibited in the principal cities of the United States." Powers lived for thirty more years, long enough to produce several versions and more than one hundred copies of *Proserpine*.

Above: Hiram Powers, Studio memorandum, 1841–1845. 85 pages, handwritten. Hiram Powers and Powers family papers, 1827–1953.

TRANSCRIPTION ON PAGE 173

Right: Hiram Powers in his modeling apron with his bust of *Proserpine* (third version), ca. 1861. Photograph by Longworth Powers. Hiram Powers and Powers family papers, 1827–1953.

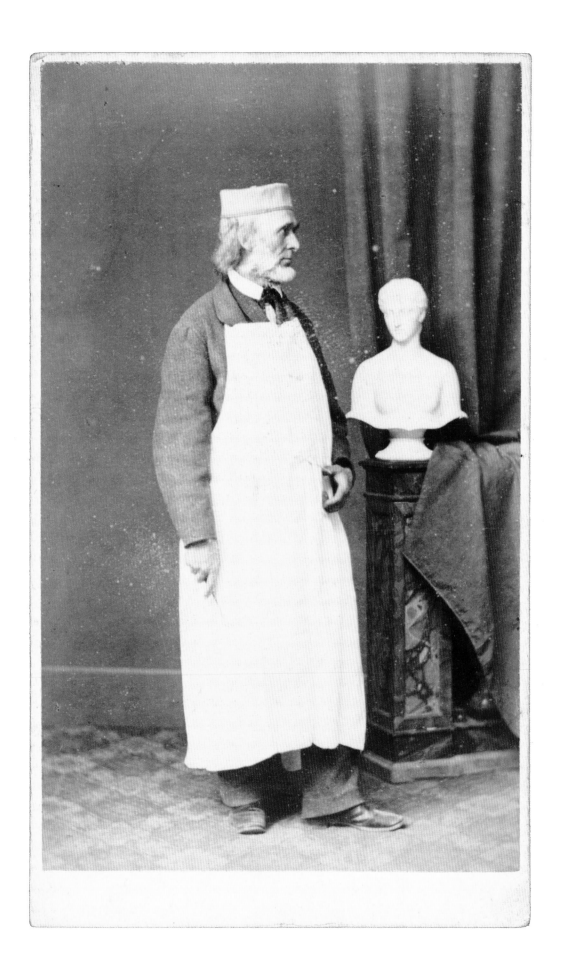

PAUL WAYLAND BARTLETT

(1865–1925)

Sculptor Paul Wayland Bartlett lived most of his life in Paris. He moved there in 1869 and set up a studio and, remarkably, his own metal foundry at 26 passage des Favorites.

In this photograph taken around 1900, he poses with his model for his statue of Lafayette. The statue, now in the Cours Albert 1er in Paris, on the Right Bank, was a gift to France in 1908 from the schoolchildren of America. Photograph by H. A. V. Coles. Don Becker collection, 1899–1949.

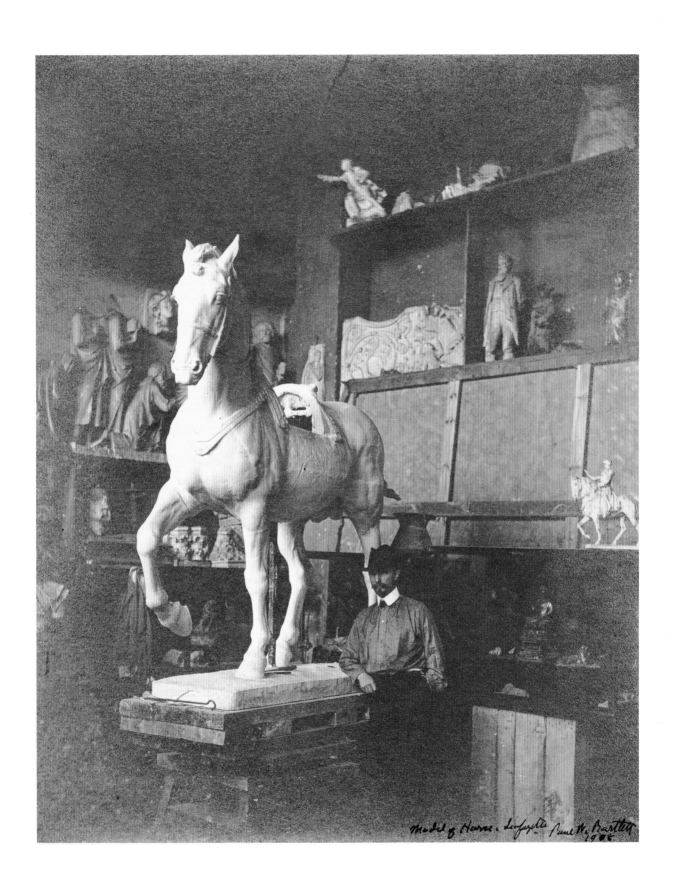

Model of Horse. Lafayette Paul W. Bartlett
1905

JOHN SINGER SARGENT

(1 8 5 6 – 1 9 2 5)

John Singer Sargent's *Madame X*, a portrait of Madame Pierre Gautreau, created a scandal at the Salon of 1884. French society was shocked by her deathly white pallor, hennaed hair, and provocative dress. Sargent first kept the painting in his Paris studio and, later, in his London studio. More than 20 years after the Salon, he exhibited *Madame X* in London, Berlin, Rome, and San Francisco, and finally sold it to the Metropolitan Museum of Art in 1916.

Like many of his contemporaries, Sargent embraced the Parisian craze for all things Japanese and decorated his space with Japanese porcelain dolls and silks.

In the October 1887 issue of *Harper's Magazine*, fellow expatriate Henry James published an article about Sargent and commented on his portrait of *Madame X*, "What shall I say of the remarkable canvas which, on the occasion of the Salon of 1884, brought the critics about our artist's ears…. It is full of audacity of experiment and science of execution; it has singular beauty of line, and certainly in the body and arms we feel the pulse of life as strongly as the brush can give it."

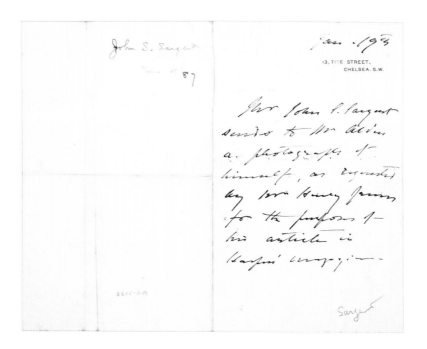

Above: Letter from John Singer Sargent sending a photograph of himself to "Mr. Alden," as requested by Henry James for an article in *Harper's Magazine*, 19 January 1887. 1 page, handwritten. John Singer Sargent collection, 1883–1923. TRANSCRIPTION ON PAGE 174

.

Right: John Singer Sargent in his studio at 41 boulevard Berthier in Paris, ca. 1884, with his famous painting *Madame X*, 1884. Sargent faces his painting *The Breakfast Table*, 1884, in progress on the easel. Photographer unknown. Photographs of artists in their Paris studios, 1880–1890.

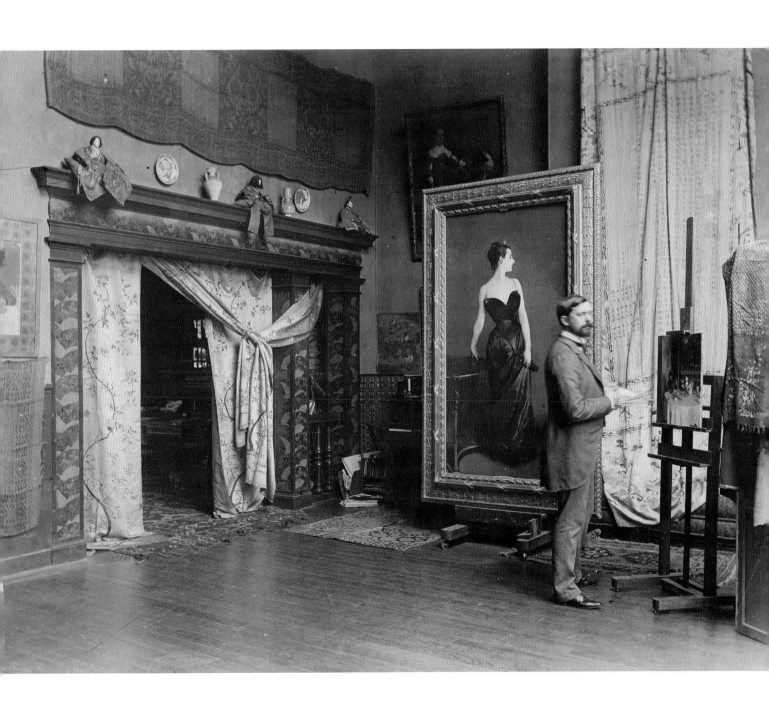

George Peter Alexander Healy

(1 8 1 3 – 1 8 9 4)

Healy's studio gallery was a visual testament to his international success as a portrait painter—he painted hundreds of portraits, including kings, queens, and United States presidents. In 1842, J. J. Abert wrote to Healy asking him to paint a portrait of President John Tyler and one of Senator William Campbell Preston for the Gallery of the National Institution in Washington, D.C. Healy painted Preston that year; Tyler sat for his portrait 17 years later at his plantation home in Virginia.

Left: Letter from J. J. Abert to George Peter Alexander Healy, 30 May 1842. 1 page, handwritten. Research material on George Peter Alexander Healy, 1811–1966. TRANSCRIPTION ON PAGE 174

Right: George Peter Alexander Healy stands with his palette and brushes in his grand studio on the rue de la Rochefoucauld in Montmartre, Paris, with an unidentified visitor, ca. 1885. Photographer unknown. Photographs of artists in their Paris studios, 1880–1890.

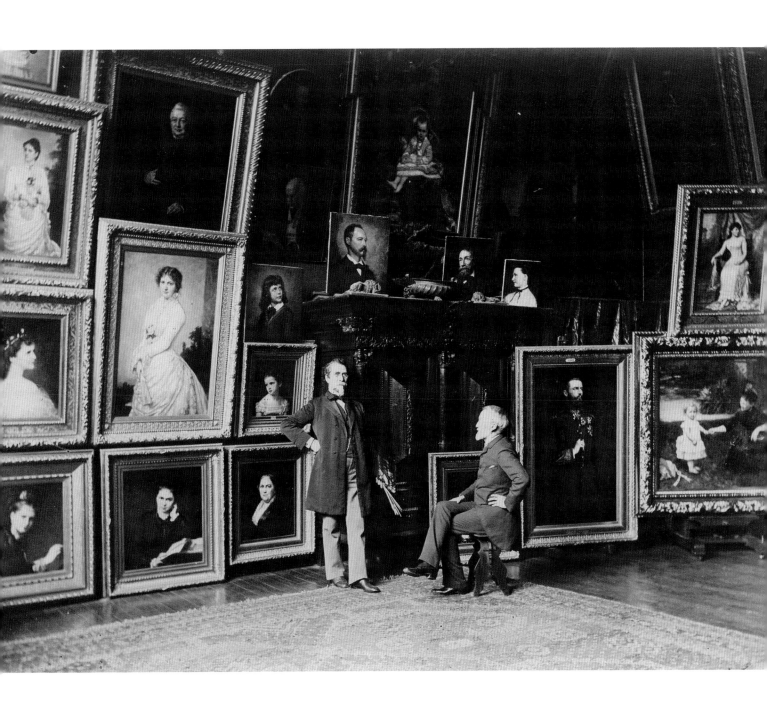

WALTER GAY

(1856–1937)

No. 43

18 Rue d'Armaillé

March 1. 89

My dear Matilda

I have waited in vain for a letter from you today.

Every time the Facteur comes, I have met him with a beating heart, only to be disappointed. If you only knew how I depend upon this letter from Nice. It is the only respite I have, during the live long day, from my troubles. I am unhappy, the whole

When Walter Gay died, the *New York Times* described him as the "dean of American artists in Paris." He moved to France in 1876 at age 20 and remained there for the rest of his life, specializing in paintings of French eighteenth-century interiors. His love of French decorative arts carried over to his studio, which he ornamented with antique furniture, textiles, pottery, and paintings. In the photograph at right, he displayed the medals he won at exhibitions on the wall behind him—an overt sign of his critical success.

In 1889, when Gay's fiancée Matilda Travers was in Nice, France, Gay was desperate for a letter from her. He writes, "I am so much a prisoner here, shut up in my studio, with nothing but memories to live upon." They married the following month in London.

Left: Love letter from Walter Gay to Matilda Travers, 1 March 1889. 4 pages, handwritten. Walter Gay papers, 1870–1980. TRANSCRIPTION ON PAGE 174

Right: Walter Gay in his studio at 11 rue Daubigny, Paris, ca. 1890. Photographer unknown. Photographs of artists in their Paris studios, 1880–1890.

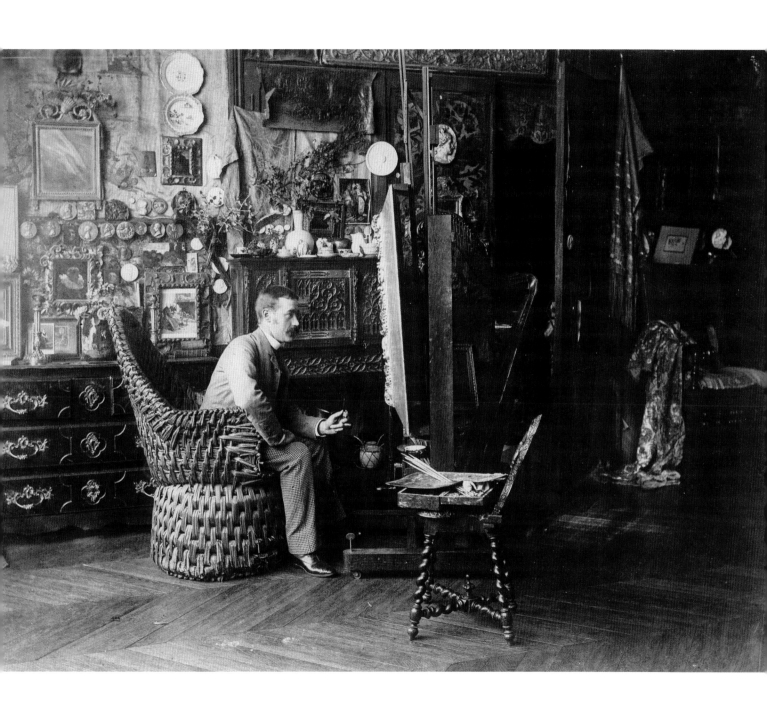

ENID YANDELL

(1 8 7 0 – 1 9 3 4)

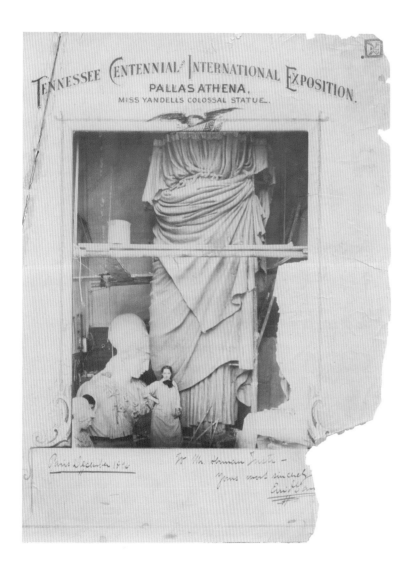

In 1894, Yandell went to Paris to study with American sculptor Frederick MacMonnies. Her studio adjoined his. While abroad, she received many commissions, but the most important was from the board of the Tennessee Centennial Exposition to make a monumental Athena for the 1897 international exposition. Yandell's statue was a faithful, colossal copy of the Roman statue of Athena known as the *Pallas de Velletri*, 1st century A.D., in the Louvre. She made the piece in three sections for ease in shipping. It was 25 feet high (40 feet with the base). A commanding presence at the exposition, Yandell's *Athena* put her male counterparts on notice that she was a force to reckon with.

Left: Advertisement for Enid Yandell at the Tennessee Centennial Exposition. Inscribed lower left, "Paris, December 1896"; and lower right, "to Mr. Herman Justi—Yours most sincerely, Enid Yandell." Justi was the editor of the *Official History of the Tennessee Centennial Exposition* (1898). Enid Yandell papers, 1878–1982.

Right: Enid Yandell at work on her colossal sculpture *Pallas Athena* in her Paris studio on the impasse du Maine in the Latin Quarter, 1896. Photographer unknown. Enid Yandell papers, 1878–1982.

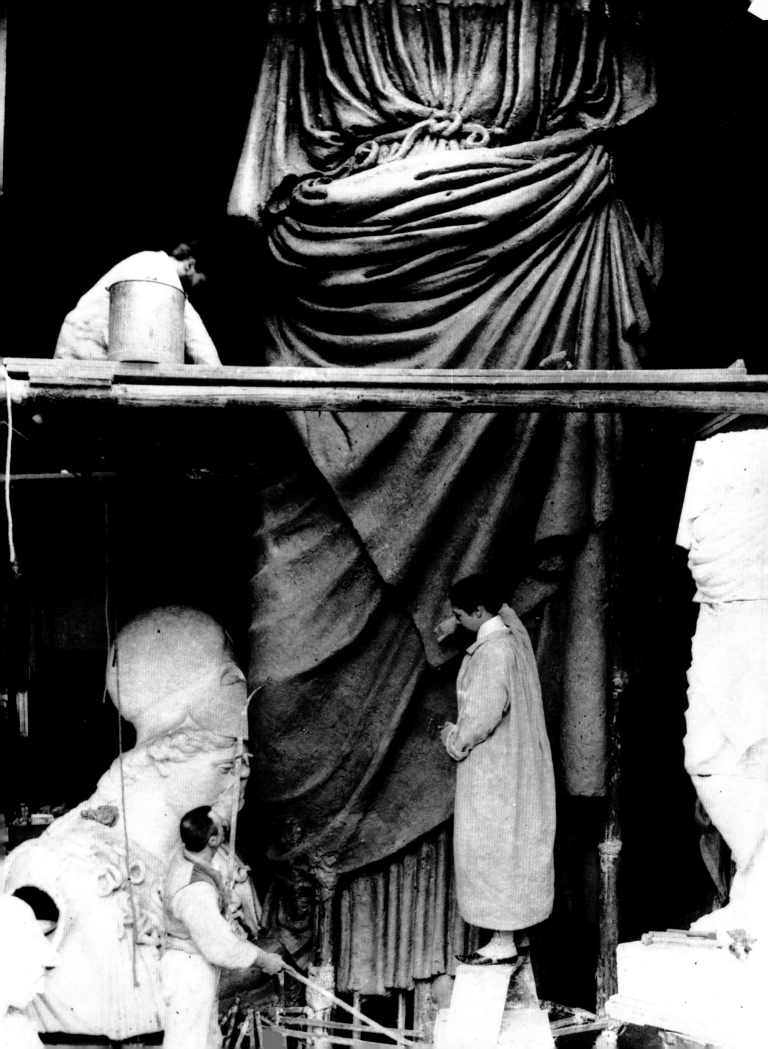

ANDREW DASBURG

(1 8 8 7 – 1 9 7 9)

In the photograph below, painter Andrew Dasburg, left, an unidentified visitor, and possibly Roland Moser, Dasburg's studio mate, right, cleaning dishes after a meal in Dasburg's Paris studio at 115 rue Notre Dame des Champs in 1910. Photographer unknown. Andrew Dasburg and Grace Mott Johnson papers, 1854–1979.

Dasburg intended to share this studio with his wife, Grace Mott Johnson, but after she had a miscarriage, she returned to the United States in February 1910. Dasburg knew Moser only slightly when they were students at the Art Students League in New York. On 11 February 1910, Dasburg wrote to Grace about Moser:

OUR COOKING IS QUITE A SUCCESS, IT'S IMPROVING RIGHT ALONG. LAST NIGHT WE HAD A STEW THAT IS A WONDER: MADE OF DUCK, POTATOES AND PEAS, WITH A GLASS OF WINE, BREAD AND CHEESE IT MADE A VERY SATISFACTORY DINNER.

In Paris, Dasburg absorbed the new currents in art; he saw paintings by Cézanne, and met Gertrude and Leo Stein, Pablo Picasso, and Henri Matisse.

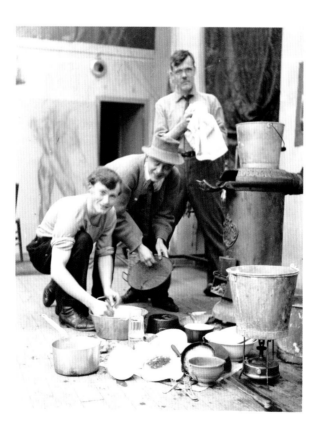

Andrew Dasburg's studio at 115 rue Notre Dame des Champs in 1910. Photographer unknown. Andrew Dasburg and Grace Mott Johnson papers, 1854–1979.

Henry Ossawa Tanner

(1 8 5 9 – 1 9 3 7)

Tanner, who was of English, African, and Native-American descent, found a receptive social climate in Paris. In 1914, he commented on an article written about him,

YOU SAY "IN HIS PERSONAL LIFE MR. T. HAS HAD MANY THINGS TO CONTEND WITH. ILL-HEALTH, POVERTY, RACE PREJUDICE, ALWAYS STRONG AGAINST A NEGRO"...TRUE— THIS CONDITION HAS DRIVEN ME OUT OF THE COUNTRY... & WHILE I CANNOT SING OUR NATIONAL HYME...STILL DEEP DOWN IN MY HEART I LOVE IT. & AM SOMETIMES VERY SAD THAT I CANNOT LIVE WHERE MY HEART IS.

Left: Draft letter from Henry Ossawa Tanner to Eunice Tietjens, 25 May 1914. 3 pages (incomplete), hand-written. Henry Ossawa Tanner papers, 1850–1978. TRANSCRIPTION ON PAGE 174

Right: Henry Ossawa Tanner in his studio at 51 boulevard Saint-Jacques in Paris, ca. 1900. On the easel is *Christ among the Doctors*, 1899–1900 (location unknown). Photographer unknown. Henry Ossawa Tanner papers, 1850–1978.

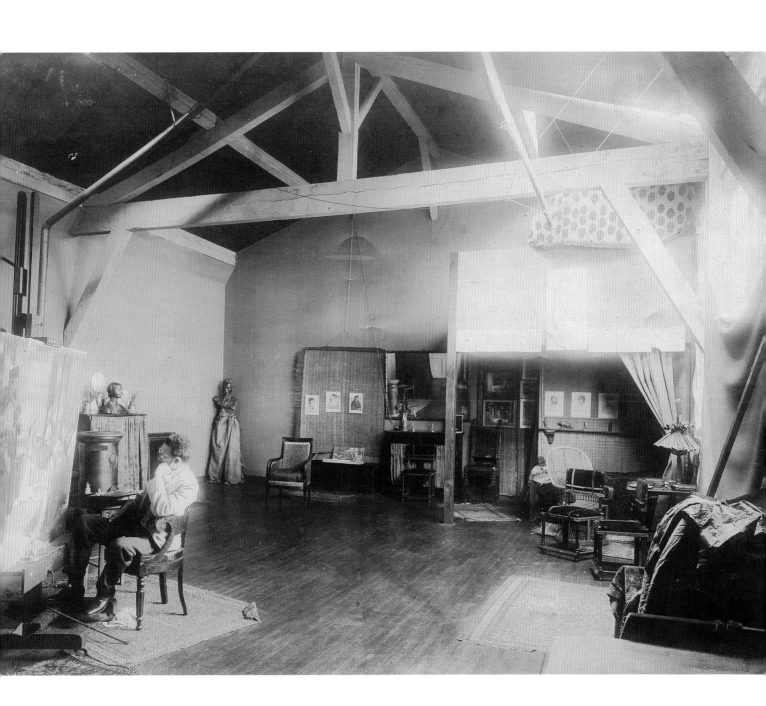

HERBERT HASELTINE

(1877–1962)

The son of America landscape painter William Stanley Haseltine (1835–1900), Herbert lived most of his life in Paris, where he excelled as an animalier. In 1934, Marshall Field purchased a group of these sculptures in marble and bronze for the Field Museum in Chicago.

In a letter to art dealer Martin Birnbaum, Haseltine grumbles about hard times.

THE FINANCIAL DEPRESSION, I SUPPOSE HAS GOT ME AT LAST—PEOPLE COME TO MY STUDIO, ADMIRE AND ADMIRE BUT DON'T BUY— NOT THEIR FAULT OF COURSE BUT IT CANNOT BE HELPED.

He asks Birnbaum's opinion about cutting his price for a possible sale to Thomas Cochran, founder of the Addison Gallery of American Art in Andover, Massachusetts.

Left: Letter from Herbert Haseltine to Martin Birnbaum, undated. 2 pages, handwritten. Martin Birnbaum papers, 1862–1970. TRANSCRIPTION ON PAGE 175

Right: Herbert Haseltine in his studio at 4 rue du Dr. Blanche in Paris, with his sculptures of British champion sheep and other animals, ca. 1930. Forbes Watson papers, 1900–1950.

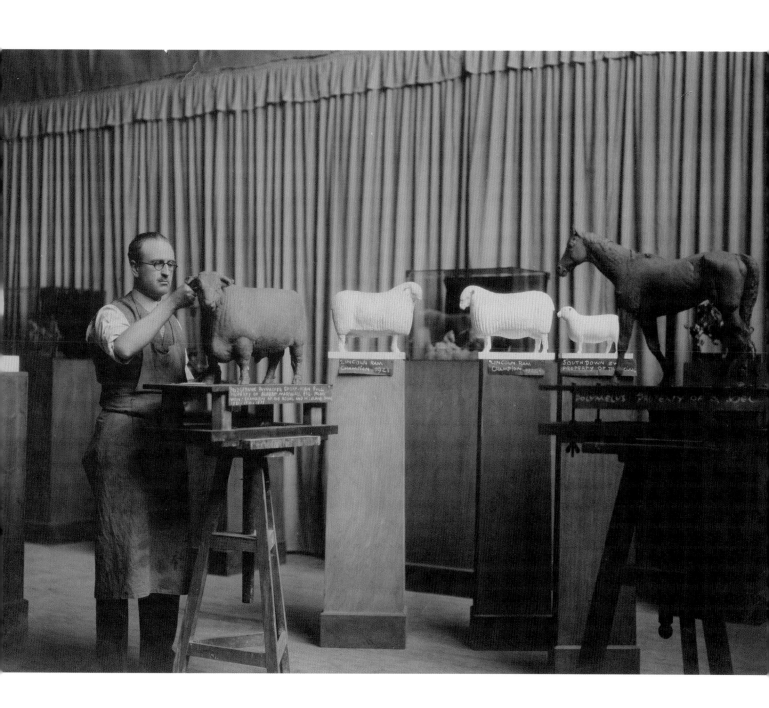

David Smith

(1 9 0 6 – 1 9 6 5)

In 1962 the Italian government gave sculptor David Smith free use of an abandoned welding factory in Voltri, Italy, to make sculptures for the Festival of Two Worlds, an arts celebration, in neighboring Spoleto. Smith was so energized by the space and the stockpile of steel—old tools and machine parts—that he found on the site that he produced 27 sculptures for the festival, his 1962 *Voltri* series. Photograph by Ugo Mulas. Miscellaneous photograph collection. © Ugo Mulas Estate. All rights reserved.

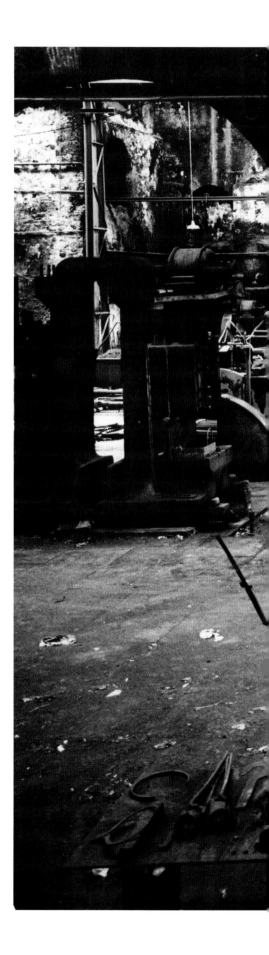

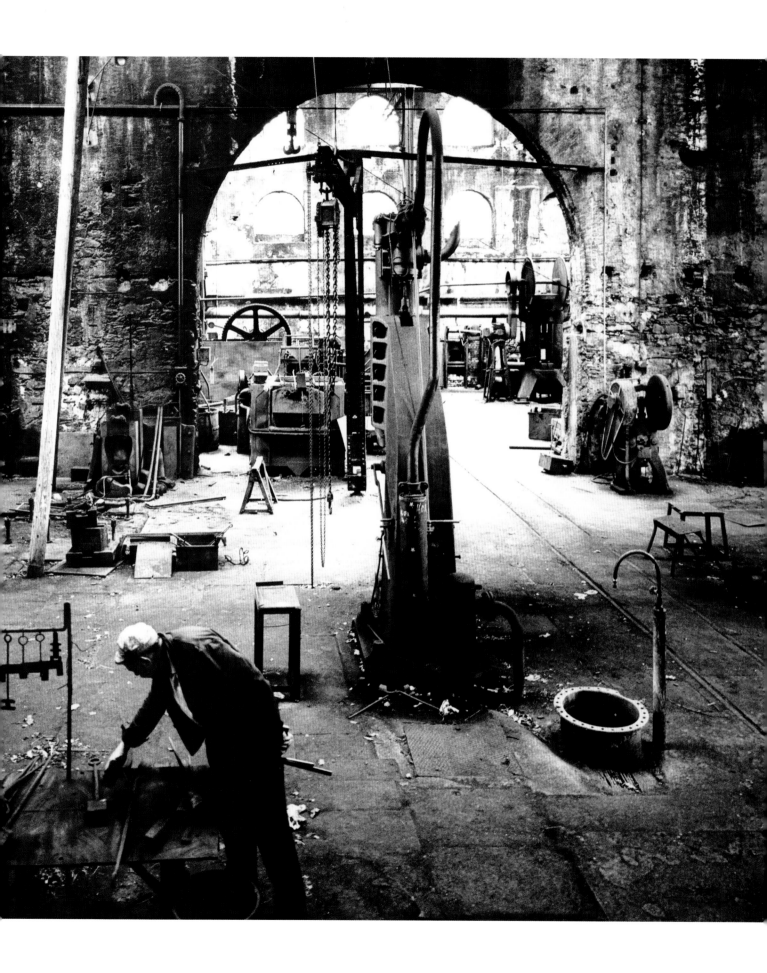

ARTISTS AND THEIR MODELS

Frederick Arthur Bridgman

(1847–1928)

In the 1880s, Bridgman specialized in scenes of contemporary Algeria. His lavishly decorated studio was a work of art in itself. With sumptuous fabrics, intricate rugs, and objets d'art from his travels to North Africa, he created an orientalist haven that was both a source of inspiration for his paintings and a gathering place for like-minded aesthetes.

Frederick Arthur Bridgman at work on his painting *The Game of Chance* in his Paris studio at 146 boulevard Malesherbes, ca. 1885. Photographer unknown. Artists in their Paris studios, 1880–1890.

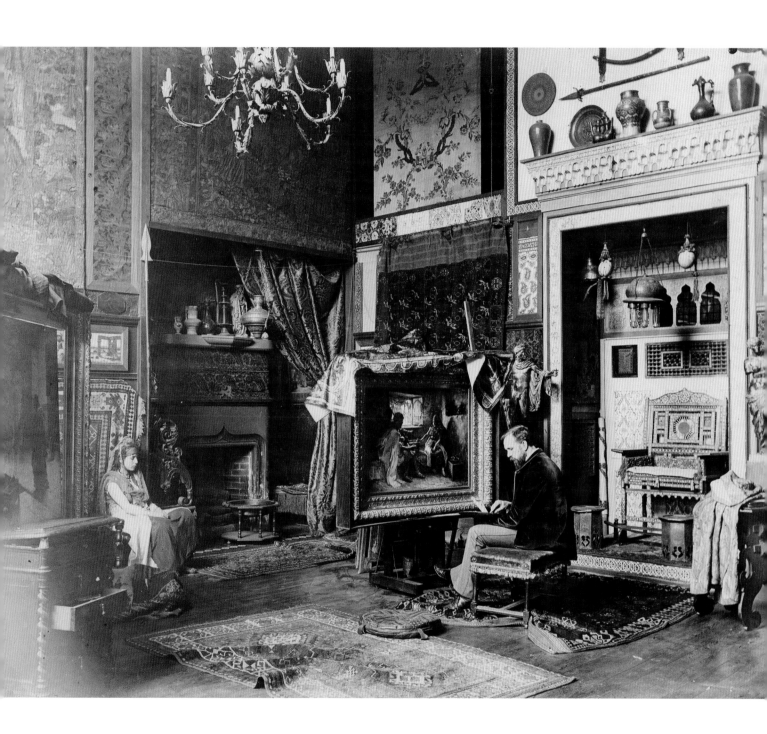

N. C. WYETH

(1882–1945)

N. C. Wyeth and Allen Tupper True (1881–1955) both studied illustration with Howard Pyle (1853–1911) in Chadds Ford, Pennsylvania. In 1904 Wyeth traveled west to seek compelling subjects to illustrate. He stayed with True's parents in Denver, Colorado, setting up a studio in a nearby office building, the Charles, at Fifteenth and Curtis Streets. While in Colorado, Wyeth soaked up scenes of the Wild West and even rode in a cattle round-up.

In 1904, Allen Tupper True wrote to his mother, "Wyeth is coming out to the West (Colo) to study cowboy and Indian life for a month. Can Mrs. Church give him a job on the K◊ ranch or can you help him to a place where he could see the puncher life of N.W. Colo. or Wyoming? When are the round ups & Indian dances? Wyeth expects to start soon and is the kind of fellow one wants to help—self-made & reliant."

Left: Letter from Allen Tupper True to his mother, 5 September 1904. 5 pages, handwritten. Allen Tupper True and True family papers, 1841–1987.
TRANSCRIPTION ON PAGE 175

Right: N. C. Wyeth in his studio in Denver, Colorado [1904]. He used his first-hand experience and a cowboy model to paint *Rounding-up, Little Rattlesnake Creek*, 1904 (on the easel), which was later published in *Scribner's* magazine. Photographer unknown. Allen Tupper True and True family papers, 1841–1987.

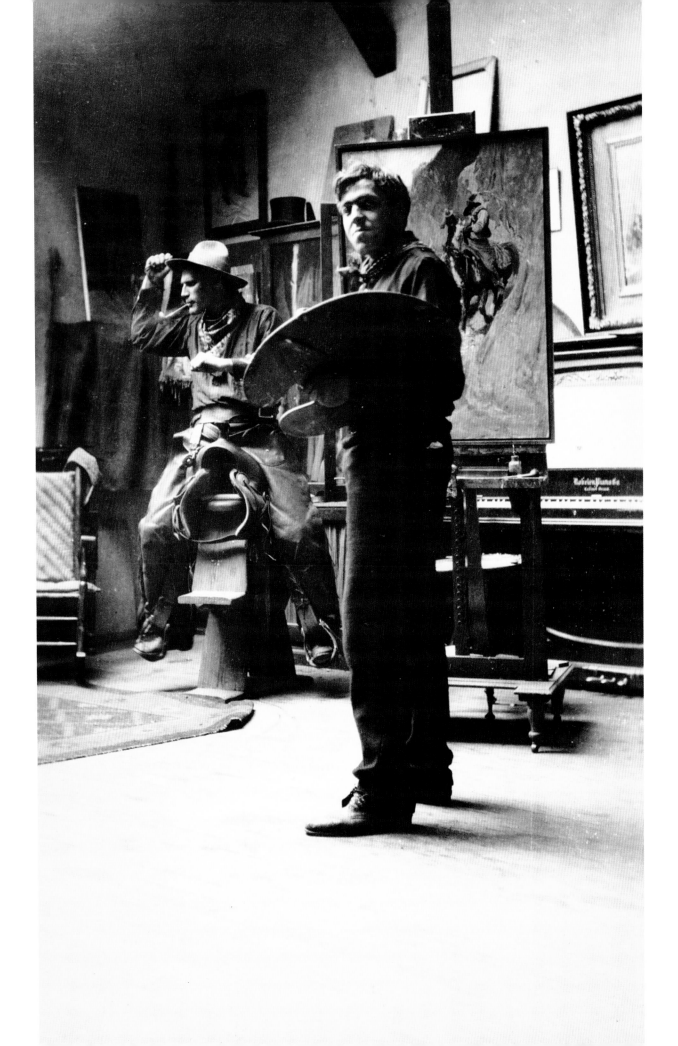

ADOLPH A. WEINMAN

(1 8 7 0 – 1 9 5 2)

THIS AGREEMENT for the erection of a monument of Abra-
ham Lincoln, made in the year one thousand, nine hundred and
seven by and between Adolph A. Weinman of 97-Sixth Avenue,
New York City, party of the first part (hereinafter called
the sculptor); and the KENTUCKY TABLET COMMISSION of the State
of Kentucky, party of the second part (hereinafter called the
Commission), w i t n e s s e t h:-

That the parties hereto in consideration of the payment
hereinafter provided to be made, and for the faithful ful-
fillment of the reciprocal promises and agreements herein-
after contained, mutually agree as follows:-

THAT the sculptor doth hereby for himself, his heirs,
executors and administrators, covenant, promise, and agree
to and with the Commission and their successors, that he shall
and will complete, and finish in every respect a Memorial
to Abraham Lincoln, consisting in of a Statue in bronze
of the said Lincoln with a pedestal of granite or marble set
complete on proper foundations on a plot in the town of
Hodgenville, Larue County, Kentucky, hereinafter designated
by the Commission, and in accordance with a model submitted
by the sculptor and approved by the Commission;

That any approaches, grass plots, grading, etc., adjacent
to the Memorial will be executed by the Commission in accord
ance with the drawings provided therefor by the sculptor:

That the sculptor shall and will find and provide such
good, proper and sufficient materials and labor of all kinds,
whatsoever, as shall be proper and sufficient for the comple-
tion and finishing of the said Memorial to the entire satis-
faction of the COMMISSION for the sum of ~~fourteen~~ *thirteen* thousand
dollars to be paid as follows:-

Adolph A. Weinman in his West
Twenty-first Street studio in New York,
ca. 1906, right. He is at work on his
large seated *Abraham Lincoln*, first cast
in 1906, commissioned for Lincoln's
birthplace, Hodgenville, Kentucky.
On the right, an assistant works on
Sir Galahad, a lectern for the George
Newhall Clarke Memorial Chapel
at the Pomfret School in Pomfret,
Connecticut. The striding group in
the top left corner is the *Maryland
Union Soldiers and Sailors Monument*
created for Baltimore, Maryland.
Photograph by James H. Hare.
Adolph A. Weinman papers, 1890–1959.

Adolph A. Weinman's contract in 1909
with the Kentucky Tablet Commission
for his *Abraham Lincoln*, for which
he was paid $13,000. 3 pages, carbon
copy typescript. Adolph A. Weinman
papers, 1890–1959.

TRANSCRIPTION ON PAGE 176

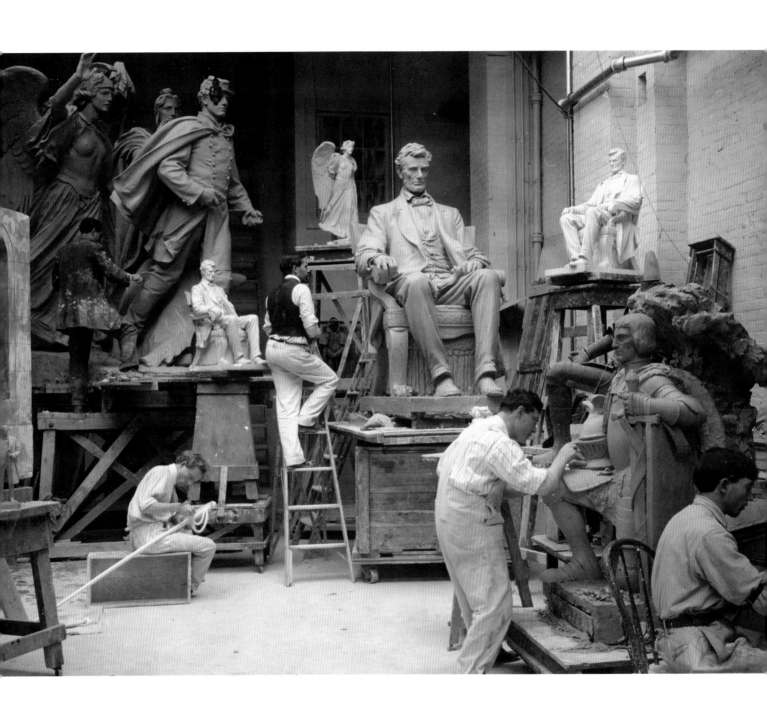

James Earle Fraser

(1876–1953)

After studying in Paris and working as an assistant to Augustus Saint-Gaudens, Fraser opened his own studio in New York City in 1902. He was famous for his portrait busts and sculptures of Native Americans and horses. He also designed the buffalo nickel, first issued in 1913. That same year he married sculptor Laura Gardin and used his buffalo nickel prize money to purchase a home and studio in Westport, Connecticut.

James Earle Fraser in his Westport, Connecticut, studio, ca. 1919, working on a model for his bronze sculpture *Journey through Life* installed in Rock Creek Cemetery, Washington, D.C., in 1920. Photographer unknown. Miscellaneous photograph collection.

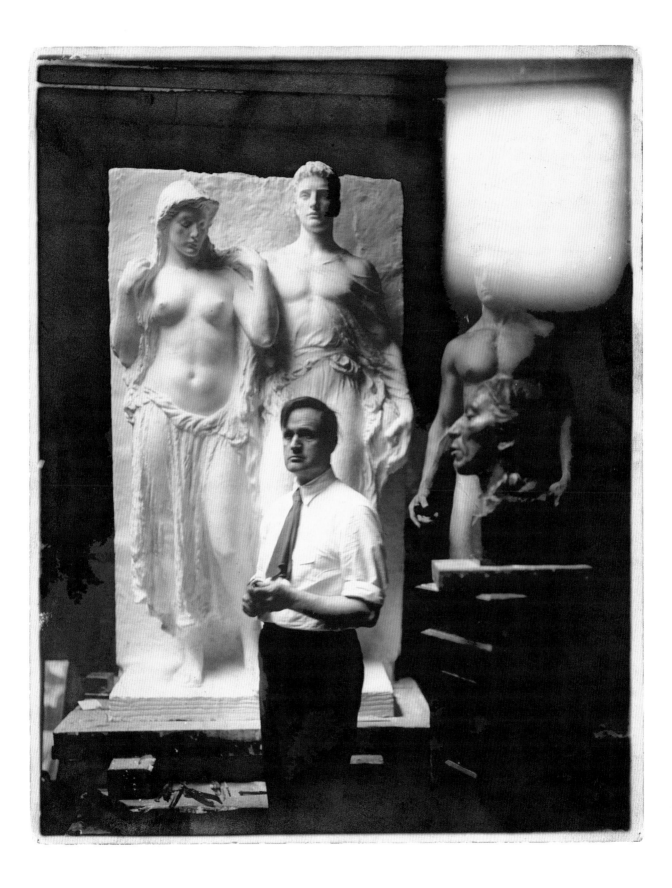

JANET DE COUX

(1904–1999)

"ELEVEN O'CLOCK ROADS"
WESTPORT, CONN.

December 17, 1940

Dear Janet;

I am a funny sort of a guy not
to have written at once to thank you and
your family for being so nice as to give
me dinner and such a pleasant evening! But,
my thanks, though late, are very much from
the heart.

Seeing your studio and its grand
light and very good proportions makes me
feel like building one like it here. I
particularly like the fact that you had only
a few things in it. You really can see and
walk around each piece.

Your light seems to me perfect.
Some day, you must make your little leanto
shed permanently enclosed, so that you can
keep the things you are not working on out-
side. That is what I would like to do, any-
way, if I had it.

I suppose by this time, your little
stone figure must be nearly complete. I think
it is a fine piece of work, and should be much
appreciated. You probably will go in the
Pittsburgh Museum. I just heard from Homer
Saint Gaudens, asking for something, but I have
nothing particularly prepared to send.

We are hoping to see you around Christmas
time. You must try out your new road, it should
bring you here in no time. Laura sends her best
to you, and we all hope you will be able to make
it at Christmas time.

Thanks again to you all,

Faithfully

In 1932, sculptor Janet De Coux apprenticed with James Earle Fraser. In a letter from Fraser to his former assistant, he comments on her studio, "Seeing your studio and its grand light and very good proportions makes me feel like building one like it here."

Left: Letter from James Earle Fraser to Janet De Coux, 17 December 1940. 1 page, typescript. Janet De Coux papers, 1927–1998.

TRANSCRIPTION ON PAGE 176

Right: Studio of Janet De Coux in Gibsonia, Pennsylvania, ca. 1940. Photographer unknown. Janet De Coux papers, 1927–1998.

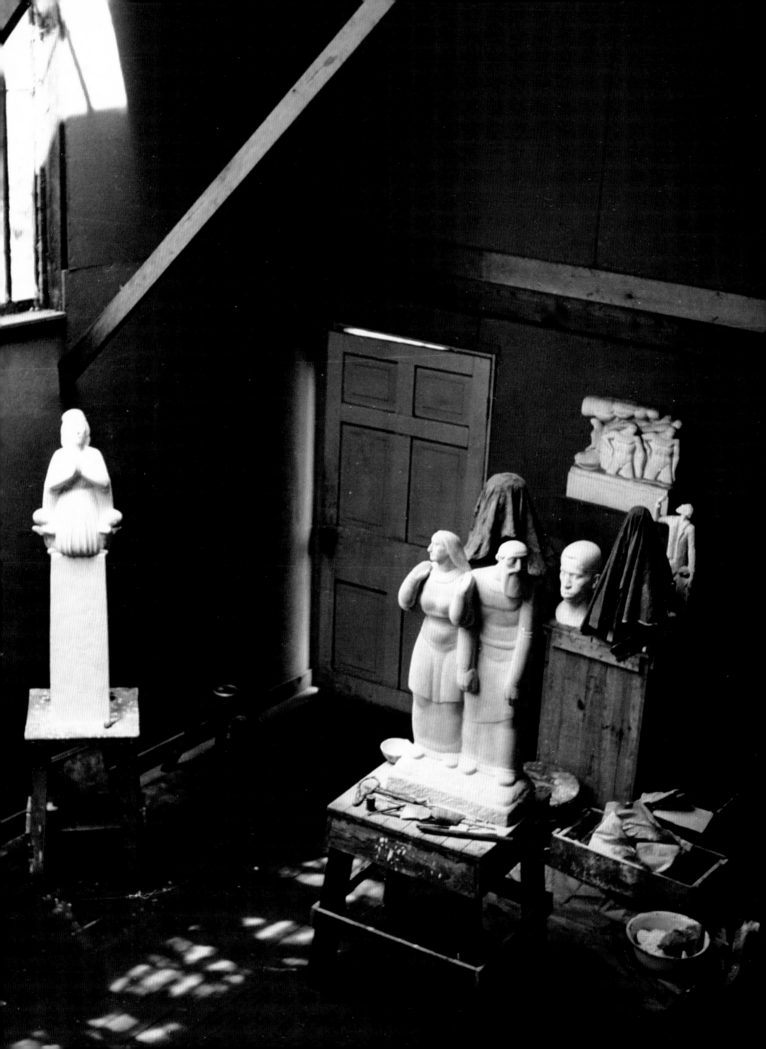

NICKOLAS MURAY

(1 8 9 2 – 1 9 6 5)

Nickolas Muray's first photography studio, right, at 120 MacDougal Street in Greenwich Village, New York City, ca. 1920. The photographs on the wall are early portraits by Muray, who later became a celebrity photographer for *Vanity Fair* and *Harper's Bazaar*. The crossed swords in the fireplace point to his passion for fencing. He was a member of the United States Olympic Fencing Team in 1928 and 1932. Photograph by Nickolas Muray. Nickolas Muray papers, 1911–1978. ©Nickolas Muray Photo Archives.

Muray kept notes on his celebrity sitters. For Clark Gable, he wrote: "man's man—pleasant afternoon"; and about Greta Garbo,

COULDN'T FIND EVENING DRESS/TO GET BARE SHOULDERS, SHE SLIPPED OFF BLOUSE—ALL NOISE STOPPED/HOWARD STRICKLING [THE HEAD OF PUBLICITY AT MGM] YELLED FOR DRAPE.

Muray photographed Garbo in 1929 at MGM studios in Hollywood for *Vanity Fair*.

```
GARBO

Very late   decolle Eve dress
            assign stage not in use
Set construction going on.

 couldn't find evening dress

 to get bare shoulders, she
 slipped off blouse --

 all noise stopped

 Howard Strickling yelled
   for drape
```

Far left: Nickolas Muray at a photo shoot, ca. 1930. Photographer unknown. Nickolas Muray papers, 1911–1978.

Near left: Muray's notes on Greta Garbo, ca. 1929. 1 page, annotated typescript. Nickolas Muray papers, 1911–1978. TRANSCRIPTION ON PAGE 177

PHILIP EVERGOOD

(1 9 0 1 – 1 9 7 3)

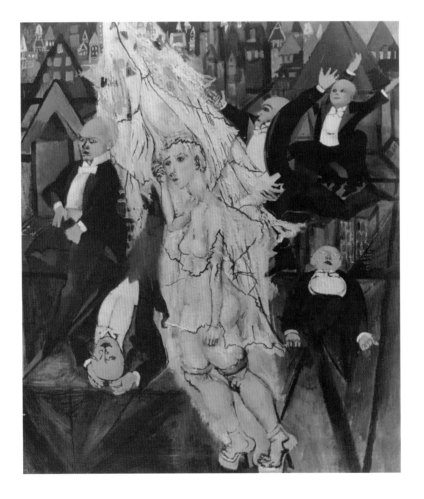

In 1952, painter Philip Evergood won a $5,000 prize from the Terry Art Institute in Miami, Florida, which he used to purchase a farmhouse in Southbury, Connecticut. He converted a barn on the property into a spacious studio with a northern exposure.

Right: Philip Evergood working with a model for his painting *Bride* (1952). At left is a photograph of the painting (unlocated). Photographs by Alfred Puhn. Alfred Puhn photographs, ca. 1950–1959.

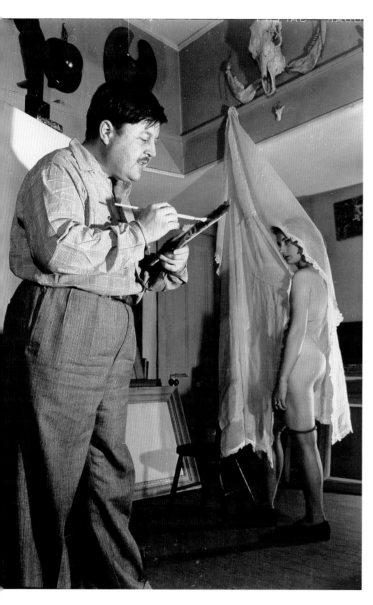
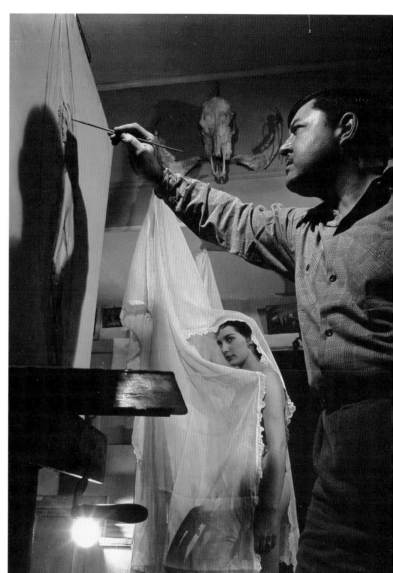

REGINALD MARSH

(1 8 9 8 – 1 9 5 4)

Reginald Marsh's studio, right, on Fourteenth Street in New York City overlooked Union Square. A keen observer of urban life, Marsh studied the streets from his studio window with his binoculars. One of his favorite subjects was the working woman. In his fluid signature style he depicted them as both stylishly curvaceous and self-possessed. In the background is Marsh's painting *Battery Belles*, 1938 (in the collection of the Swope Art Museum). Photographer unknown. Reginald Marsh papers, 1887–1955.

Reginald Marsh, figure study, ink and wash on paper, 15 × 10 cm, ca. 1945. Reginald Marsh papers, 1887–1955.

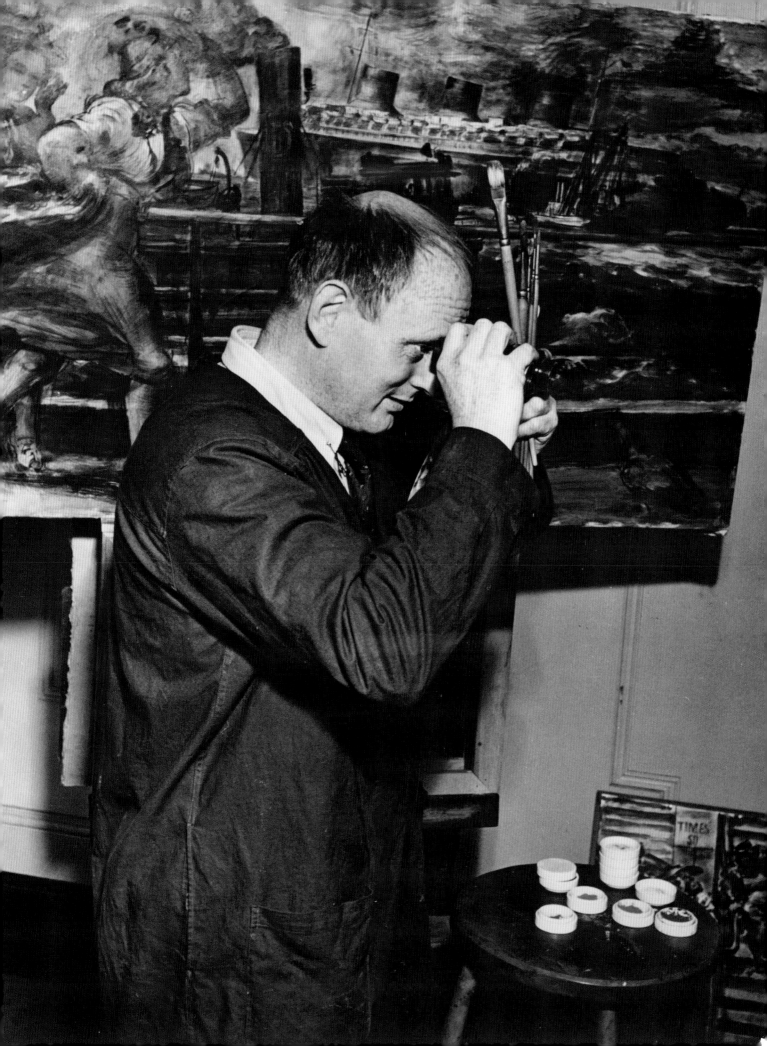

WILLIAM ZORACH

(1 8 8 7 – 1 9 6 6)

ABSTRACT AND NONE
OBJECTIVE - SCULPTURE
TAUGHT. IN 6 EASY-
LESSONS - RESULTS
GUARENTEED OR IT'S
YOUR OWN FAULT
COURSE OF 6 LESSONS
$100ºº NO REFUNDS
WM Zorach

In 1936, William Zorach remodeled an old carriage house at 276 Hicks Street in Brooklyn, New York, as his home and studio. His wife, Marguerite, painted upstairs, where they lived for a time. The downstairs space, a generous 25 by 100 feet, was Zorach's sculpture studio.

Left: Letter from William Zorach to his daughter Dahlov Ipcar, 5 February 1949 (detail). 2 pages, handwritten. Dahlov Ipcar papers, 1906–1997.
TRANSCRIPTION ON PAGE 177

.

Right: William Zorach drawing from a model, ca. 1955. Photograph by Alfred Puhn. Alfred Puhn photographs, ca. 1950–1959.

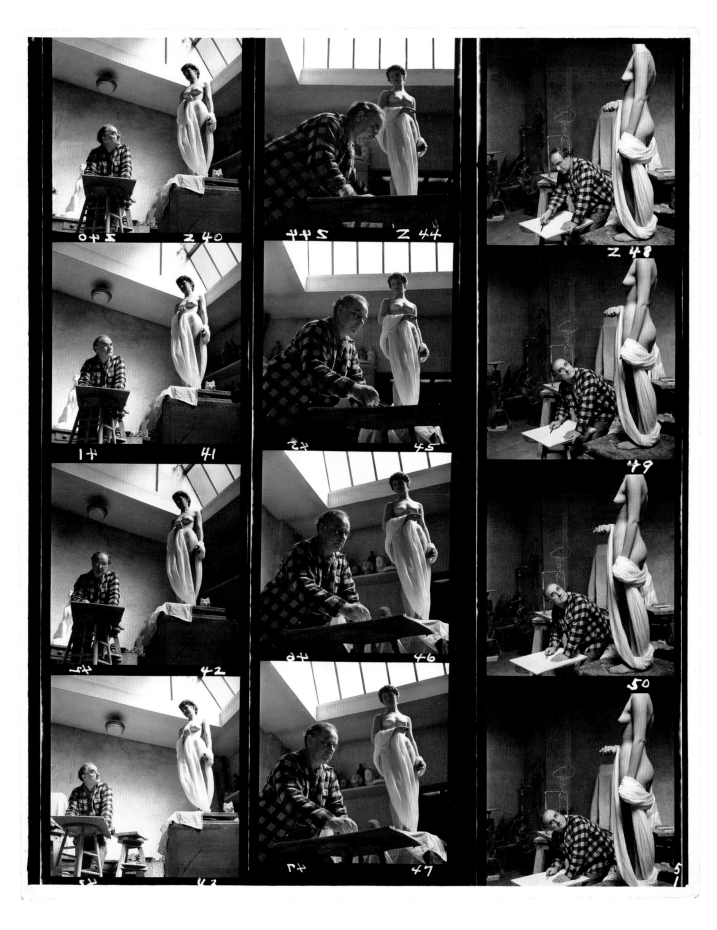

3

THE STUDIO AS A SOCIAL SPACE

Frank Duveneck

(1848–1919)

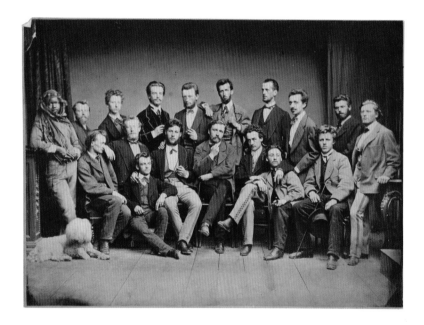

In 1874, painter Frank Duveneck
shared a studio on Fourth Street in
Cincinnati, Ohio, with sculptor
Frank Dengler (1853–1879). In the
photograph at right, from left to
right, Dengler, Duveneck, and painter
Henry F. Farny (1847–1916) relax in
front of Duveneck's painting of Joan
of Arc (featured in a local Germanic
festival in 1875). Duveneck, Dengler,
and Farny were students together
in Munich. In the Cincinnati studio
they re-created the collegial bohemian
atmosphere they had known in
Germany. Photographer unknown.
Frank and Elizabeth Boott Duveneck
papers, 1851–1972.

William von Diez's class at the Munich Academy of Fine Arts in 1871. Diez is seated at the
center with his hand at his chin. Frank Duveneck is in the front row holding a cane and
top hat. Photographer unknown. Frank and Elizabeth Boott Duveneck papers, 1851–1972.

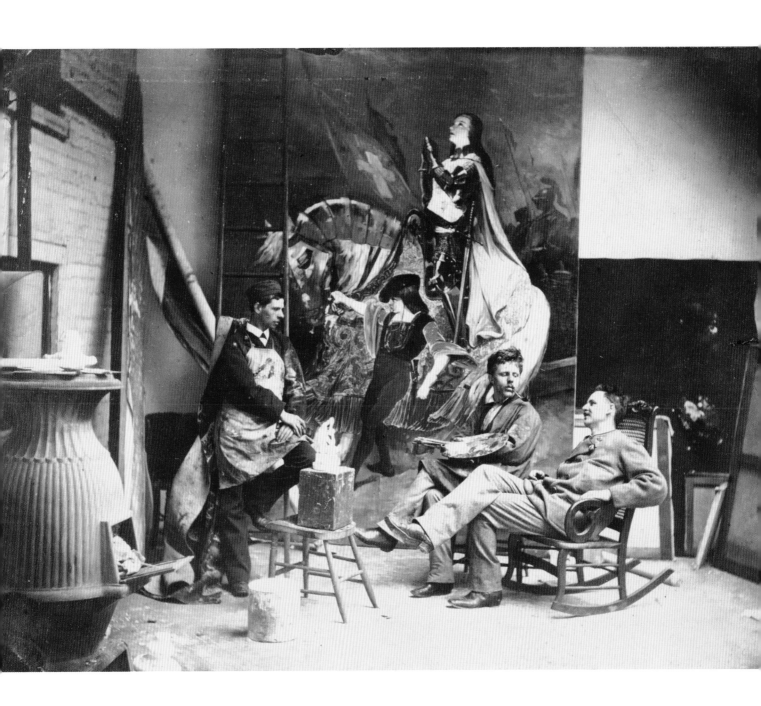

SHERWOOD STUDIO BUILDING

In the late nineteenth century, the Sherwood Studio Building at the corner of Fifty-seventh Street and Sixth Avenue in New York City was considered the uptown hub of the art world. Unlike other studio buildings at the time, the Sherwood was designed for artists with families. An in-house restaurant served meals in common rooms or delivered them to individual apartments. Informal social gatherings flourished—poker games, plays, costume parties, concerts, dinners, and teas as well as public studio receptions.

A costume party at the Sherwood Studio Building, 1889. Left to right: William Allen, Thomas S. Sullivant, Samuel Isham, Robert Reid, Harry W. Watrous, Robert Ward Van Boskerck, Carlton Chapman, Willard Metcalf, and Herbert Denman. Photographer unknown. Macbeth Gallery records, 1838–1968.

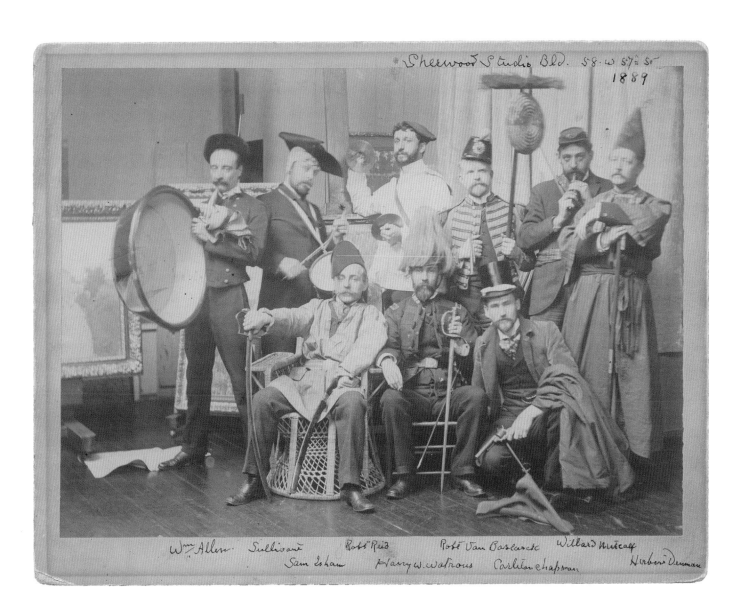

Wm Allen. Sullivan Robt Reid Robt Van Boskerck Willard Metcalf

Sam Isham Harry W. Watrous Carlton Chapman Herbert Denman

DENNIS MILLER BUNKER

(1 8 6 1 – 1 8 9 0)

In 1890, painter Dennis Miller Bunker wrote to his fiancée, Eleanor (Nell) Hardy, about a studio in the Sherwood Building, their future home. He had been to Reginald Coxe's apartment and drew the floor plan for her. Noting its benefits, he wrote:

IT WOULD BE JUST THE PLACE FOR US. I THINK THE ROOMS ARE JUST WHAT WE NEED. EVERYTHING IS ALL TOGETHER AS YOU SEE. A GOOD STUDIO—AND IN THE BEDROOM A JOLLY BIG BATH-TUB.

Bunker was 29 when he and Eleanor moved to the Sherwood in 1890. He died two months later of spinal meningitis.

Above: Letter from Dennis Miller Bunker to Eleanor Hardy, 1890. 8 pages, handwritten. Dennis Miller Bunker papers, 1882–1943.
TRANSCRIPTION ON PAGE 177

.

Right: Dennis Miller Bunker, ca. 1886. Photograph by H.G. Smith. Dennis Miller Bunker papers, 1882–1943.

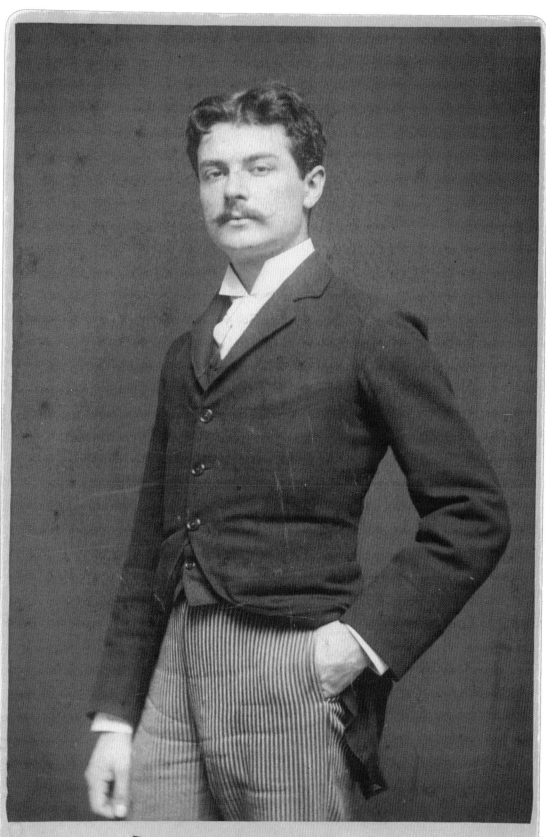

BUNKER

Arthur Wesley Dow

(1857–1922)

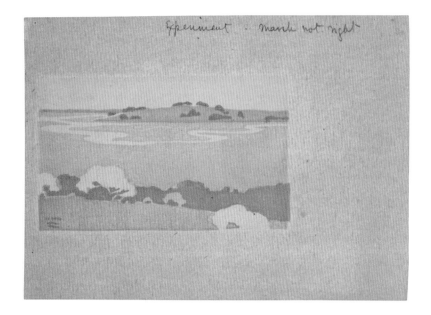

When Dow returned to Ipswich, Massachusetts, in 1890 from his studies in France, he transformed an old store into an atelier, surrounding himself with the landscapes that he had painted in France. The painting on the easel is *Au Soir*, which Dow painted in Brittany in 1889 and exhibited at the 1889 Paris Exposition Universelle. He also painted in Brittany with Henry Kenyon (1861–1926), his classmate at the Académie Julian in Paris. They remained lifelong friends. Dow and Kenyon found the marshes and small fishing villages of the North Shore to be strikingly similar to Pont-Aven in Brittany.

Above: Arthur Wesley Dow, study for a print with the notation "Experiment—Marsh not right," ca. 1901. 11 × 16 cm. Arthur Wesley Dow papers, 1858–1978.

.

Right: Arthur Wesley Dow, right, and Henry Kenyon, left, in Dow's studio in Ipswich, Massachusetts, ca. 1890. Photographer unknown. Arthur Wesley Dow papers, 1858–1978.

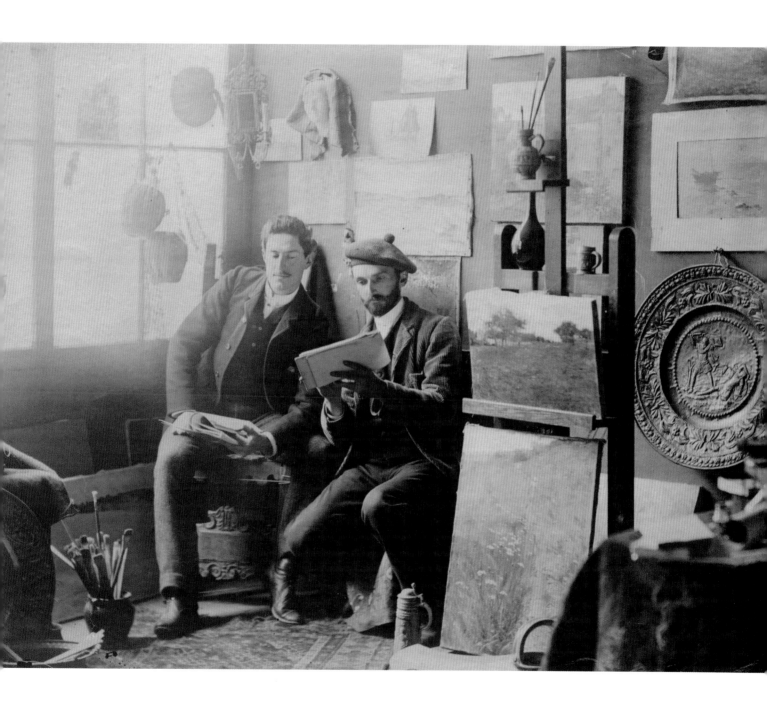

BESSIE POTTER VONNOH

(1 8 7 5 – 1 9 5 5)

East Side is east; West Side is west;
And ne'er the twain shall meet;
Save when they come together on
Old Sixty-Seventh Street.
We don't pretend we're swanky
Nor even very neat,
Yet there's a certain oomph about
Old Sixty-Seventh Street.

We have a livery stable,
It's called a "Riding Club,"
And 'cross the street at Number one
A restaurant and pub,
A place where H. C. Christy
Drew ladies in the nude
I don't advice your going there
In case you are a prude.

We also have a laundry
To wash your little shirts;
A drug store on the corner
With things to cure your hurts.
A tailor shop to make your clothes
Or just to press your pants,
And several of the buildings
Have places for the Dance.

Bessie Potter Vonnoh
Will mold your little head
So we can talk about you
Long after you are dead.
Or if you do not like the face
Bequeathed you by your mother,
Just see our Mr. Benda,
And get yourself another.

You cannot get too deep for us,
E'en in the deep blue sea,
For we can go a half-mile down
With Dr. Willie B.
But we prefer to scale the heights,
And when we leave for Heaven,
We hope we'll make the take-off
From good old Sixty-Seven.

(Verse by Lorraine (Mrs. Richard F.) Maynard)
of 33 W. 67th St. — Might have been
written for a big party in the studio.)

Bessie Potter Vonnoh gained a national reputation for her bronze fountains, portrait busts, and figure groups of mothers and children. In 1905, she moved into the newly completed cooperative studio building at 33 West Sixty-seventh Street in New York. She placed her art strategically around her two-storied studio, demonstrating the value of sculpture in the home. She often held parties and served as the president of the Sixty-seventh Street Studio Association for more than 20 years.

BESSIE POTTER VONNOH
WILL MOLD YOUR LITTLE HEAD
SO WE CAN TALK ABOUT YOU
LONG AFTER YOU ARE DEAD.
OR IF YOU DO NOT LIKE THE FACE
BEQUEATHED YOU BY YOUR MOTHER,
JUST SEE OUR MR. BENDA,
AND GET YOURSELF ANOTHER.

Left: Poem by Lorraine Maynard, "33 W. 67th Street Studio," ca. 1910. 1 page, annotated typescript. Richard Field Maynard papers, 1895–1979.

TRANSCRIPTION ON PAGE 178

Right: A dance in the studio of Bessie Potter Vonnoh, 33 West Sixty-seventh Street, ca. 1906. The woman dancing in the center is Bessie Potter Vonnoh. Photographer unknown. Frank Vincent DuMond papers, 1866–1982.

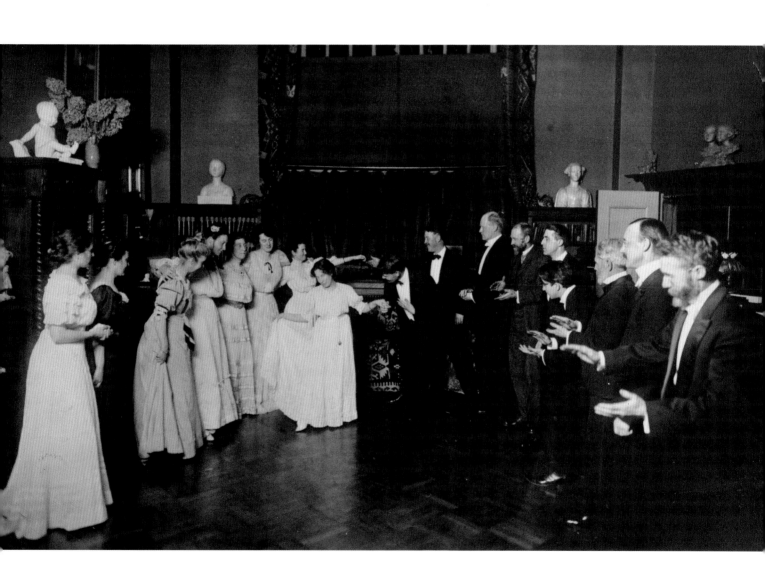

CHARLES KECK

(1875–1951)

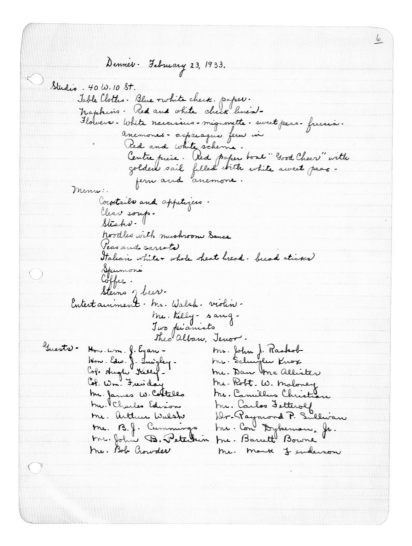

Charles Keck was known for his monumental sculpture and portrait busts. His cavernous studio at 40 West Tenth Street in New York had 30-foot-high ceilings, with huge doors opening onto the street, perfect for large sculpture projects and for parties.

Left: Charles Keck's notes for a dinner party at his studio, 23 February 1933. 1 page, handwritten. Charles Keck papers, 1905–1954.

TRANSCRIPTION ON PAGE 178

Right, top: Keck stands in front of his maquette for a monument to Dom Pedro I, Emperor of Brazil, King of Portugal (1798-1834). At the top center is Keck's *Lewis and Clark*, ca. 1919. Photographer unknown. Charles Keck papers, 1905–1954.

Right, bottom: Keck's studio decorated for a party with flags, garlands, and Japanese lanterns, ca. 1920. Photographer unknown. Charles Keck papers, 1905–1954.

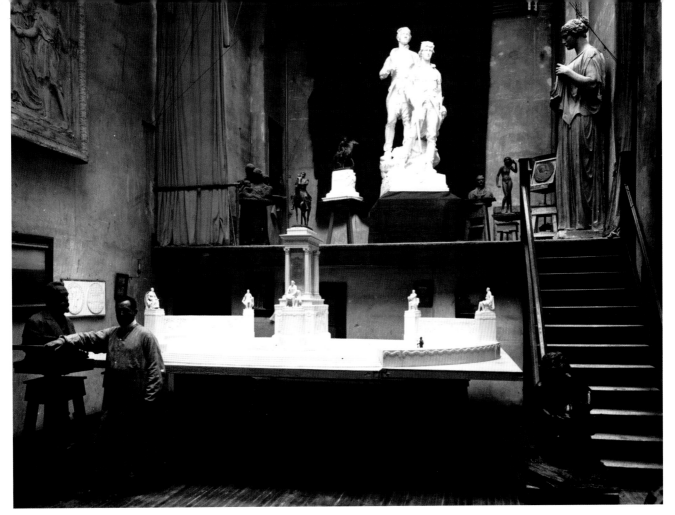

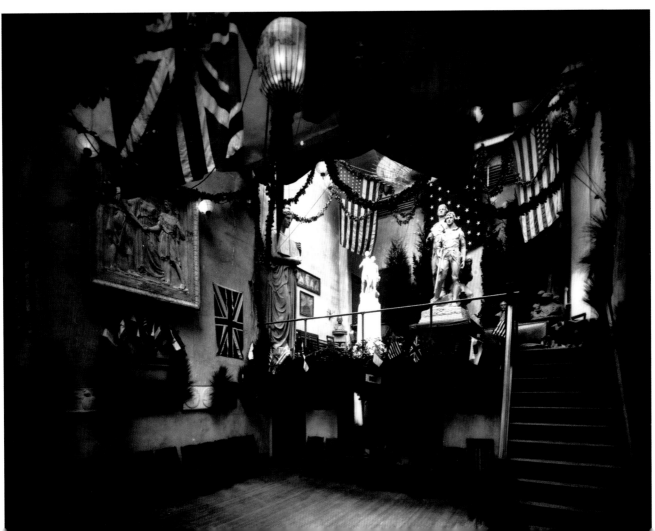

JOHN SLOAN

(1871–1951)

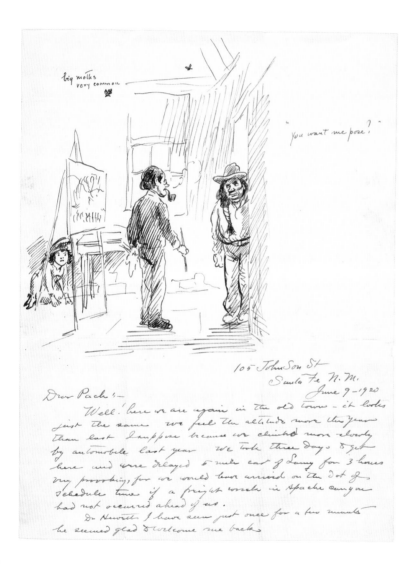

Beginning in 1919, New York painter John Sloan spent more than 30 summers in Santa Fe, New Mexico. In a letter to artist and art writer Walter Pach (1883–1958), Sloan sketches his Santa Fe studio, complete with local models and large moths. Inspired by a religious procession in Santa Fe, he wrote, "I have started painting nearly a week went by before I felt ready—a Corpus Christi procession through the roads and over the bridge Sunday—gave me a theme."

Left: Letter from John Sloan to Walter Pach, 9 June 1920. 2 pages, hand-written, illustrated. Walter Pach papers, 1883–1980. TRANSCRIPTION ON PAGE 178

.

Right: John Sloan, at the easel, with his artist-friends Will Shuster, standing, and Josef Bakos, seated, in Sloan's Santa Fe studio, 1939. Photograph by Ernest Knee and Len Bouché. Miscellaneous photograph collection.

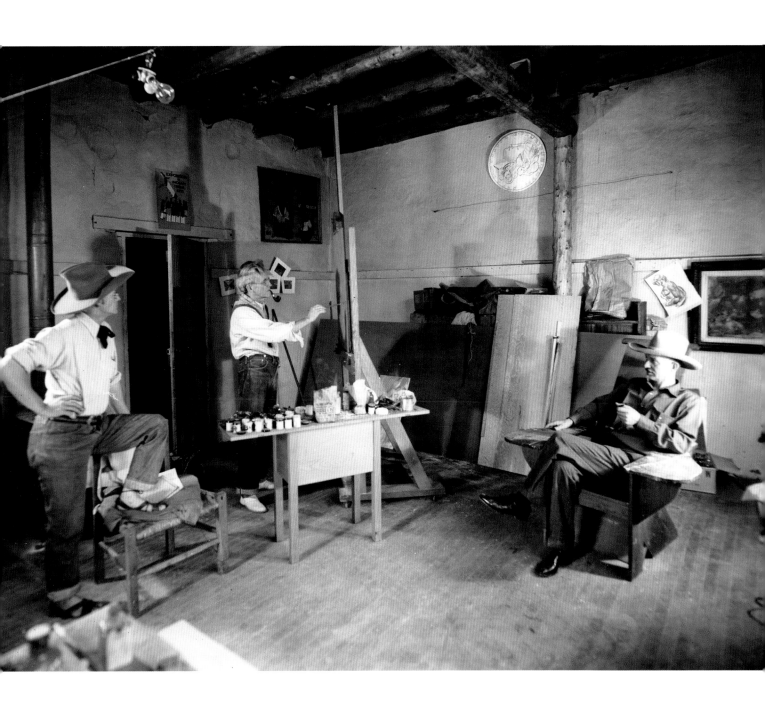

MOSES SOYER

(1 8 9 9 – 1 9 7 4)

Moses Soyer's studio at Fifty-ninth Street and Amsterdam Avenue in New York was a magnet for talented, lively people—poets, dancers, and artists—including many students.

Moses Soyer, in a white shirt, holding brushes, stands between his twin Raphael, seated, and their younger brother Isaac, standing. The Soyer brothers, all painters, frequently gathered to critique one another's work. On the easel is a painting of Moses' wife, Ida, a dancer. On the platform, still in costume, Ida chats with one of Moses' students, Alice Twitchell. Other students paint, talk, and peruse props to use in paintings.

Studio of painter Moses Soyer, 14 July 1940. Photograph by Cosmo-Sileo. Moses Soyer papers, 1920–1974.

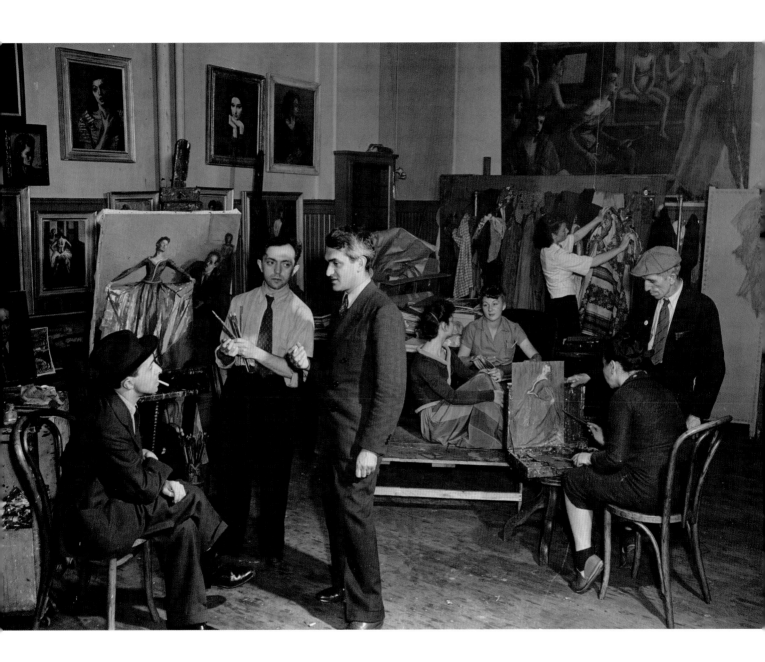

CARL HOLTY

(1900–1973)

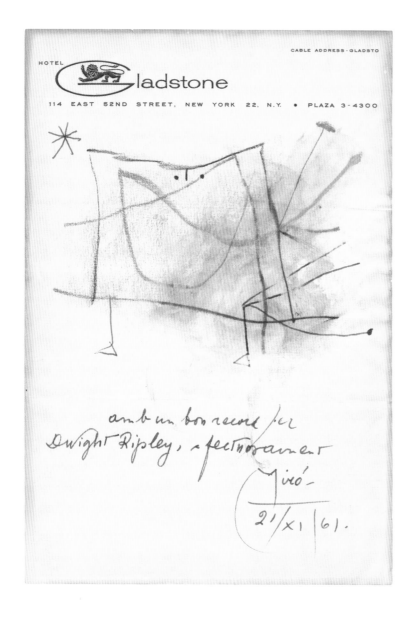

At right, painter Carl Holty and others at a tea party in a studio. The man in the center is the Spanish painter Joan Miró (1893–1983). Holty is at far left. In 1947, Miró used Holty's New York studio when he was working on a mural for a restaurant in Cincinnati. The Miró mural was first shown at the Museum of Modern Art before it traveled to Cincinnati.

Art collector Dwight Ripley (d. 1973) was the fortunate recipient of a charming sketch by Miró on stationery from the Hotel Gladstone in New York City, left. Miró wrote, "with a good memory of Dwight Ripley Affectionately, Miró," in his native language of Catalan.

Illustrated note from Joan Miró to Dwight Ripley, 21 November 1961. 1 page, handwritten. Dwight Ripley papers relating to Joan Miró, ca. 1945–1961.

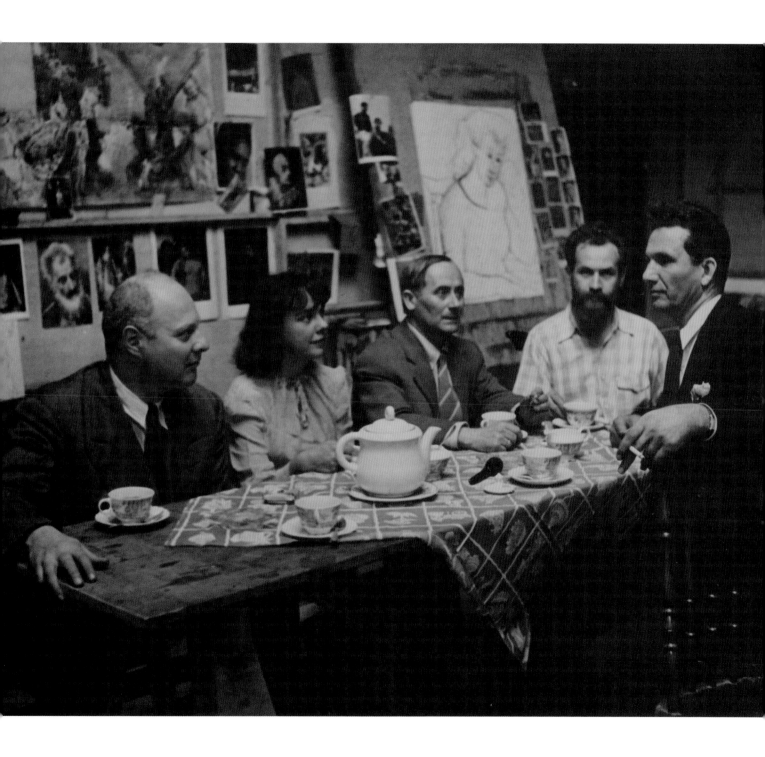

Ellsworth Kelly

(B. 1923)

In the late 1950s, artists gravitated to the tip of Manhattan in search of cheap loft spaces. An old industrial building at 3-5 Coenties Slip, a tiny street overlooking the East River, was ideal. Ellsworth Kelly had the top floor with skylights. Agnes Martin (1912–2004) took the ground floor for $45 a month. At one point, Robert Indiana (b. 1928) and Jack Youngerman (b. 1926) were down the street and Robert Rauschenberg (b. 1925), Jasper Johns (b. 1930), and Larry Poons (b. 1937) were around the corner on Pearl Street. James Rosenquist (b. 1933) came to the area later. At Coenties Slip, Kelly explored organic forms (an example athis left), as well as the hard-edged shapes and bold colors that were the cool essence of minimalism. Kelly used the trapeze swing to take a stretch.

Ellsworth Kelly and Agnes Martin in Kelly's studio at 3-5 Coenties Slip in 1957. Photograph by Hans Namuth. Hans Namuth photographs and papers, 1952–ca. 1985. © 2006 Hans Namuth Estate.

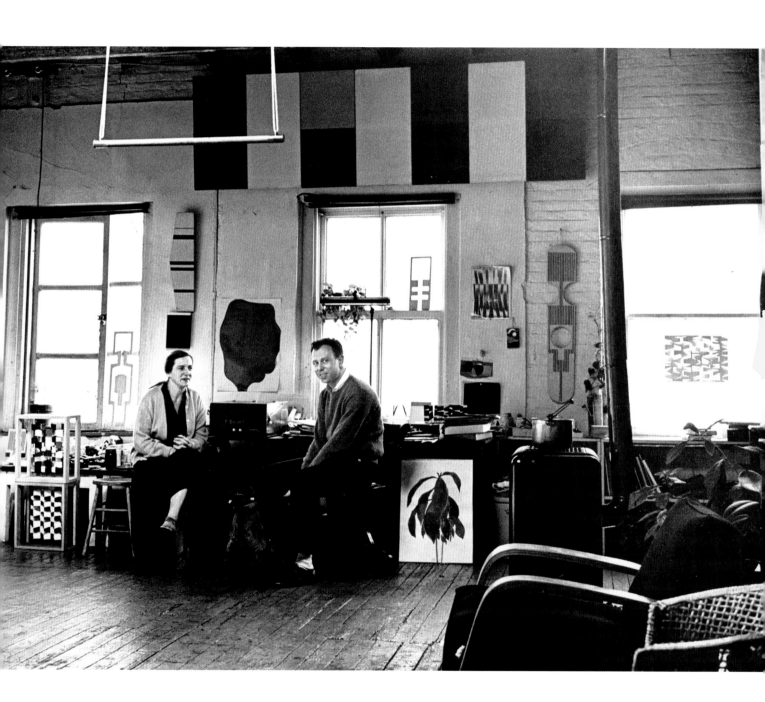

ANDY WARHOL

(1928–1987)

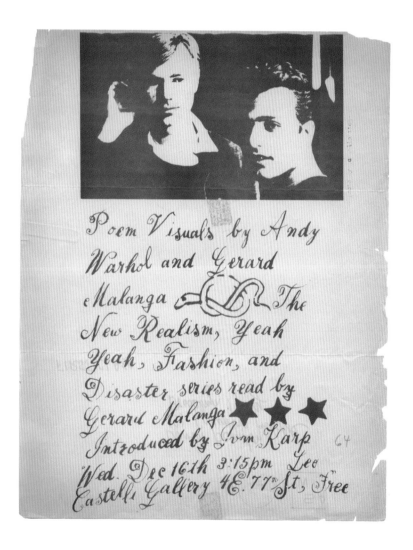

Andy Warhol, right, poses as the deadpan front man at the original Factory at 231 East Forty-seventh Street, New York City, in 1964. His assistants, Philip Fagan, left, and poet Gerard Malanga, right, are behind him in a field of his silk-screened *Flowers*. Miscellaneous photograph collection. © 2006 Andy Warhol Foundation / Artists Rights Society (ARS), New York. © Ugo Mulas Estate. All rights reserved.

Gerard Malanga (b. 1943) was Andy Warhol's assistant from 1963 to 1970. On 16 December 1964, one day before the closing of Warhol's Flowers exhibition at the Leo Castelli Gallery, Malanga read poems from his Fashion and Disaster series at the gallery. The Flowers show was Warhol's first exhibition with Leo Castelli. The announcement for the reading, left, a photocopied flyer mailed to friends, included an image of Warhol and Malanga taken by Edward Wallowitch, as well as the distinctively loopy script of Warhol's mother, Julia Warhola. David Bourdon papers, 1953–1998.

TRANSCRIPTION ON PAGE 179

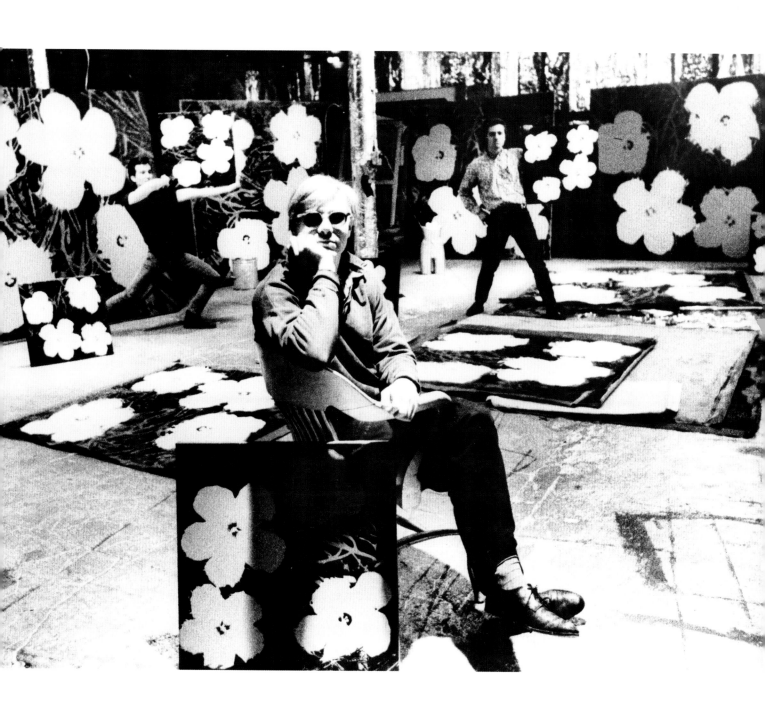

Ray Johnson and Chuck Close

(1 9 2 7 – 1 9 9 5 , b . 1 9 4 0)

May 3, 1969

Dear Richard C,

Please send this face collage to Lucy Lippard.

RAY JOHNSONG

FACE COLLAGE BY RAY JOHNSON

FAKE COLLAGE BY RAY JOHNSON

In the photograph at right, Ray Johnson is in the process of drawing Chuck Close's nose for a series of drawings of noses. At the time, Close was working on paper pulp portraits, and the bowls in the background hold different colors (mainly shades of white, gray, and black) of paper pulp.

In 1962 Ray Johnson established the New York Correspondence School (also known as the New York Correspondance School), an international network of poets and artists who exchanged artwork through the postal system. In this letter to Richard C, left, he sends a face collage to art writer and activist Lucy Lippard. Lucy R. Lippard papers, ca. 1940–1995.

Ray Johnson, standing, and Chuck Close, on the floor, in Close's studio on West Third Street, New York City, in 1983. Photograph by Lenore Seroka. Lenore Seroka photographs, 1977–1984. © 2006 Lenore Seroka.

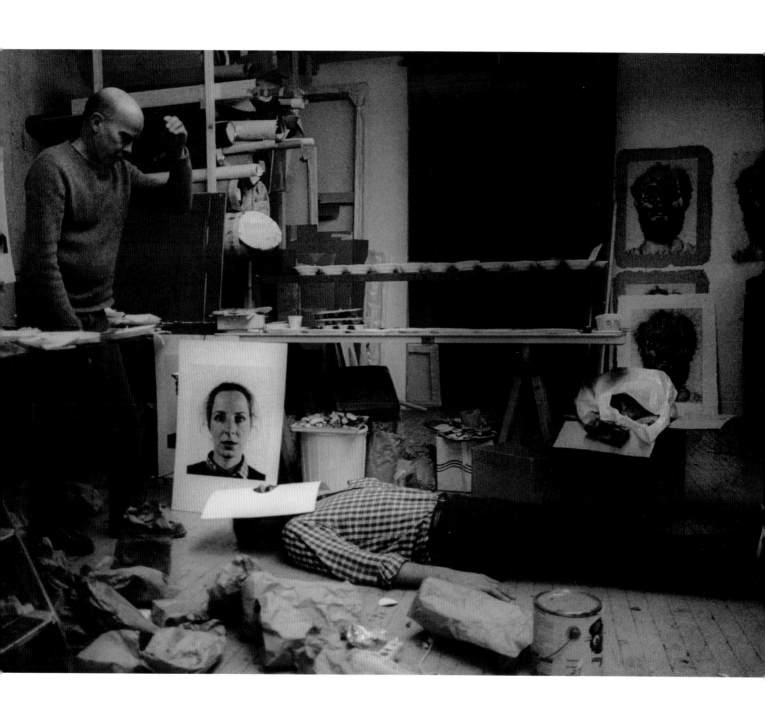

4

ARTISTS AT WORK

JOHN QUINCY ADAMS WARD

(1 8 3 0 – 1 9 1 0)

John Quincy Adams Ward apprenticed with Henry Kirk Brown (1814–1886) in Brooklyn from 1849 to 1856, before he established his own studio and flourished as a maker of statues and equestrian monuments. His commissions were so plentiful that in 1882, architect Richard Morris Hunt (1828–1895) designed a new studio for him at 119 West Fifty-second Street, New York, that gave him ample space for his large public commissions.

At right, Ward sits with a model of his monument to President James A. Garfield in his studio. Photograph by Pach Brothers, ca. 1887. Miscellaneous photograph collection. The Society of the Army of the Cumberland, a Civil War veterans organization based in Ohio, commissioned the monument in 1884, just three years after Garfield was assassinated. It was unveiled at the foot of the United States Capitol on 12 May 1887. Ward and Hunt collaborated on the pedestal and base sculptures. The artfully arranged weapons on the wall may allude to Ward's hobbies—he was an avid sportsman—but more likely they were props for his sculpture.

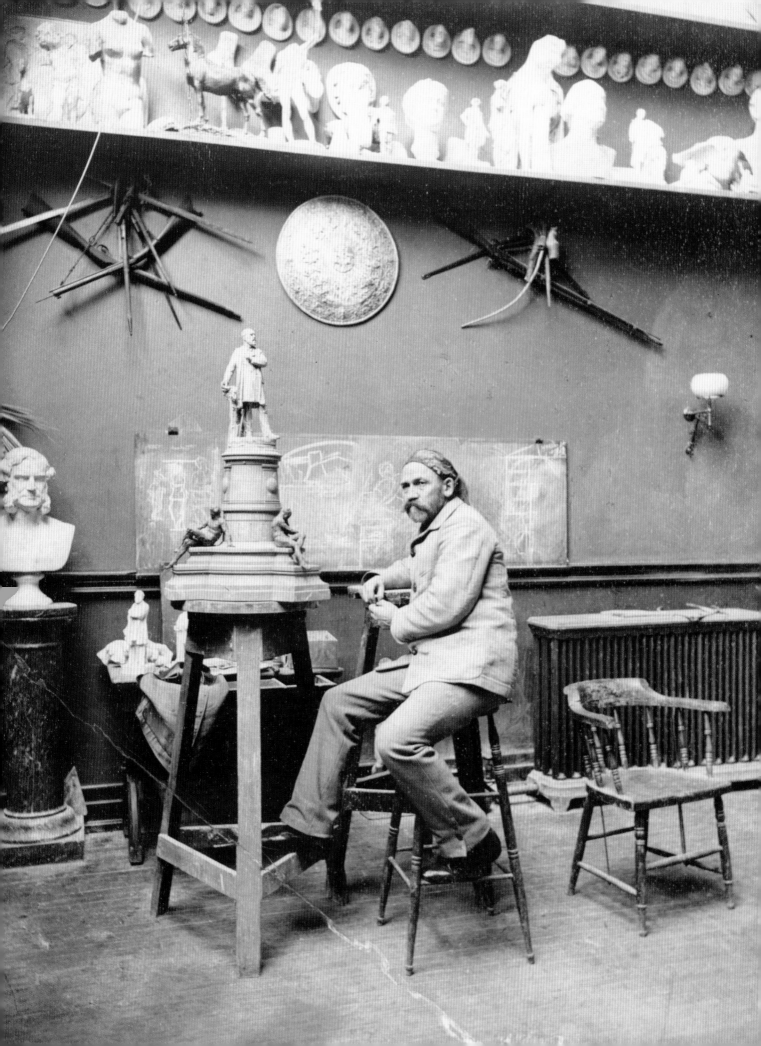

PHILIP MARTINY

(1858-1927)

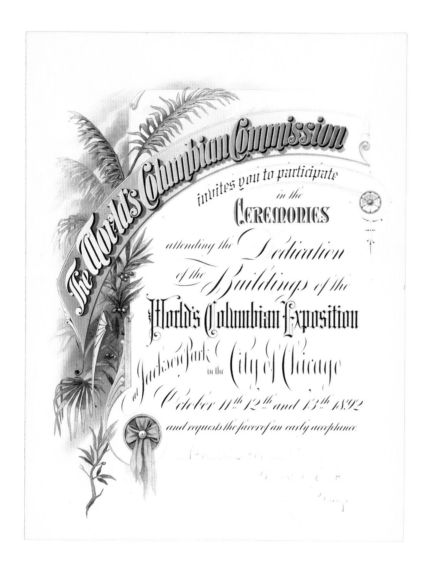

Sculptor Philip Martiny received his big break in 1891 and 1892 when he was commissioned to create sculptural decorations for the Agriculture and Fine Arts Buildings at the World's Columbian Exposition, held in Chicago in 1893. He began the work in New York, then moved to temporary studios in the Forestry Building in Chicago to complete the models and oversee the installation.

Left: Philip Martiny's invitation to the dedication ceremonies at the World's Columbian Exposition, 11–13 October 1892. Philip Martiny papers, 1858–1973.

Right: Philip Martiny and his models for the Columbian Exposition, in the Forestry Building, Chicago, 1892. Photographer unknown. Philip Martiny papers, 1858–1973.

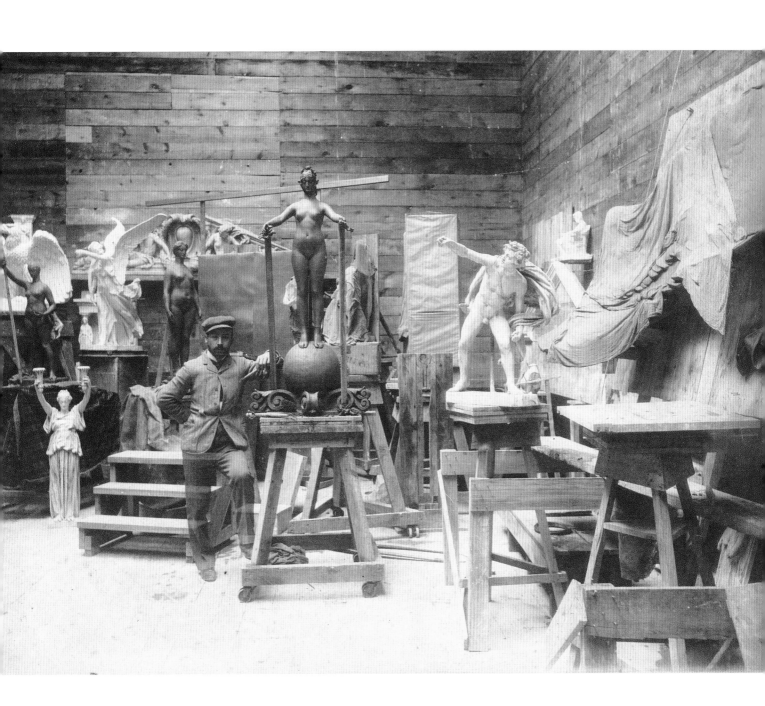

VIOLET OAKLEY

(1874–1961)

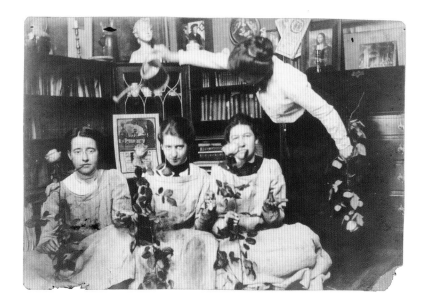

Studios are sometimes communal affairs among friends who band together for professional support. That was the case for the "Red Rose Girls"—Violet Oakley, Jessie Wilcox Smith, and Elizabeth Shippen Green—who had studied together at the Pennsylvania Academy of the Fine Arts and established themselves at the Red Rose Inn in Villanova, where they lived and worked from 1902 to 1906. Their friend Henrietta Cozens, a horticulturist, joined them and managed the household and garden.

At left, Henrietta Cozens tends her "garden" of three roses—left to right, Green, Oakley, and Smith—in their painting smocks at their first studio at 1523 Chestnut Street in Philadelphia. Her gesture mimics the poster for their first joint exhibition at the Plastic Club of Philadelphia in February 1902 (in the background). Photographer unknown. Violet Oakley papers, 1841–1981.

Violet Oakley—illustrator, muralist, and designer of stained glass—in her Red Rose Inn studio. Photographer unknown. Violet Oakley papers, 1841–1981.

FRANCIS DAVIS MILLET

(1846–1912)

Long before Andy Warhol created his Factory, painter and muralist Francis Davis Millet opened what he called his "art factory" in Washington, D.C., in 1907. Millet, standing in the photograph at right, supervises work on the mural *The History of Shipping from the Earliest Recorded Use of Boats until the Present Time,* for the Customs House in Baltimore, Maryland, completed in May 1908. Millet's vast studio was located at 1256 Wisconsin Avenue in the Georgetown neighborhood of Washington, D.C. Millet, who advised Presidents Theodore Roosevelt and William H. Taft on artistic affairs, went down with the *Titanic* on 15 April 1912. Photographer unknown. Miscellaneous photograph collection.

Letter from Francis Davis Millet to Augusto Floriano Jaccaci, 22 May 1908, in which he writes, "I am just finishing today the Baltimore work (vicariously) having sent two men to Baltimore to tone down one or two details." 2 pages, handwritten. August Jaccaci papers, 1903–1914. TRANSCRIPTION ON PAGE 179

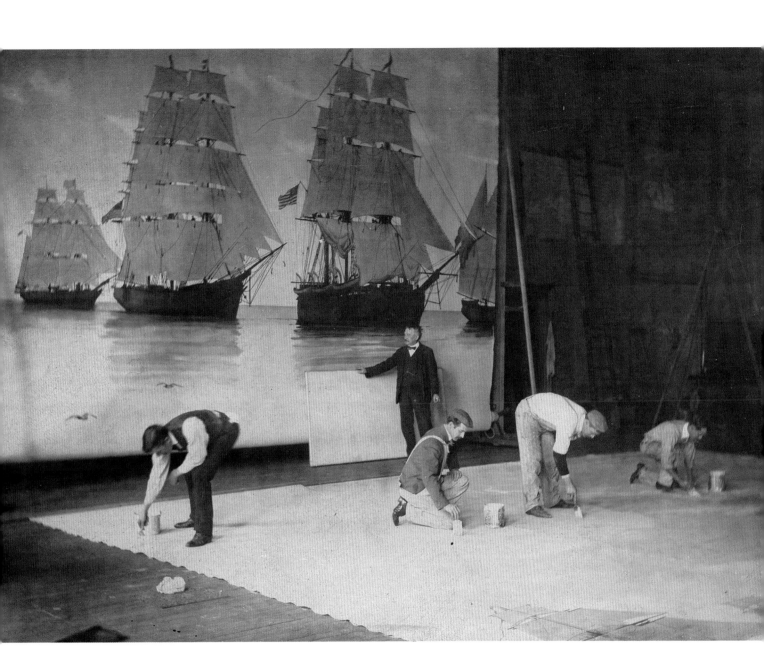

ABRAHAM WALKOWITZ

(1880–1965)

One of the first American modernists, Walkowitz experimented with new ways of looking at the world through the lens of Cézanne and the French fauves. He was part of Alfred Stieglitz's circle and a devotee of Isadora Duncan. A feisty progressive, Walkowitz said,

I WAS A RADICAL. I WAS FEARLESS. THERE WERE NO "IFS" WITH ME. I KNEW I WAS RIGHT. IN ORDER TO BE RIGHT YOU MUST FIRST ALWAYS BE WRONG, AND THEN YOU ARE RIGHT. I

ALWAYS SAY THERE ARE THREE THINGS WE HAVE TO GO THROUGH IN LIFE: FIRST STATE IS FEAR, SECOND STATE IS SNEER, THIRD STATE IS CHEER.

Interview of Abraham Walkowitz conducted by Abram Lerner and Mary Bartlett Cowdrey for the Archives of American Art, 8 and 22 December 1958.

Walkowitz's studio was next door to the American Art Galleries of the American Art Association at 6 East Twenty-third Street. One of Walkowitz's first encounters with new French art was an exhibition of Monet's paintings of the Rouen Cathedral at the American Art Galleries in March 1896. Walkowitz may have set up his own studio as a kind of alternative gallery, left, displaying his work for all visitors to see.

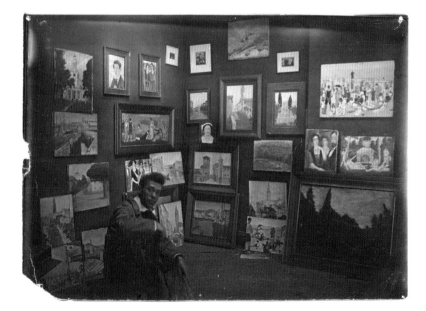

Abraham Walkowitz in his studio at 8 East Twenty-third Street, New York City, in 1908. Walkowitz confronts the viewer with a defiant air. His painting *In the Opera*, 1908 (on the easel), was one of twelve works that he exhibited in the 1913 Armory Show. Photographer unknown. Abraham Walkowitz papers, 1880–1965.

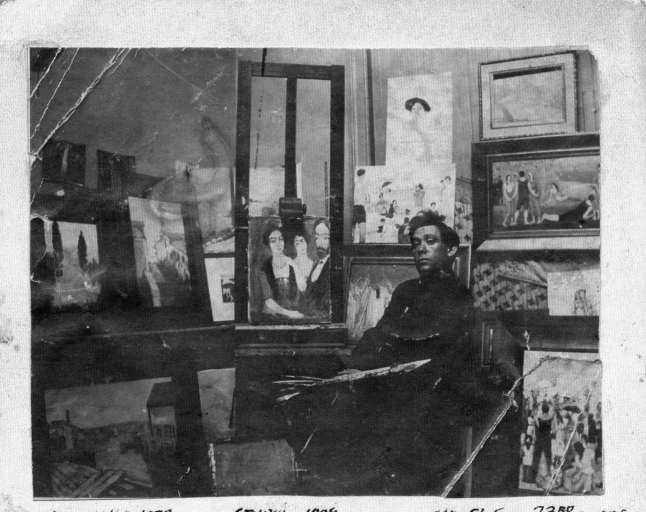

A. WALKOWITZ STUDIO 1908 NO 8 EAST 23RD ST. N.Y.

WILLIAM MERRITT CHASE

(1849–1916)

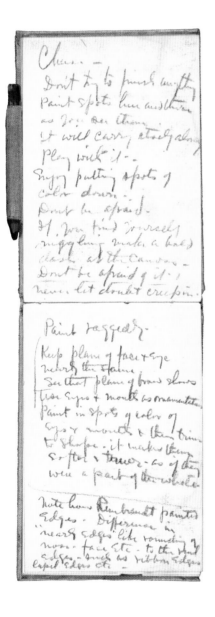

In 1912, Harriet Blackstone (1864–1939) took a painting class with American impressionist William Merritt Chase in Bruges, Belgium. In her notebook she recorded his pointed lessons:

ENJOY PUTTING SPOTS OF COLOR DOWN. DON'T BE AFRAID—IF YOU FIND YOURSELF NIGGLING MAKE A BOLD DASH AT THE CANVAS—DON'T BE AFRAID OF IT—NEVER LET DOUBT CREEP IN.

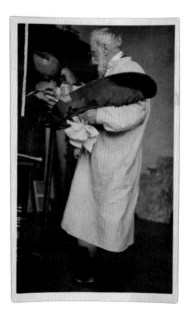

William Merritt Chase had a famous studio in the Tenth Street Studio Building. It was brimming with art and artifacts from his travels abroad, including Japanese umbrellas, Venetian tapestries, white and pink stuffed cockatoos, swords, pistols, and a Persian incense lamp. Chase patterned his lavishly stocked studio after European models. Doing so not only provided exotic props for his paintings and a source of aesthetic stimulation but also served as a grand setting for selling art.

Far left: Notebook of Harriet Blackstone, 1912. 25 pages. Harriet Blackstone papers, 1864–1984.
TRANSCRIPTION ON PAGE 179

.

Left: Photo postcard of William Merritt Chase in Bruges, Belgium, 1912. Photograph by Harriet Blackstone. On the verso Blackstone wrote, "Chase was pleased with this and ordered many postcards." Harriet Blackstone papers, 1864–1984.

.

Right: William Merritt Chase's studio in the Tenth Street Studio Building, at 51 West Tenth Street, New York City, ca. 1880. Photograph by George Collins Cox. Miscellaneous photograph collection.

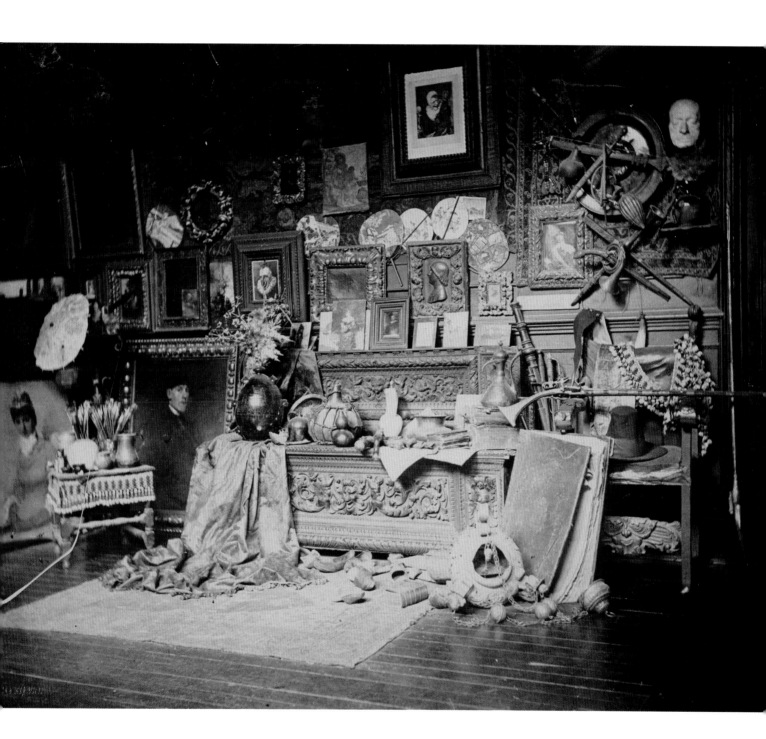

GEORGE GREY BARNARD

(1 8 6 3 – 1 9 3 8)

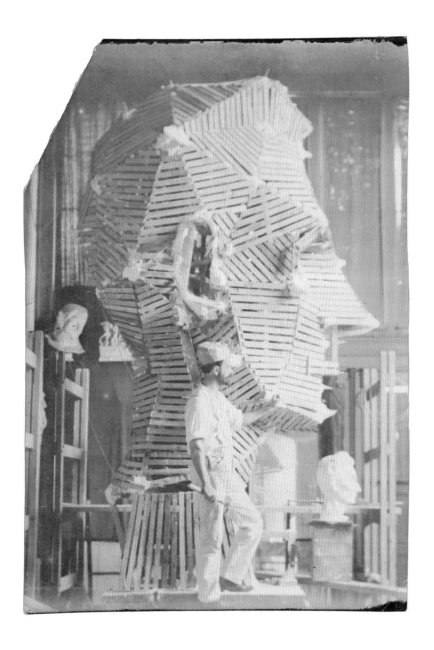

George Grey Barnard's studio was in an old stable adjoining his home and the Cloisters, his collection of medieval sculpture and architectural fragments, on Fort Washington Avenue in New York City. For several years *Lincoln in Thought*, ca. 1916, was the showpiece of a studio exhibition. In 1925, philanthropist and collector John D. Rockefeller Jr. purchased the Cloisters and its contents for the Metropolitan Museum of Art.

Left: George Grey Barnard's studio assistant with the wooden armature for *Lincoln in Thought*, ca. 1916. Photographer unknown. George Grey Barnard papers, 1884–1963.

Right: Barnard works on his colossal plaster head *Lincoln in Thought*. Ida Tarbell, a Lincoln biographer, watches at right. Photograph by Underwood & Underwood. George Grey Barnard papers, 1884–1963.

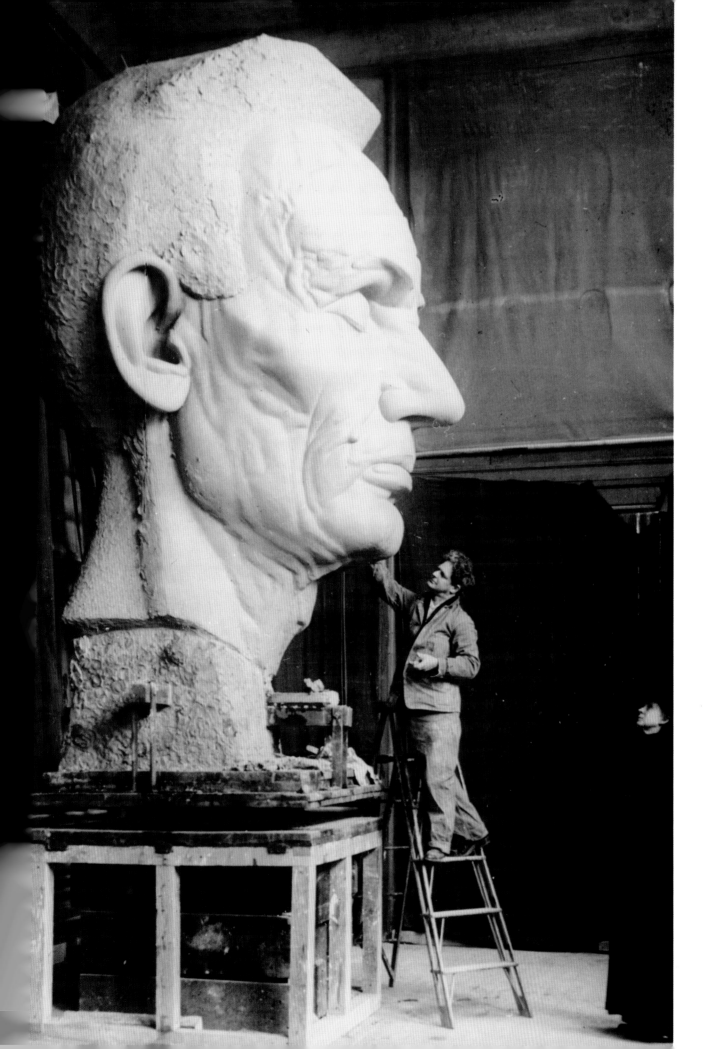

AGNES PELTON

(1881–1961)

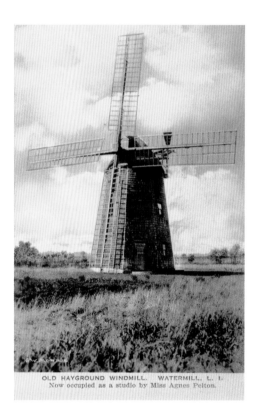

OLD HAYGROUND WINDMILL. WATERMILL, L. I.
Now occupied as a studio by Miss Agnes Pelton.

In October 1921, painter Agnes Pelton found the perfect secluded home and studio in Water Mill, New York, near Southampton: the Hayground windmill, built in 1809 and one of the last working windmills on Long Island. When Pelton moved there, she was experimenting with what she called "imaginative paintings," expressive abstractions inspired by natural elements—birds, trees, flowers, and the landscape. She also specialized in portraits. Pelton was one of the few women to exhibit in the Armory Show of 1913, the first major exhibition of modern art in the United States. She was also a founding member of the Transcendental Painting Group, formed in Taos, New Mexico, in 1938.

POST CARD
Southampton, L. I., June 14, 1923

(over)

You and your friends are cordially invited to a
First View of the Exhibition of
Children's Portraits in Pastel by Agnes Pelton
(Studio in Hay Ground Windmill, Water Mill, L. I.)
To be held in the
Memorial Hall (Herrick Road)
Wednesday Afternoon, June 20, at 4 o'Clock
Under the Auspices of
Mrs. Thomas H. Barber, Mrs. Goodhue Livingston
Mrs. John E. Berwind, Mrs. James P. Lee
Tea at 5 o'Clock
Exhibition to be continued until, and including, June 27
HOURS 10 A. M. to 1 P. M. 2:30 to 5:30 P. M. SUNDAY AFTERNOON 2:30 to 5:30
THIS SPACE FOR MESSAGE. THIS SPACE FOR ADDRESS.

Left, top and bottom: Agnes Pelton exhibition announcement, 20 June 1923. Agnes Pelton papers, 1886–1958.

.

Right: Agnes Pelton in her studio in the Hayground windmill, in Water Mill, New York, ca. 1923. Photographer unknown. Agnes Pelton papers, 1886–1958.

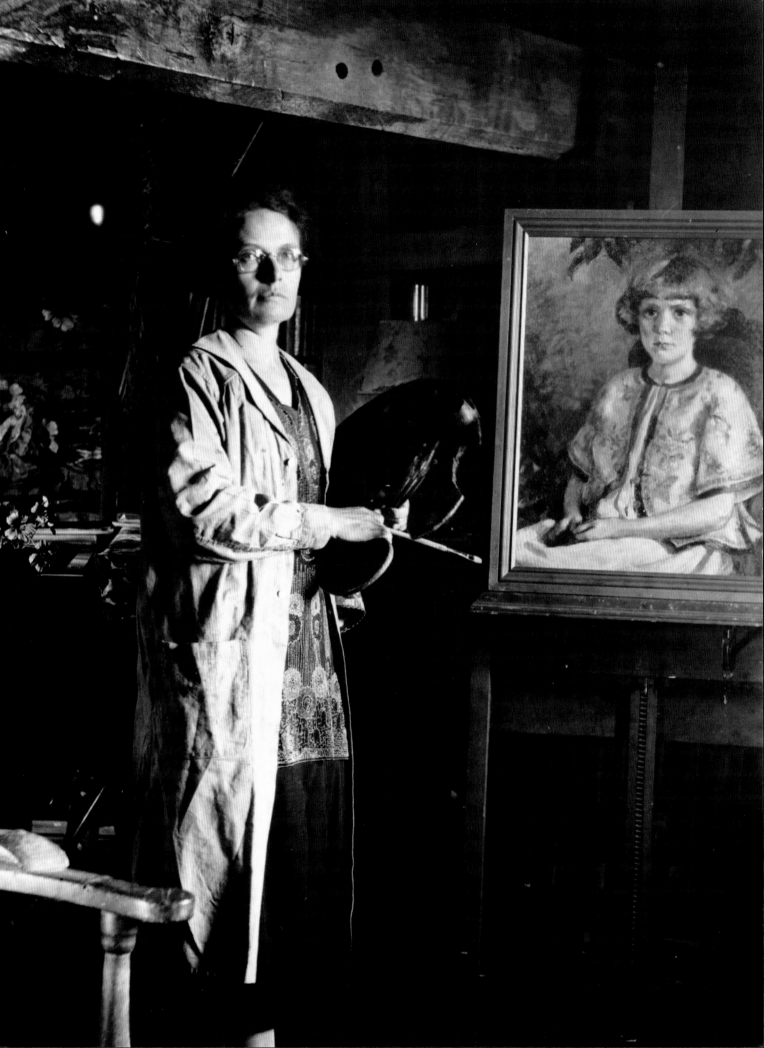

KATHARINE LANE WEEMS

(1 8 9 9 – 1 9 8 9)

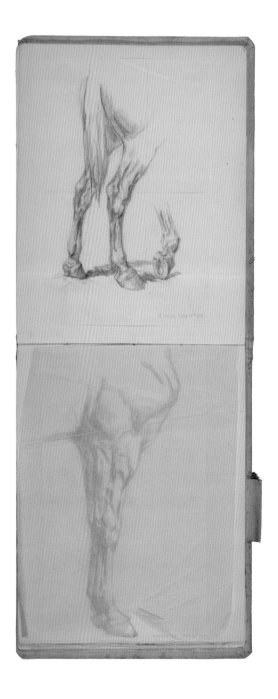

Weems, a noted animal sculptor, developed an early appreciation for art from her father, who was the president of the board of trustees of the Museum of Fine Arts, Boston. In 1914, she and her father visited John Singer Sargent in his London studio to see his murals for the Boston Public Library, which left an indelible impression on her. To mark the occasion, her father bought her an anatomical model of a horse like one she had seen and admired in Sargent's studio.

Left: Katharine Lane Weems, sketch of horse's legs, Zürich, 16 July 1914 (copied from a book of drawings by Rosa Bonheur). Katharine Lane Weems sketchbook, 1913–1915. 31 pages. Katharine Lane Weems papers, 1865–1989.

Right: Katharine Lane Weems at work in her studio in Manchester, Massachusetts, ca. 1930. Photograph by George H. Davis Studio. Katharine Lane Weems papers, 1865–1989.

Grant Wood

(1 8 9 2 – 1 9 4 2)

In 1924, Wood converted a spacious turn-of-the-century carriage house into his studio. He lived and worked there until 1935. A dyed-in-the-wool regionalist, Wood often wore overalls for his photographs, underscoring his agrarian worldview. He autographed the publicity shot at right, "To Mrs. Ness—in appreciation—Grant Wood ('Exhibit A')." "Mrs. Ness" was Zenobia B. Ness, the director of the Iowa Art Salon at the annual state fair. "Exhibit A" refers to Wood himself, presented as the quintessential Iowan.

Grant Wood burst onto the American scene in 1930 when two of his paintings, *Stone City*, 1930, and *American Gothic*, 1930, were included in the annual juried show of American art at the Art Institute of Chicago. *American Gothic* won a bronze medal and was purchased for the permanent collection of the Art Institute. In this letter to Zenobia B. Ness, Wood announces his triumph and his efforts to drum up publicity, while acknowledging his debt to her and the Iowa State Fair.

Cedar Rapids Ia Oct 28– 1930

Hurray!

Two paintings of mine in the American show — "Stone City" and "American Gothic"! Two is the maximum and only a few make it each year

I am having photos of the two made in the art Institute and will get them when I go in. next week. Intend to have

Left: Letter from Grant Wood to Zenobia B. Ness, 28 October 1930. 4 pages, handwritten. Grant Wood papers, 1930–1983. © Grant Wood Estate / Licensed by VAGA, New York, NY. TRANSCRIPTION ON PAGE 179

Right: Grant Wood in his studio at 5 Turner Alley, Cedar Rapids, Iowa, with his painting *The Midnight Ride of Paul Revere*, 1931. Photograph by John W. Barry. Grant Wood papers, 1930–1983.

104 • ARTISTS AT WORK

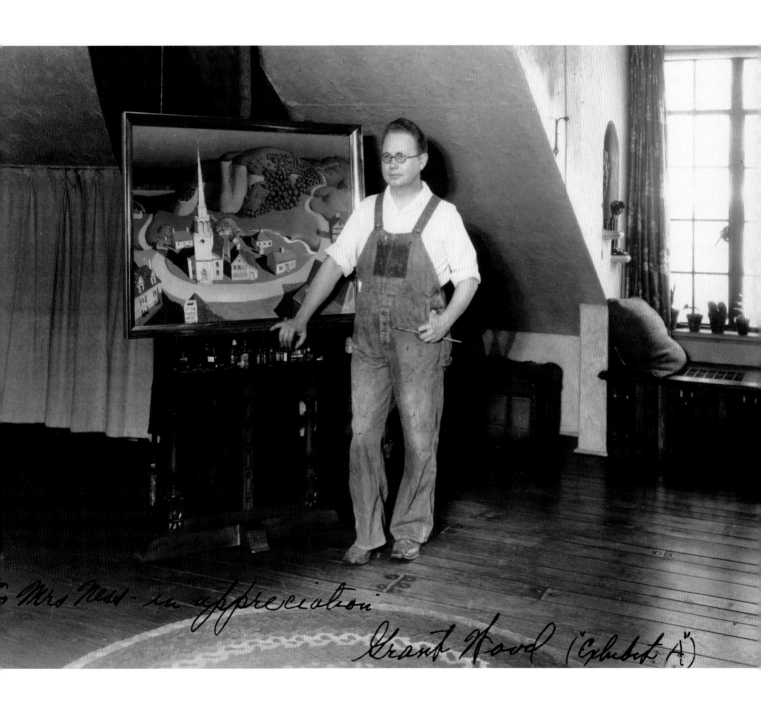

To Mrs Ness - in appreciation

Grant Wood ("Exhibit A")

John Storrs

(1 8 8 5 – 1 9 5 6)

In the 1920s and 1930s Storrs was much in demand as a modernist sculptor. His simple reductive forms had an elegant machine aesthetic that appealed to architects and disciples of modernism, such as Alfred Stieglitz.

In a letter to his wife Marguerite, Storrs, then in New York, wrote:

I SPENT MOST OF FRIDAY AFTERNOON WITH STIEGLITZ IN HIS NEW GALLERY. I JUST HAPPENED TO HAVE MY PHOTOS WITH ME WHICH HE ASKED TO SEE. HE WAS VERY ENTHUSIASTIC & WE HAD A FINE TALK. HE TOLD ME THAT [GASTON] LACHAISE HAD GOTTEN TO BE IMPOSSIBLE & THAT HE NO LONGER HAD ANY OF HIS THINGS & SAID THAT HE WOULD LIKE TO HAVE SOME OF MY THINGS IN HIS GALLERY!

Despite their mutual enthusiasm, Storrs never exhibited at Stieglitz's gallery, An American Place.

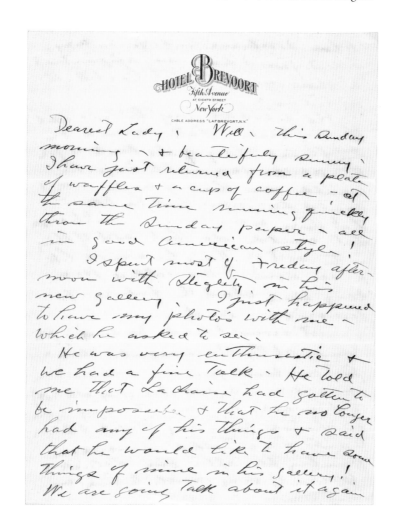

Left: Letter from John Storrs to his wife, 30 March 1930. 4 pages, handwritten. John Henry Bradley Storrs papers, 1847–1987.
TRANSCRIPTION ON PAGE 180

Right: John Storrs works on a plaster model in his studio at 854½ North State Street in Chicago, for the Hall of Science in Chicago's A Century of Progress International Exposition, 1933. Photographer unknown. John Henry Bradley Storrs papers, 1847–1987.

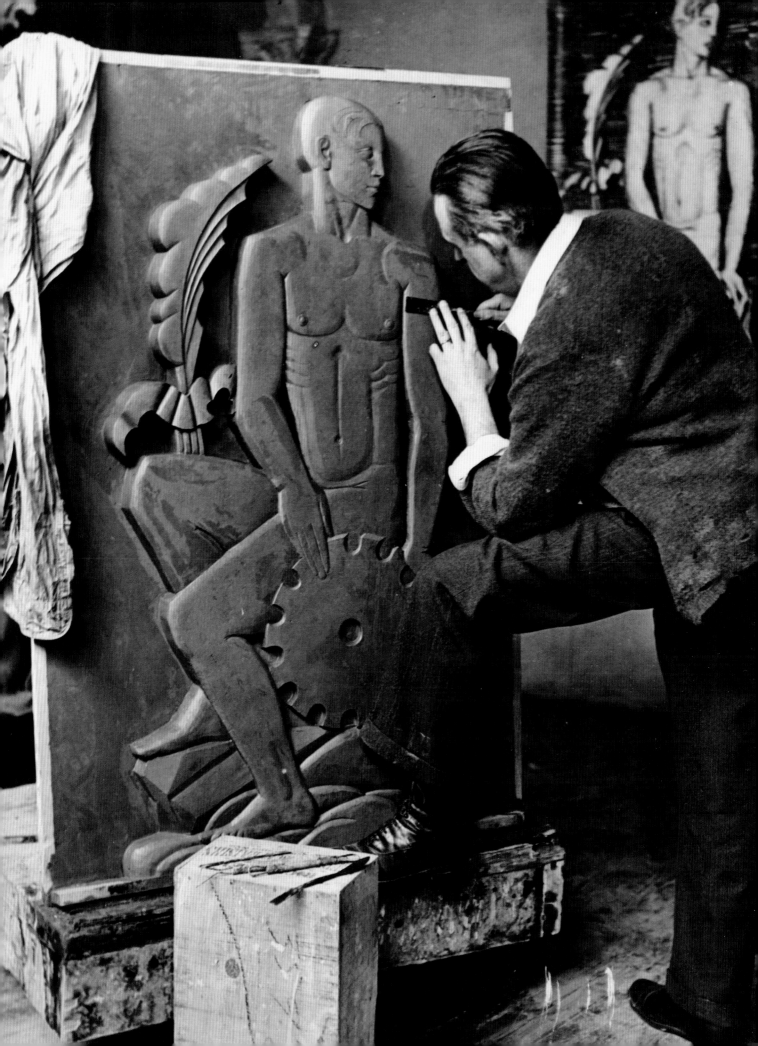

CHAIM GROSS

(1904–1991)

Known for his direct carving in wood, Gross also worked in stone and occasionally in plaster. At the New York World's Fair, on 27 May 1940, Gross gave a live demonstration of his wood-carving techniques. In *Harvest*, 1939, which was destroyed after the fair, he abstracted the human form to create a physically powerful family group.

Left: New York World's Fair Commission payment voucher for *Harvest* by Chaim Gross, 2 June 1939. Chaim Gross papers, 1920–1983.

Right: Chaim Gross in a temporary studio working on *Harvest*, 1939, (in plaster) for the French Building at the Court of Peace, New York World's Fair, 1939. The "teacup" he holds is for wet plaster. Photograph by Peter A. Juley & Son. Miscellaneous photograph collection.

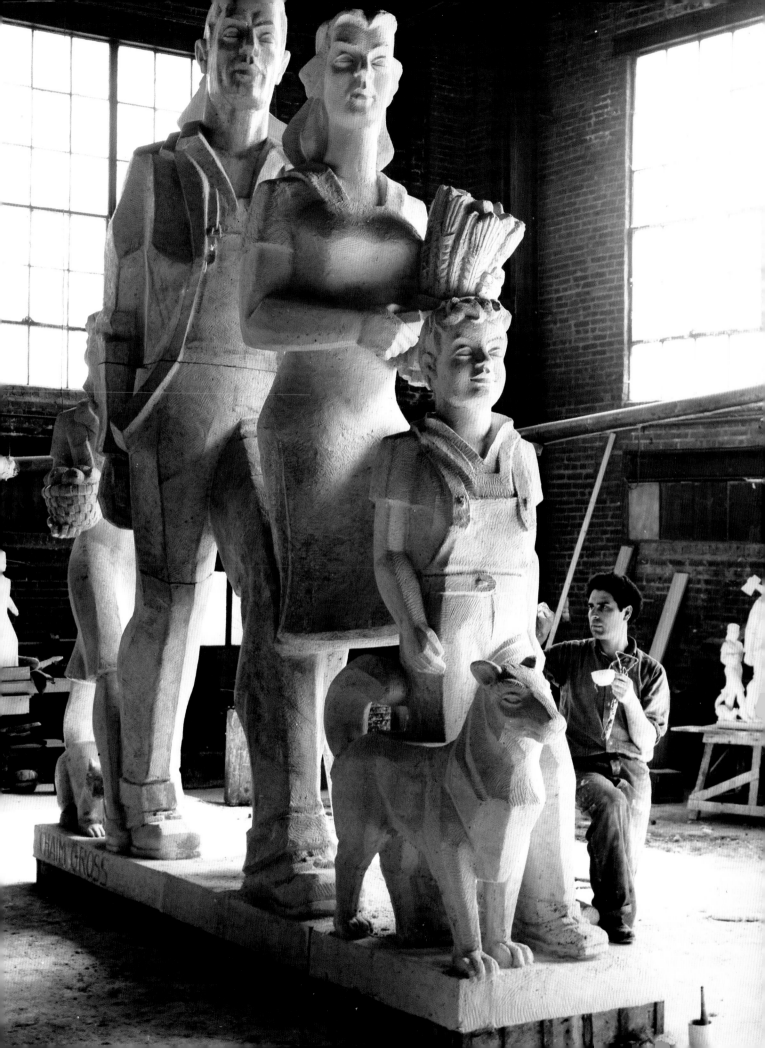

ROBERT BOARDMAN HOWARD

(1896–1983)

Sculptor Robert Boardman Howard, right, working on a full-scale model of his *Whale Fountain*, which was made in polished black granite for the court of the San Francisco Building at the Golden Gate International Exposition, held in San Francisco (Treasure Island) in 1939 and 1940. Photographer unknown. Robert Boardman Howard papers, 1916–1975.

Statement by Robert Boardman Howard, left, for a book about American art and artists to be published by Pellegrini & Cudahy in 1953:

THE IRRESISTIBLE URGE TO MAKE SCULPTURE SEEMS TO COME FROM SOURCES THAT HAVE ALWAYS BEEN MYSTERIOUS TO ME. I KNOW ONLY THIS; THAT I MUST MAKE SHAPES WITH TOOLS, AND FIND A GREAT SATISFACTION IN OVERCOMING THE INNUMERABLE PROBLEMS OF MATERIALS, PHYSICS, MECHANICS—AND REALIZING THE IDEA.

Robert Boardman Howard papers, 1916–1975. TRANSCRIPTION ON PAGE 180

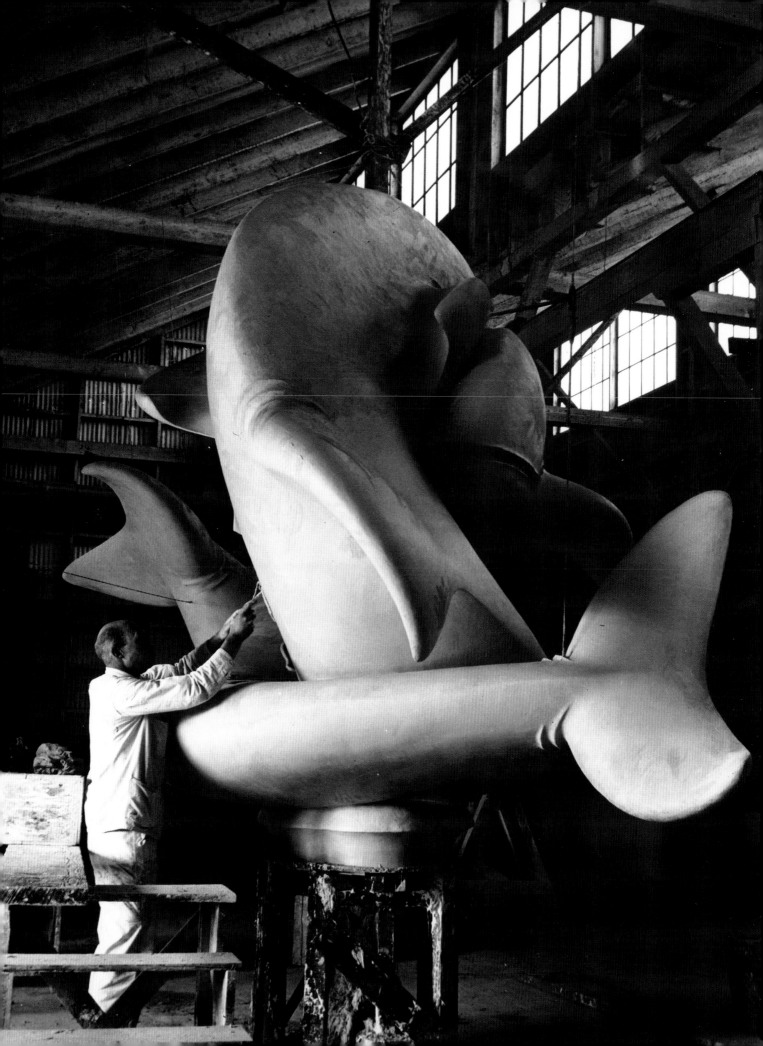

EUGENIE GERSHOY

(1901–1983)

Gershoy, who was known for her fanciful multicolored figures, was employed by the sculpture division of the Works Progress Administration/Federal Art Project from 1935 to 1939.

She did her creative work in her home studio at 145 West Fourteenth Street in New York City and supervised the making of casts from her models in the WPA/FAP workshop at 6 East Thirty-ninth Street.

Around 1936, the Washington office of the WPA/FAP assembled an anthology of brief essays, including Gershoy's, about the WPA by artists and administrators who worked on the projects. It was later published in the book *Art for the Millions* (1975). For Gershoy, one of the outstanding features of the WPA/FAP was the freedom accorded artists to choose their own subjects.

Left: Eugenie Gershoy essay, "Fantasy and Humor in Sculpture," ca. 1936. 1 page, edited carbon copy typescript. Eugenie Gershoy papers, 1914–1983.

TRANSCRIPTION ON PAGE 181

.

Right: Eugenie Gershoy works on a papier-mâché figure of a cancan dancer in her home studio, 29 October 1940. Photograph by Max Yavno. Federal Art Project, Photographic Division collection, 1935–1942. © 1998 The University of Arizona Foundation.

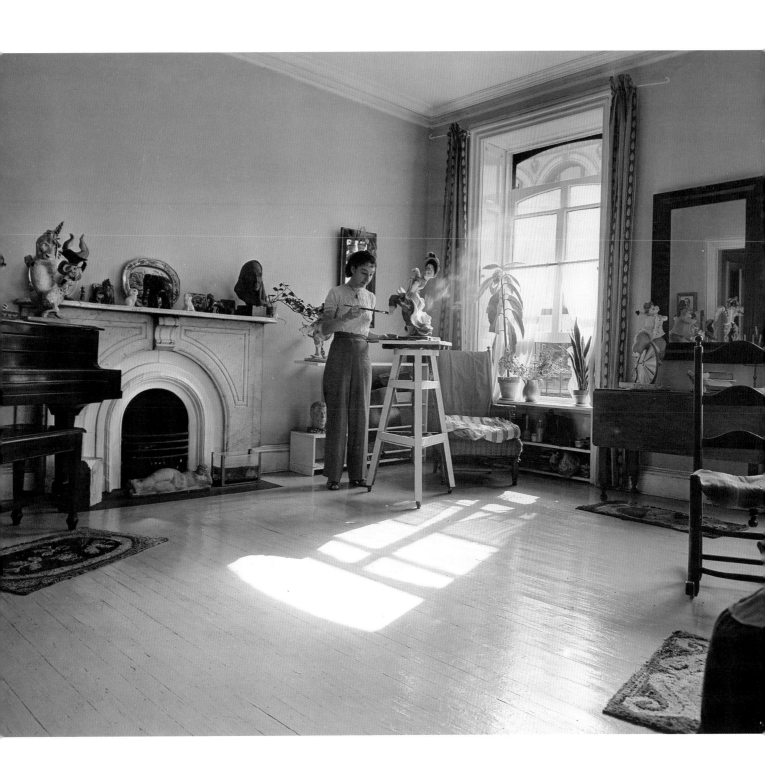

YASUO KUNIYOSHI

(1889–1953)

Painter, printmaker, and photographer Yasuo Kuniyoshi, right, in his studio at 30 East Fourteenth Street in New York City, 31 October 1940. Photograph by Max Yavno for the WPA Federal Art Project, Photographic Division.

© The University of Arizona Foundation. Kuniyoshi is working on his painting *Upside Down Table and Mask*, 1940 (in the Fukutake Collection, Okayama, Japan). Downtown Gallery records, 1824–1974.

After the bombing of Pearl Harbor, Kuniyoshi, who was pro-democracy, anti-imperialist, and anti-fascist, was briefly placed under house arrest and his funds impounded. He wrote to artist George Biddle, "A few short days has changed my status in this country, although I myself have not changed at all." Biddle was a boyhood friend of President Franklin D. Roosevelt and had given Roosevelt the idea for a government-supported mural and arts program. Kuniyoshi proved his loyalty to the United States and was helped and supported by his circle of prominent American artists.

Draft letter from Kuniyoshi to George Biddle, 11 December 1941. 3 pages, handwritten. Yasuo Kuniyoshi papers, 1921–1993.

TRANSCRIPTION ON PAGE 181

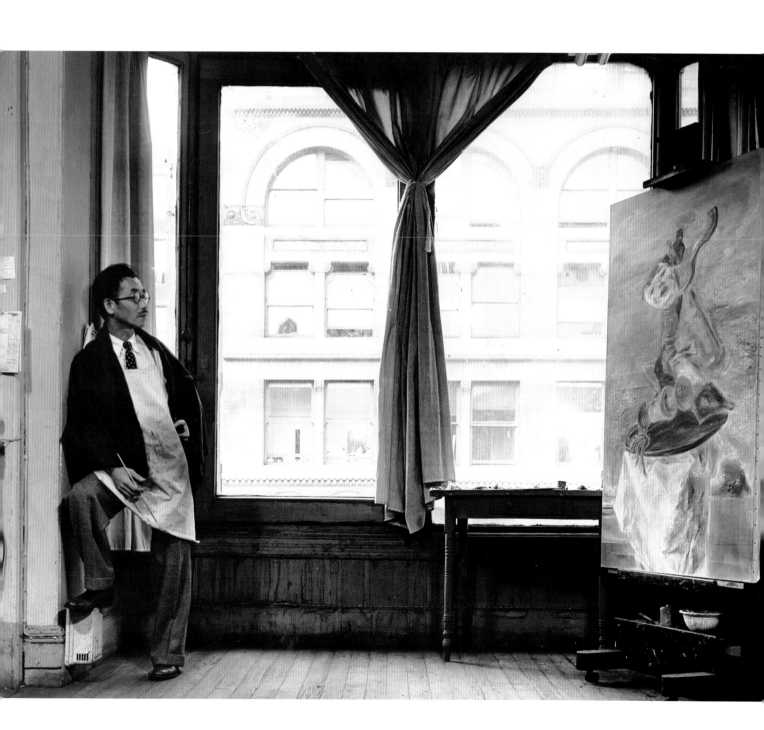

BLANCHE LAZZELL

(1 8 7 8 – 1 9 5 6)

Blanche Lazzell divided her time between her home in Morgantown, West Virginia, and her summer studio in Provincetown, Massachusetts, where she taught classes in painting, composition, and color woodblock printing. In 1926, she built a studio on a wharf overlooking Provincetown harbor. Each summer, she cultivated a lush array of zinnias, sunflowers, petunias, morning glories, and holly-hocks in flower boxes and pots that circled her porch. Her most progressive cubist compositions were inspired by her flowers and views of Provincetown.

WOOD BLOCK PRINTS
BY
BLANCHE LAZZELL

Top, left: Blanche Lazzell watering her flowers at her Provincetown studio, 1942. Photographer unknown. Postcard produced by W. G. Stiff. Blanche Lazzell papers, 1890–1982.

.

Bottom, left: Lazzell's garden, 1942. Photographer unknown. Print from an original color slide. Blanche Lazzell papers, 1890–1982.

.

Bottom, right: Pamphlet about Lazzell's woodblock prints, undated. Blanche Lazzell papers, 1890–1982.

.

Right: Lazzell's studio, Provincetown, 1942. Photographer unknown. Blanche Lazzell papers, 1890–1982.

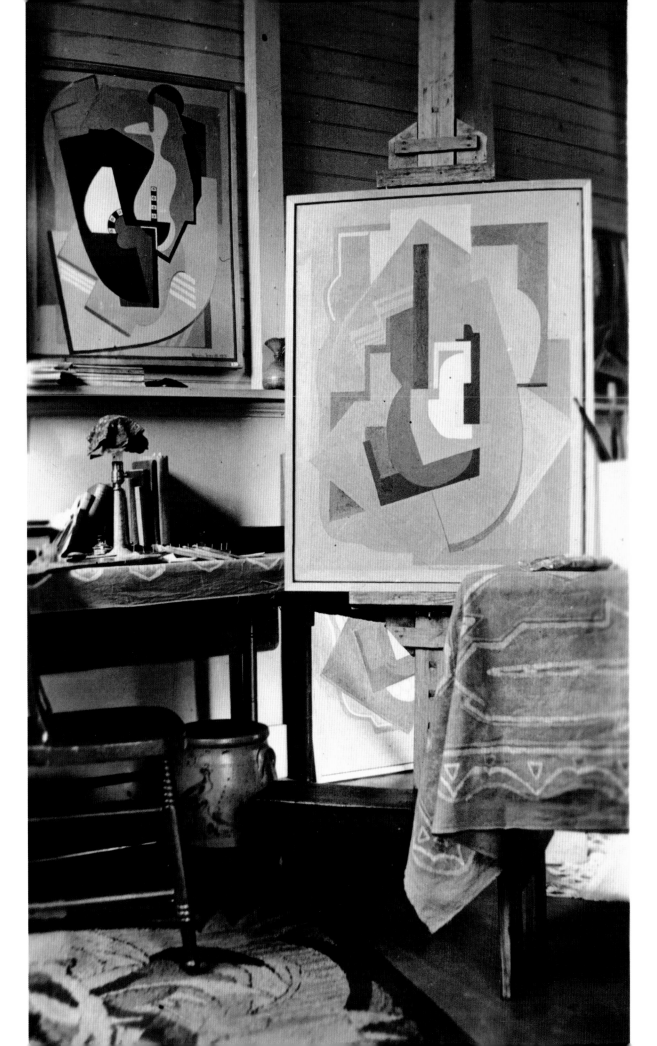

ALEXANDER CALDER

(1 8 9 8 – 1 9 7 6)

TEL. WOODBURY — CONGRESS 3-2266

CALDER
PAINTER HILL ROAD
R. F. D. ROXBURY,
CONN., U S A

Washington

R. 47

1½

3½ mi

North
Woodbury

R. 6

Newtown
R. 25

Stepney

R. 59

Easton

EXIT
46

N.Y.

Merritt Pkwy

Calder was a tinkerer. His cluttered studio stands in sharp contrast to his spare, elegant mobiles that hold color and shape in perfect balance.

With an invitation to Ben Shahn (1898–1969), Calder enclosed a map to his home. Calder's utilitarian set of driving instructions is infused with his fascination for elements poised in harmony.

Left: Letter from Alexander Calder to Ben Shahn, 24 February 1949, with map. 2 pages, handwritten. Ben Shahn papers, 1879–1990. © 2006 Estate of Alexander Calder / Artists Rights Society (ARS), New York. TRANSCRIPTION ON PAGE 182

. .

Right: Alexander Calder in his Roxbury, Connecticut, studio, ca. 1960. Photographer unknown. Alexander Calder papers, 1927–1967.

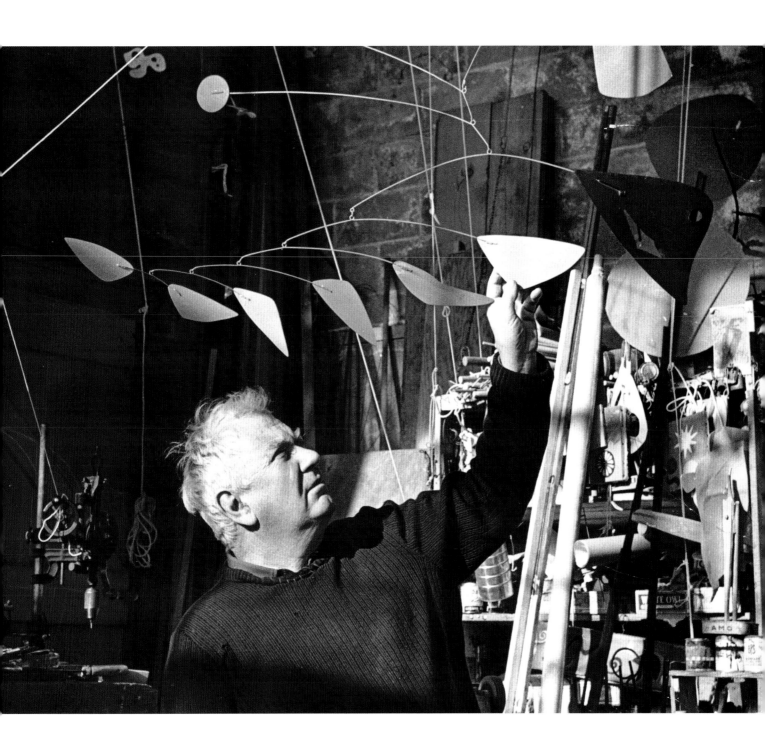

JACKSON POLLOCK

(1912–1956)

In 1945 Jackson Pollock and Lee Krasner moved to the Springs, a rural hamlet near East Hampton, Long Island. The property, now a National Historic Landmark, included a small shingle-style wood-frame house with a nearby barn that Pollock made into a studio. It was here that he developed his "poured" paintings. In the photograph at right, Pollock demonstrates his technique on a completed painting, *No. 32*, 1950.

Jackson Pollock (below, left) in front of his painting *Portrait and a Dream* in 1954, one year after the painting was completed. Photograph by Hans Namuth. Jackson Pollock and Lee Krasner papers, ca. 1905–1984. © 2006 Hans Namuth Estate. On the back of the photograph, Pollock wrote:

TECHNIC [SIC] IS THE RESULT OF NEED—NEW NEEDS DEMAND NEW TECHNICS [SIC]—TOTAL CONTROL—DENIAL OF THE ACCIDENT—STATES OF ORDER— ORGANIC INTENSITY—ENERGY AND MOTION MADE VISIBLE— MEMORIES ARRESTED IN SPACE, HUMAN NEEDS AND MOTIVES— ACCEPTANCE—

JACKSON POLLOCK

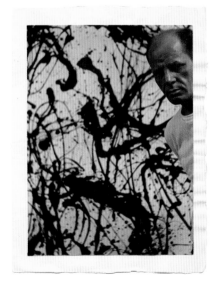

Technic is the result of a need—
New needs demand new Technics———
total control ——— denial of
the accident ———
States of order —
Organic intensity ———
energy and motion
made visible———
memories arrested in space,
human needs and motives——
acceptance———
Jackson Pollock

Jackson Pollock in his studio, the Springs, Long Island, New York, 1950. Photograph by Rudy Burckhardt. Jackson Pollock and Lee Krasner papers, ca. 1905–1984. © 2006 Rudy Burckhardt Estate / Artists Rights Society (ARS), New York.

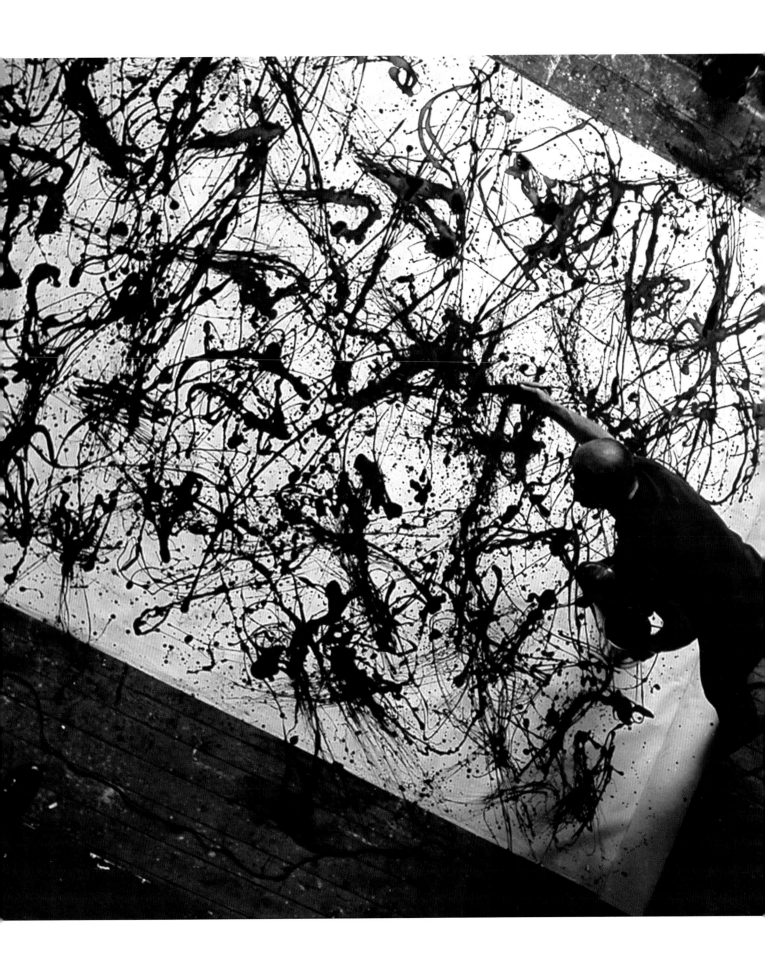

WILLEM DE KOONING

(1904–1997)

De Kooning was famously tormented by *Woman I*. Unsure of his new direction, he struggled with his ferocious abstraction, at one point leaving the unresolved painting in the hallway outside his studio. With the encouragement of art historian Meyer Shapiro, de Kooning finished *Woman I* and moved out of the Fourth Street studio into an era of greater acceptance.

By 1953, Willem de Kooning had moved to a new studio at 68 East Tenth Street. Elaine's studio was at 132 East Twenty-eighth Street. Both had summer studios in East Hampton.

Left: Elaine de Kooning (1918–1989) and Willem de Kooning's notes for their 1953 joint tax return itemizing studio expenses. 2 pages, annotated typescript. Elaine and Willem de Kooning financial records, 1951–1969.

TRANSCRIPTION ON PAGE 182

Right: Willem de Kooning in his studio at 85 Fourth Avenue, New York City, 1952. An early version of *Woman I*, 1952, is in the background. Photograph by Kay Bell Reynal. Photographs of artists taken by Kay Bell Reynal, 1952.

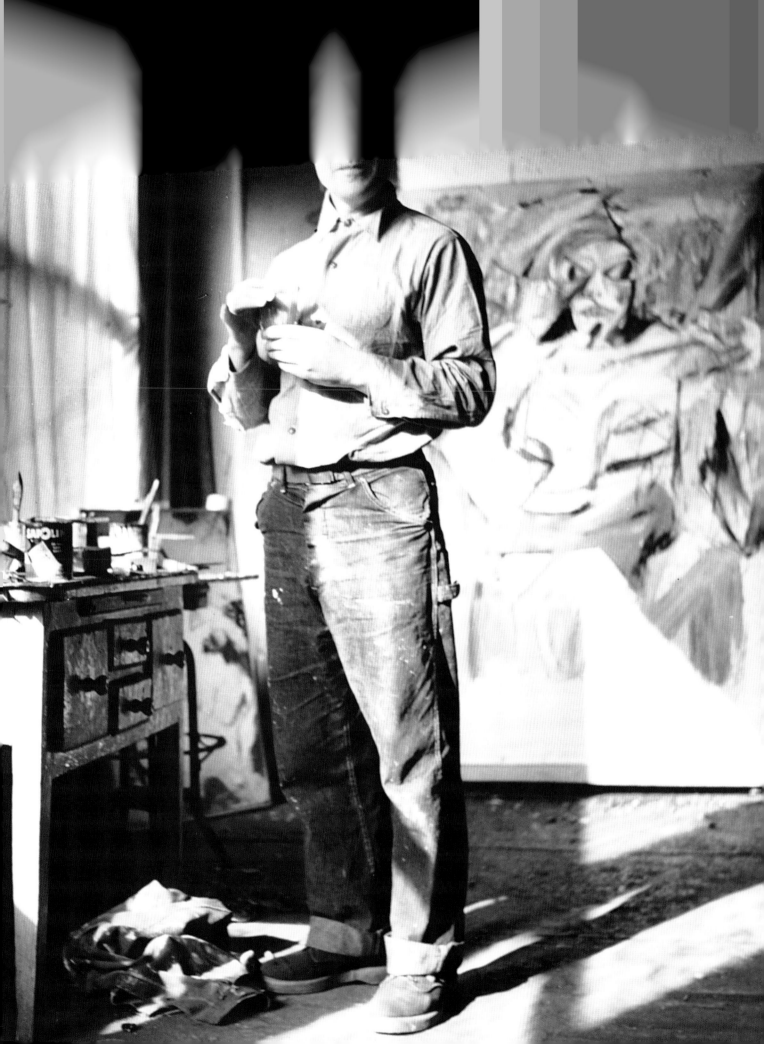

Marcel Duchamp

(1 8 8 7 – 1 9 6 8)

For Duchamp, a studio was more a state of mind than a physical space. In a 1963 interview on the occasion of the fiftieth anniversary of the 1913 Armory Show, Duchamp explained why he stopped painting,

I DON'T FEEL LIKE PAINTING ANYMORE....I ONLY BELIEVE IN CREATION, OR CREATIVENESS, WHICH YOU CAN'T DO EVERY DAY. YOU HAVE GOT TO, YOU HAVE TO HAVE AN IDEA, AND IT DOESN'T COME ALL THE TIME, SO WHEN I STOPPED HAVING IDEAS, I JUST STOPPED PAINTING.

Interview conducted by Martha Deane, for the *Martha Deane Show*, WOR, New York City, 1963. Milton Brown and Marcel Duchamp interviews, 1963.

Marcel Duchamp in his studio, a fourth-floor walk-up at 210 West Fourteenth Street, New York City, 1952. Photograph by Kay Bell Reynal. Photographs of artists taken by Kay Bell Reynal, 1952.

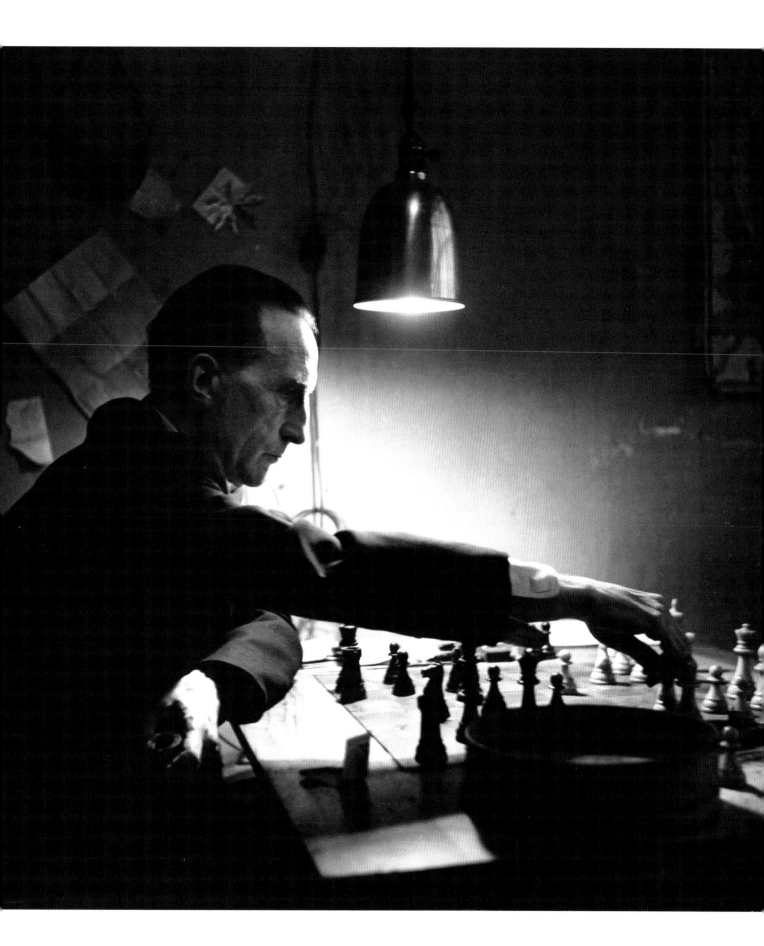

HANS HOFMANN

(1 8 8 0 – 1 9 6 6)

As a teacher and painter, Hans Hofmann inspired generations of artists. In 1933, he opened the Hans Hofmann School of Fine Arts in New York City, where he imparted lessons learned from Picasso, Braque, Matisse, and Delaunay and encouraged his students to:

[EMBRACE A] WORLD OF UNEXHAUSTIBLE CREATIV[E] POSSIBILITIES—AS AN ARTIST I NEVER HAVE BELONGED TO ANY GROUP. I AM NOT A TEACHER IN THE USUAL SENSE EITHER. . . . I ENJOY THE WRONG REPUTATION THAT I LOVE TO TEACH. WHAT I REALLY LOVE . . . IS THE STEADY CONTACT WITH NEW POSSI-BILITIES IN THE FUTURE—WITH NEW GENERATIONS.

Above: In an undated essay, "About myself, my work, my school," Hans Hofmann considers teaching as a means to artistic independence. 3 pages, handwritten. Hans Hofmann papers, ca. 1904–1978. TRANSCRIPTION ON PAGE 183

.

Right: Hans Hofmann in his studio at 53 East Ninth Street in New York City, 1952. The Hans Hofmann School of Fine Arts was around the corner on Eighth Street from 1933 to 1958. Photograph by Kay Bell Reynal. Photographs of artists taken by Kay Bell Reynal, 1952.

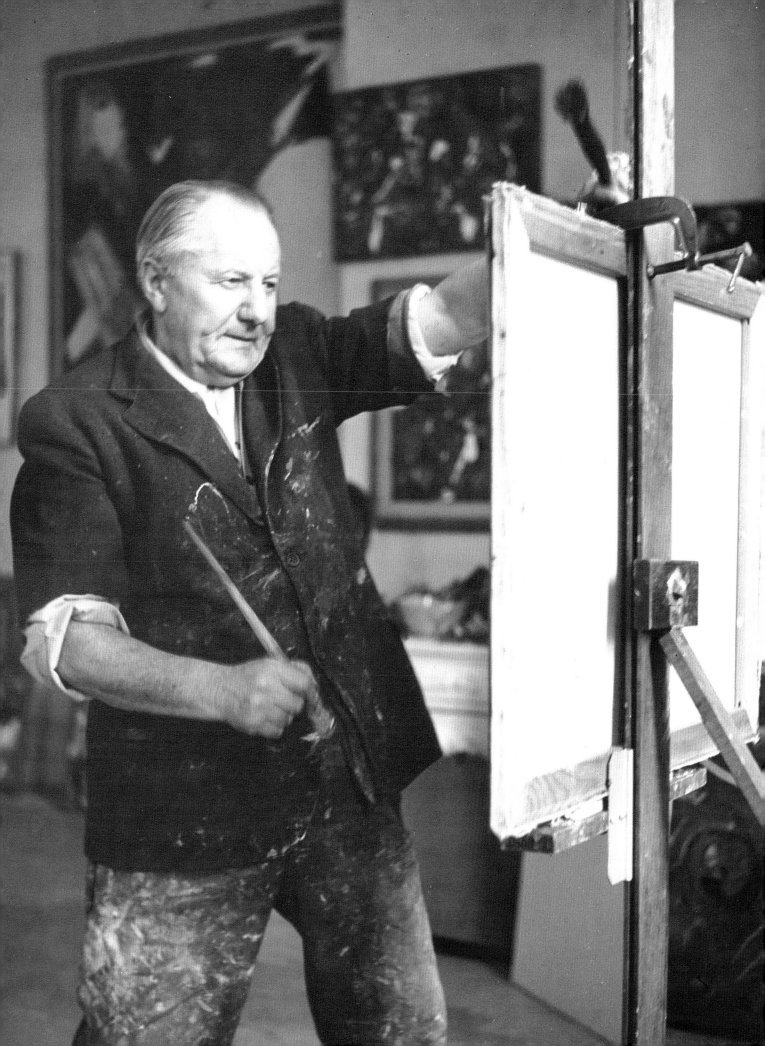

JOHN MARIN

(1 8 7 0 – 1 9 5 3)

The good picture —
No one wonders at more than
the one who created it —
 Made — with an inborn
instinct — which in time begets
an awareness — and these
periods of awareness are —
the - red letter - days in the Creators
life Made — by an instinctive
recognition of the - Basic -
The great horizontal - the Culmination
of rest The great Upright - the
Culmination of activity — for
all things sway away from or
Toward these two — A recognition
of the back bones - as it were - of
movement - all objects within the
picture obeying the magnetic
pull of these back bones —
 Having - not - these back
bones of movement - in the
mind's eye - there can be no real creation

Marin, known for his expressive watercolors of the Maine coastline, often painted his landscapes from memory in his New Jersey studio.

In a statement to his dealer Edith Gregor Halpert, left, Marin held that a "good picture" should "embrace a thrill—based on a life experience." Like many artists, Marin found words inadequate for conveying aesthetic experience. He concluded, "How vaporish the comments of most commentators." 2 pages, handwritten. Downtown Gallery records, 1824–1974. © 2006, Artists Rights Society (ARS), New York. TRANSCRIPTION ON PAGE 184

John Marin in his studio in Cliffside, New Jersey, 1952. Photograph by Kay Bell Reynal. Photographs of artists taken by Kay Bell Reynal, 1952.

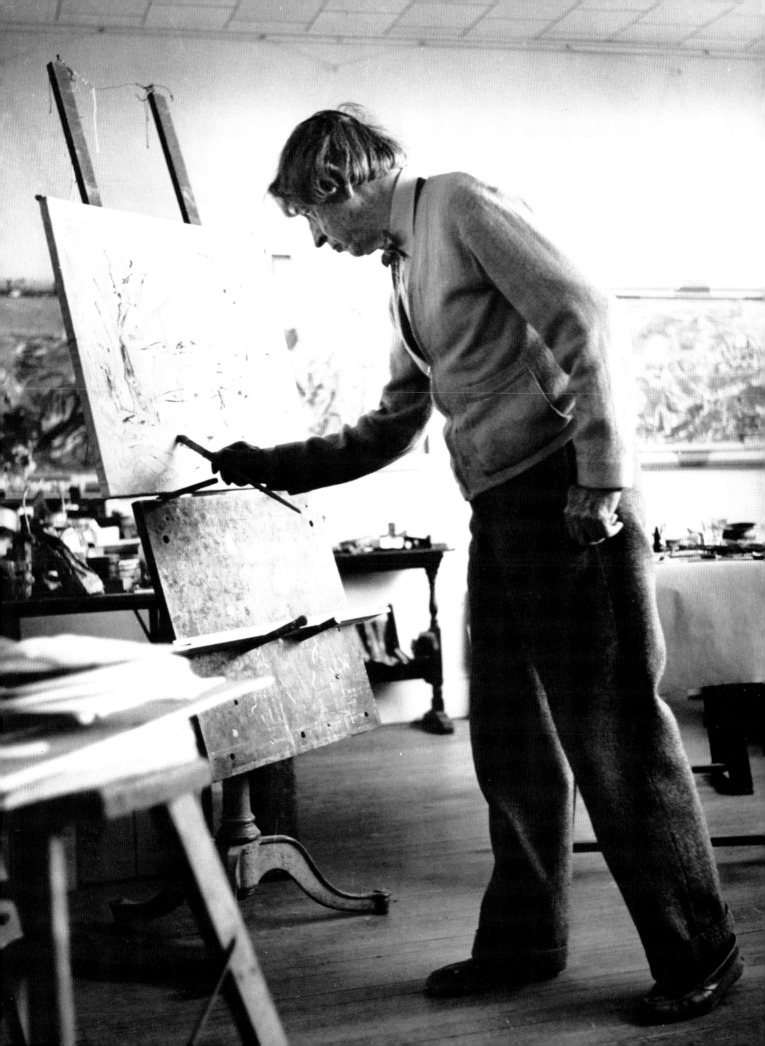

ROBERT MOTHERWELL

(1915–1991)

> c/o Chareau
> 215 E. 57
> 18 Feb 58
>
> Dear Joe: For a long time
> I wanted to write you about
> the marvelous "box" that you
> made for me – but when I contem-
> plate it, + think of the grace
> of your gesture, I am moved on
> a much deeper level than those
> for which I have words, + [illegible]
> irritated at my inadequacy.

Here, in his rolled-up, paint-smeared jeans, Motherwell looks the part of the 1950s rebel. It is unclear why the painting is turned to face the photographer.

While Motherwell is known as a principal practitioner and theoretician of abstract expressionism, he was also a fan of Joseph Cornell (1903–1972), whose assemblages explored the intertwined sensations of seeing, feeling, and remembering. In this 1950 letter to Cornell, Motherwell struggles with the inadequacy of words to express his thanks for a "box" that Cornell made for him. "You are the only complete artist this country has," he wrote.

Left: Letter from Robert Motherwell to Joseph Cornell, 18 February 1950. 3 pages, handwritten. Joseph Cornell papers, 1804–1986. © 2006 Dedalus Foundation, Inc./Licensed by VAGA, New York, NY.
TRANSCRIPTION ON PAGE 184

Right: Robert Motherwell in his studio on Fourteenth Street in New York, 1952. Photograph by Kay Bell Reynal. Photographs of artists taken by Kay Bell Reynal, 1952.

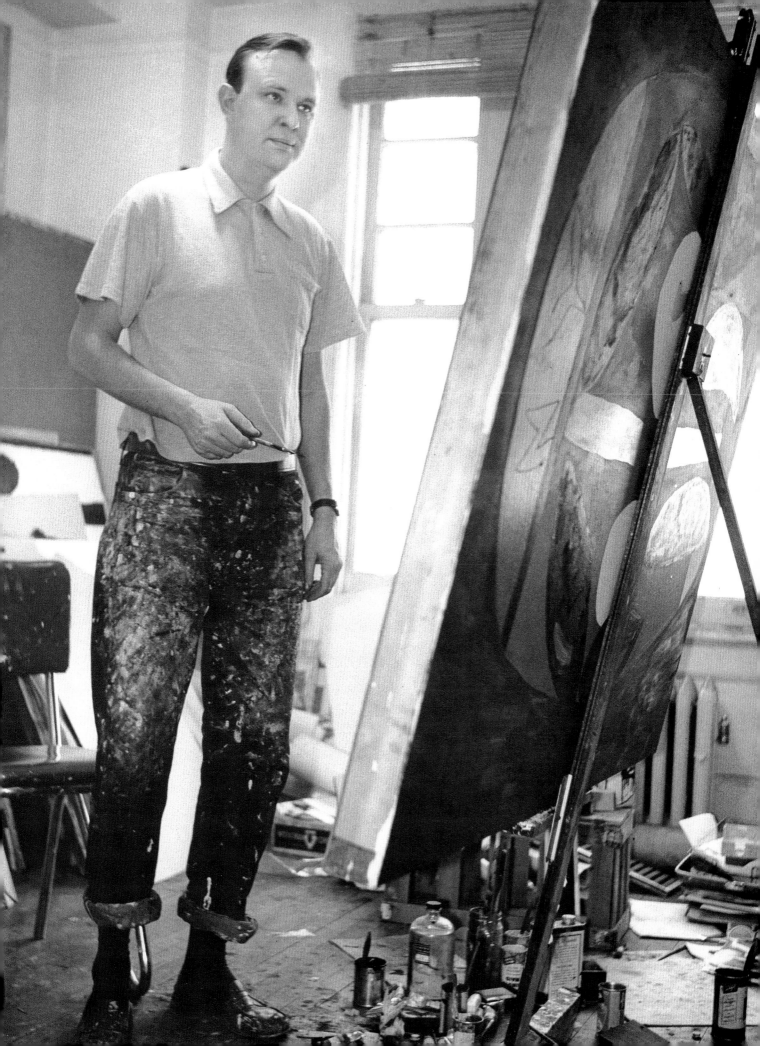

Saul Steinberg

(1914–1999)

Renowned for his covers and drawings that appeared in *The New Yorker* for nearly six decades, Saul Steinberg was one of America's most admired draftsmen. Beginning in 1959, playing with his personae as an artist, he made a series of paper-bag masks, and Inge Morath photographed him and others wearing them. In this photograph, a masked Steinberg is seated in his studio in his apartment on East Seventy-first Street in New York, where he was then living with his wife, painter Hedda Sterne.

In 1967, Charles Blitzer, then assistant secretary for art and history at the Smithsonian Institution, hosted a luncheon for Saul Steinberg. Steinberg's remarks are, on close inspection, a stream of nonsense in the form of a grand proclamation handwritten in a fanciful, antiquated script on Smithsonian letterhead. Blitzer framed the whimsical document, and it hung in the Smithsonian Castle for many years before it was transferred to the Archives of American Art in 2002. © The Saul Steinberg Foundation/ Artists Rights Society (ARS), New York.

Left: Remarks prepared by Saul Steinberg for a luncheon given in his honor at the Smithsonian Institution, 27 February 1967. 2 pages, handwritten. © The Saul Steinberg Foundation/ Artists Rights Society (ARS), New York.

. .

Right: *Man at His Desk* (from the *Mask* series with Saul Steinberg), 1959. Photograph by Inge Morath. Miscellaneous photograph collection. © The Estate of Inge Morath/ MAGNUM. Mask by Saul Steinberg © The Saul Steinberg Foundation / Artists Rights Society (ARS), New York.

MARK ROTHKO

(1903–1970)

Rothko's stained canvases, with glowing soft-edge squares and rectangles, were the abstract embodiment of emotion and meaning. By the 1960s, he was a hero to many artists. In an interview, painter Al Held recalled a visit to Rothko's studio:

I WENT TO SEE ROTHKO, AND ROTHKO ALSO WAS EXTREMELY GRACIOUS. ROTHKO TREATED ME LIKE I WAS A PRINCE. HE SAT ME DOWN, LITERALLY PULLED OUT EVERY PAINTING IN HIS STUDIO, SHOWED ME ALL HIS PAINTINGS, WAS VERY PATIENT, SPENT THE WHOLE AFTERNOON WITH ME. THEN WE WENT DOWN TO A BAR, HE BOUGHT ME A DRINK AND A SANDWICH, AND WE TALKED FOR A WHILE. THEN I SORT OF REALIZED THAT IT WAS TIME TO GO. I WAS SORT OF MAKING MY GOODBYES, WAS THANKING HIM PROFUSELY AND I SAID "WELL, MR. ROTHKO, IN ABOUT SIX MONTHS PERHAPS WE COULD DO THIS AGAIN," YOU KNOW, REALLY THANKING HIM. HE SAID, "OH, NO, NO, NO, YOU SHOULDN'T SEE ME; YOU SHOULD FIND YOUR OWN CONTEMPORARIES AND BUILD YOUR OWN WORLD, YOUR OWN LIFE, LIKE I DID WITH MY CONTEMPORARIES. IT'S VERY UNHEALTHY." AND I FELT LIKE A TERRIBLY REJECTED LOVER.

Interview of Al Held conducted by Paul Cummings for the Archives of American Art, session 2, 12 December 1975.

Mark Rothko in his studio on West Fifty-third Street in New York City, 1952. Photograph by Kay Bell Reynal. Photographs of artists taken by Kay Bell Reynal, 1952.

HANANIAH HARARI

(1912 – 2000)

Harari kept two easels and two separate drawing tables in his studio; one set was for abstract paintings in the morning, and the other was for commercial jobs in the afternoon.

Harari writes about his creative and financial frustrations:

THROUGH THE YEARS, I HAVE BEEN ABLE TO PURSUE MY OWN WORK AT A PACE THAT HAS ALMOST UNBEARABLY TRIED MY PATIENCE. THE PROBLEM OF EARNING A LIVING, OF MANAGING ONE'S AFFAIRS IN THIS ENVIRONMENT, INTERFERES TO A MONUMENTAL DEGREE WITH CREATIVE POSSIBILITIES.

Left: Draft letter from Hananiah Harari to "Dan," 28 June 1961. 3 pages, handwritten. Hananiah Harari papers, 1939–1983. TRANSCRIPTION ON PAGE 184

.

Right: Harari in his studio in Croton-on-Hudson, New York, ca. 1960. Photographer unknown. Hananiah Harari papers, 1939–1983.

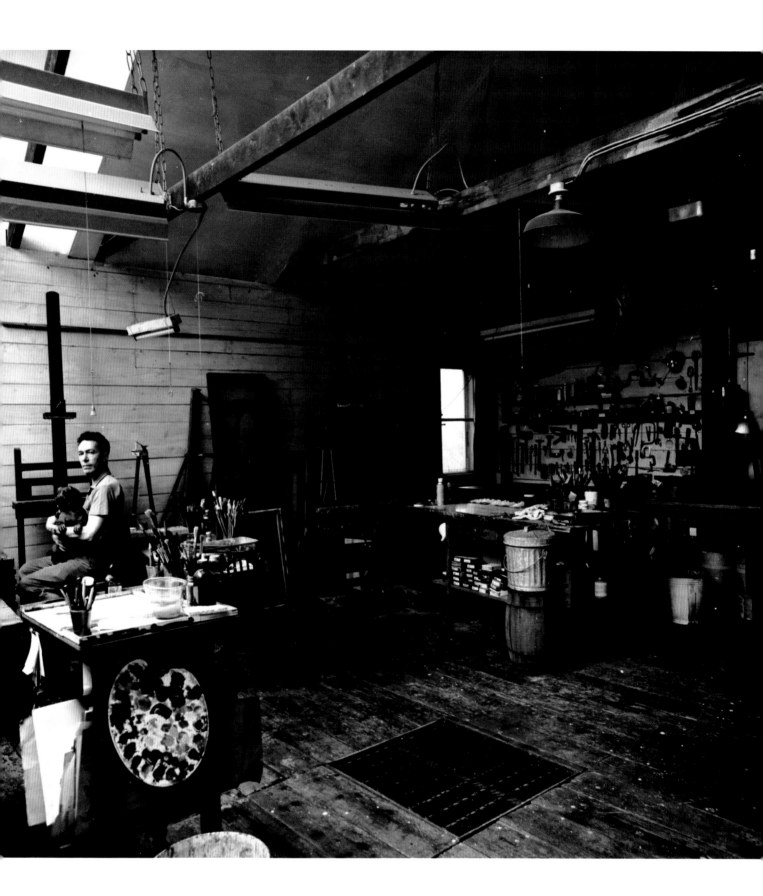

CLAES OLDENBURG

(B. 1929)

Claes Oldenburg works here on his first version of *The Store*, an assemblage of objects—food, clothes, appliances—made of chicken wire, paint, and plaster for the exhibition *Environments, Situations, Spaces* at the Martha Jackson Gallery in May 1961. A leader in the avant-garde, Oldenburg wrote:

I AM FOR AN ART THAT DOES
SOMETHING OTHER THAN
SIT ON ITS ASS IN A MUSEUM.
I AM FOR AN ART THAT GROWS
UP NOT KNOWING IT IS ART
AT ALL, AN ART GIVEN THE
CHANCE OF HAVING A STARTING
POINT OF ZERO.

Left: Claes Oldenburg statement for *Environments, Situations, Spaces* at the Martha Jackson Gallery in May 1961. 3 pages, edited carbon copy typescript. Ellen Hulda Johnson papers, 1939–1980.
TRANSCRIPTION ON PAGE 185

.

Right: Claes Oldenburg in his studio at 330 East Fourth Street in New York in 1961. Photograph by Robert R. McElroy. Ellen Hulda Johnson papers, 1939–1980. © Estate of Robert R. McElroy/Licensed by VAGA, New York, NY.

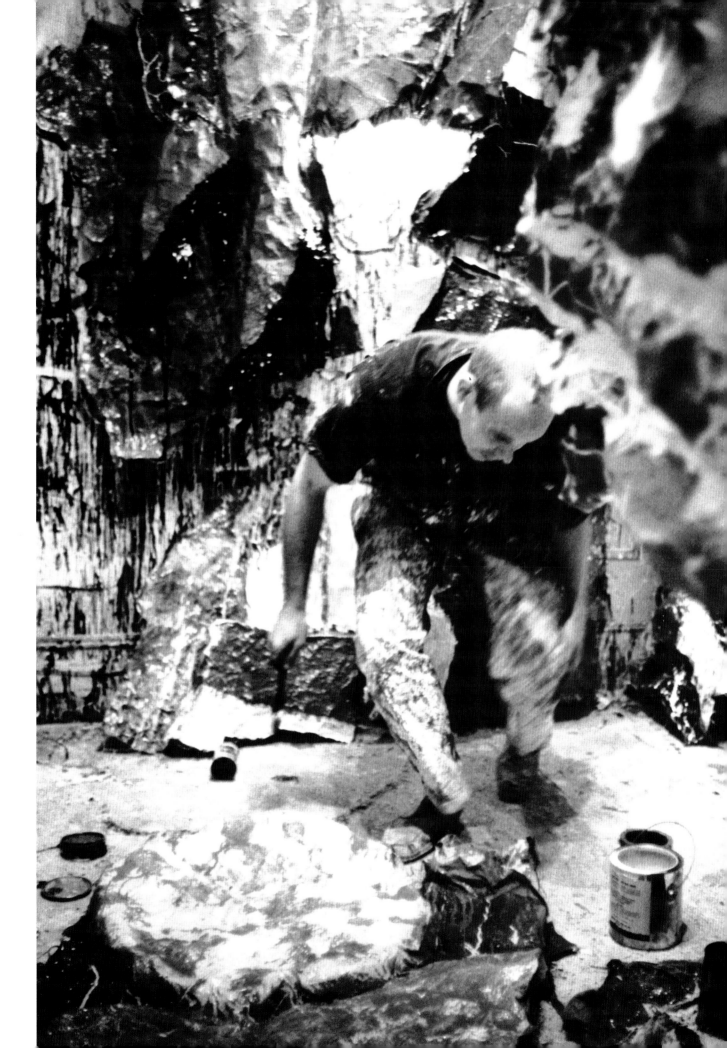

WILLIAM P. DALEY

(B . 1 9 2 5)

William P. Daley, who received the American Craft Council's gold medal for consummate craftsmanship, taught at various universities before his 30-year tenure at the Philadelphia College of Art (now the University of the Arts). In 1982, he wrote about the importance of drawing in his creative process,

WHEN POSSIBILITIES EMERGE WHICH SEEM TO MERIT FURTHER DEVELOPMENT, I SHIFT FROM TYPING PAPER TO DRAWING DIRECTLY ON MY PRE-PREPARED STUDIO WALLS . . . DRAWING IS A WAY OF USING IMAGES TO NURTURE THOUGHT.

At right, Daley in his studio, a converted one-car garage at his home in Feasterville, Pennsylvania, 1962. Photograph by Murray Weiss. William P. Daley papers, 1905–2003. The drawings on the wall are, left to right, a segment of a 20-foot-long raised-tile mural for a new laboratory at the Palmolive Peet Corporation (never realized); his vertical pot drawings; and a template for his sculpture *Adam*, 1962. Daley is working on the legs for *Adam*. His *Eve*, 1962, sits on a platform to his right.

William P. Daley essay, "On Drawing," that appeared in *American Ceramics*, vol. 1, no. 1 (Winter 1982). 6 pages, edited typescript. William P. Daley papers, 1905–2003. TRANSCRIPTION ON PAGE 185

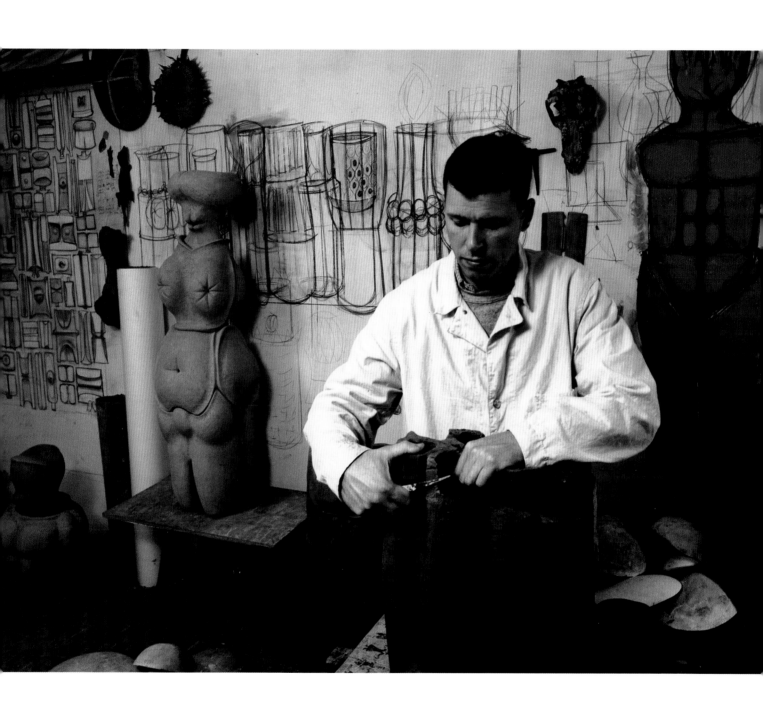

LEE KRASNER

(1918–1984)

Lee Krasner, right, in her studio at the Springs, Long Island, New York, 1962. Krasner's husband, Jackson Pollock, had once used the same space. When Pollock got some money in the early 1950s, he renovated the studio, adding drywall, heat, and electric lights. Photograph by Hans Namuth. Hans Namuth photographs and papers, 1952–ca. 1985. © 2006 Hans Namuth Estate.

Unable to convince Pollock to join her in Paris in the summer of 1956, Krasner corresponded with him in New York. "I miss you & wish you were sharing this with me," she wrote, only three weeks before he died in an auto accident while she was still in Europe.

Letter from Lee Krasner to Jackson Pollock, 21 July 1956. 1 page, handwritten. Jackson Pollock and Lee Krasner papers, ca. 1905–1984.

TRANSCRIPTION ON PAGE 186

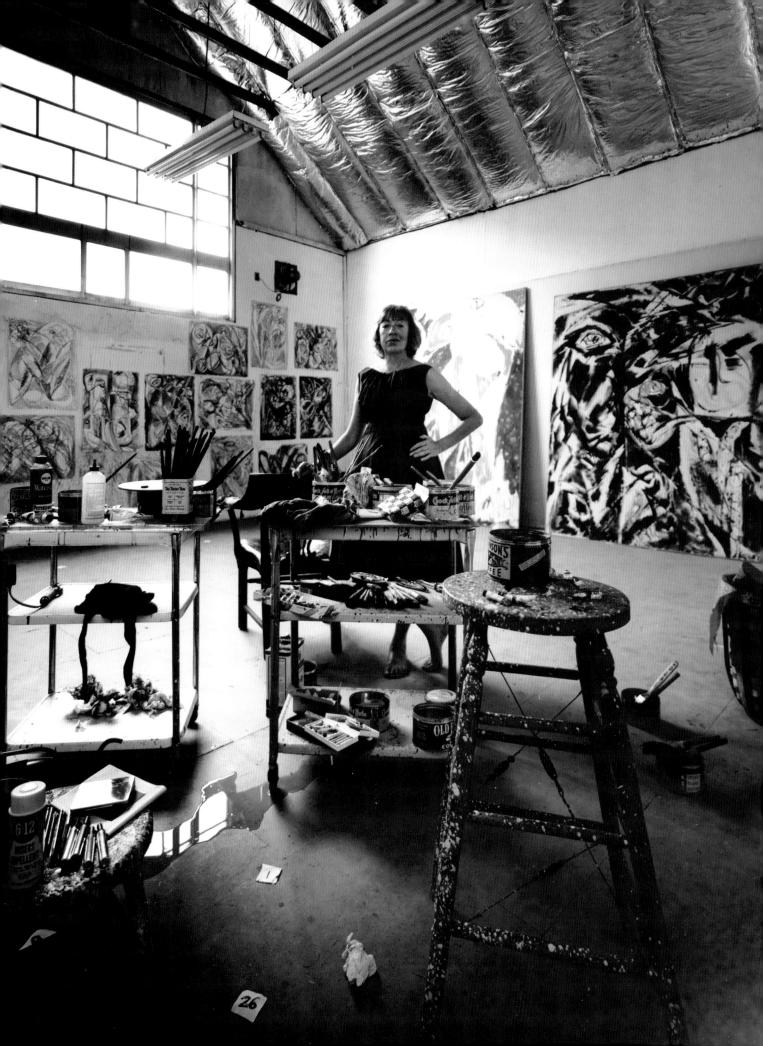

AD REINHARDT

(1 9 1 3 – 1 9 6 7)

In 1963 when painter Ad Reinhardt won a $1,000 prize from the Art Institute of Chicago, he had a lively exchange with artist Abe Ajay about the corrupting influence of such approval.

Ajay equates the purity of Reinhardt's minimalist enterprise with artistic integrity. "Corruption is like peanuts. It takes an uncommon kind of inner strength to know when to stop. . . . While I haven't removed the nice picture of your bent over bald head from my bulletin wall, I have stopped burning the two candles which flanked it during 1962." The enshrined "baldy picture" is most likely the photograph taken by Fred W. McDarrah in 1962 for the book *Art: USA: Now*, a compendium of major American artists that was published that year. In his response, Reinhardt pokes fun at his conflicted desire to be "loved, prized, worshipped," and his need to distance himself from the art world.

Left: Letter to Ad Reinhardt from Abe Ajay, [2 February] 1963, with Reinhardt's handwritten response [5 February 1963]. 1 page. Ad Reinhardt papers, 1930–1967. TRANSCRIPTION ON PAGE 187

Right: Ad Reinhardt in his studio at 732 Broadway in New York City, 1 March 1961. Photograph by Fred W. McDarrah. Lee Nordness business records and papers, ca. 1950–1974. © Fred W. McDarrah.

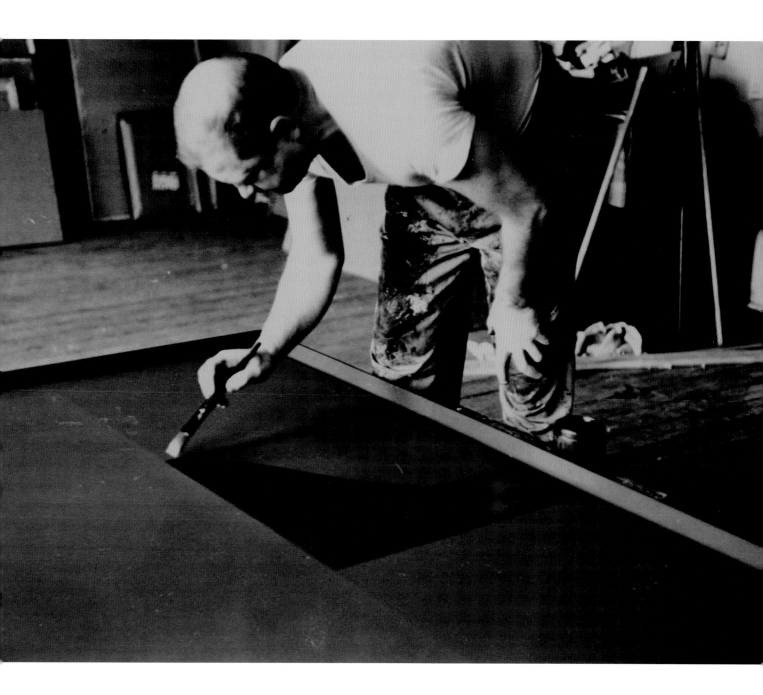

James Rosenquist

(B. 1933)

Ellen Hulda Johnson's snapshots, right, and notes, below, from her visit to the studio of painter James Rosenquist at 429 Broome Street, New York City, on 4 April 1963. Ellen Hulda Johnson papers, 1939–1980.

Johnson (1910–1992) was one of the first art historians in the United States to teach contemporary American art. Her courses at Oberlin College and her writings were informed by her first-hand experience of artists in their studios. She photographed pop artist Rosenquist with his painting of a giant paintbrush as well as the messy expanse of his loft space. Rosenquist, who used found images for his art, pinned source material to his studio wall.

In her notes, written on Savoy Hilton Hotel stationery, she remarks,

HAS MOTORCYCLE—BLUE, FUSSES WITH IT. BOY OF HIS TIME. WHEN THINGS PILE UP, LIKES TO GET ON IT, CLICK & SAIL AWAY. THERE IS IN HIS WORK THAT KIND OF ABRUPT MOVEMENT, QUICK CHANGES IN TEMPO & SCALE & PLACE.

9 pages, handwritten. Ellen Hulda Johnson papers, 1939–1980.

TRANSCRIPTION ON PAGE 187

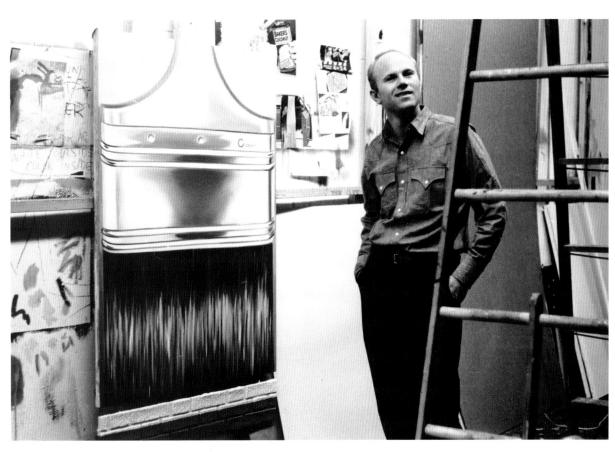

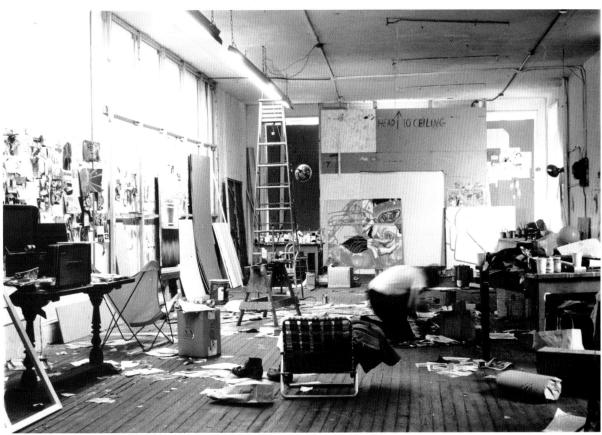

George Segal

(1924-2000)

George Segal was known for his rough, life-size white plaster casts of human figures set in ordinary situations with real chairs, tables, and other artifacts of everyday life. Energized by the tension between known settings and the interior life of his cast figures, his work added a psychological edge to pop art production.

In 1963, Segal wrote to art historian Ellen Hulda Johnson about his recent trip to Paris for the opening of his show at Ileana Sonnabend's gallery; about making a sculpture of Sonnabend's son, Michael, "tensely playing an American pinball machine"; and about being back home in his studio:

WITHDRAWAL TO MY STUDIO HAS BEEN MARVELOUS. WORKING ON ART FULLTIME ENCOURAGES MY COMPULSIVE WORKING HABITS. CONCENTRATION IS SIMPLER. I'M CURRENTLY INVOLVED IN A GAS STATION 25' LONG AND A MOVIE MARQUEE WHICH IS A WALL OF COLD FLUORESCENT LIGHT 8' SQUARE WITH A FIGURE REMOVING THE LAST LETTER FROM THE BLANK, BLAZING SIGN.

Nov 7, 1963

Dear Ellen,

The strange thing is, I haven't heard from Ileana since my show opened, which was two weeks ago. Ileana and I flew back to the States together about Sept 11. One person whose judgment I trust told me of the extremely hostile reaction of American expatriate painters and poets. French reaction seems to range from hostility to enthusiasm.

I made a sculpture in Paris of Michael Sonnabend tensely playing an American pinball machine and it was extremely difficult to work there. Incredible complications getting the simplest materials and hand tools, working publicly and living in an atmosphere incredibly and minutely sprung to life from the memory of French art & writing, complete even to expected clichés.

The Sonnabends were marvelously gracious to us, anxious to reveal the essential nature of the French to us, took us touring, spent endless hours translating questions from curious novelists, artists, critics, really working very hard to persuade the logical & verbal French of American stance & attitude.

Yet the French don't have the American situation and environment & have powerful conservative feelings. I was pained to disturb the nostalgic withdrawal into a dream of the past I found in some American friends. But I was swamped and staggered by the soaring greatness of Chartres and the late

Left: Letter from George Segal to Ellen Hulda Johnson, 7 November 1963. 2 pages, handwritten. Ellen Hulda Johnson papers, 1939–1980. © The George and Helen Segal Foundation/Licensed by VAGA, New York, NY. TRANSCRIPTION ON PAGE 188

Right: George Segal in his studio in South Brunswick, New Jersey, on 29 July 1963. Photograph by Ellen Hulda Johnson. Ellen Hulda Johnson papers, 1939–1980.

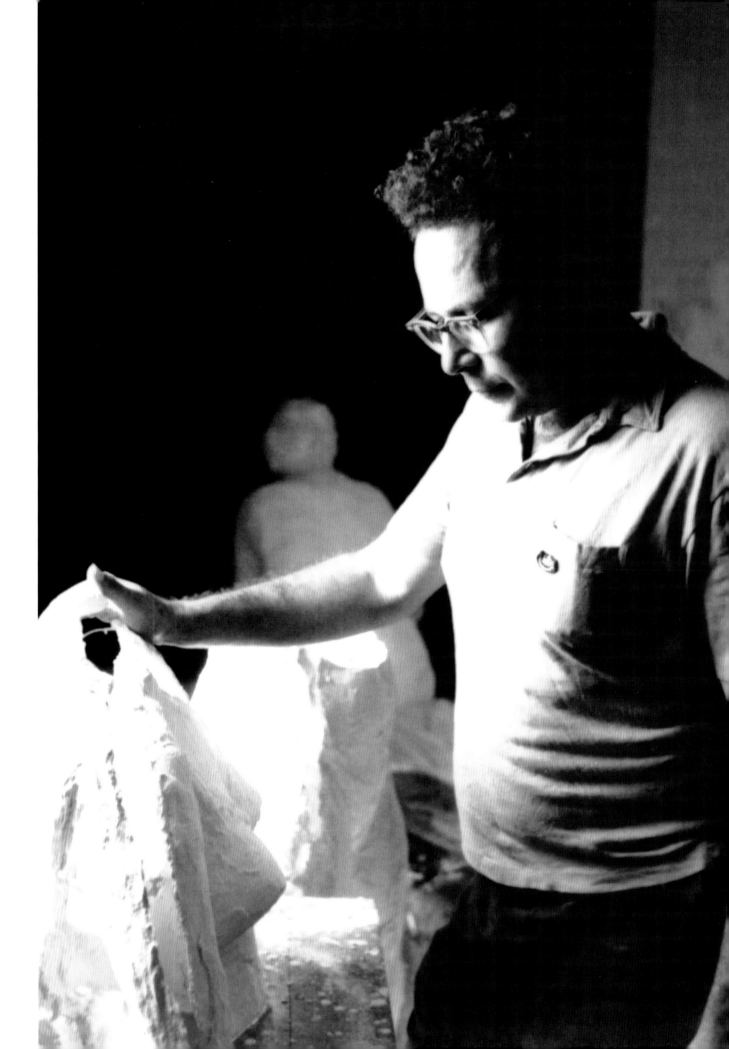

AL HELD

(1928–2005)

In 1960, when Held took over Sam Francis' studio in New York at 940 Broadway, the scale of his painting began to change. He adjusted his work to fit the available space. He said,

I IMMEDIATELY SWITCHED TO CANVAS AND, OF COURSE, ENLARGED THE SCALE TO FIT THE ENVIRONMENT. THE STUDIO WAS SO LARGE THAT I IMMEDIATELY STARTED PAINTING PAINTINGS THAT SORT OF LOOKED NATURAL IN THAT STUDIO. AND THEY GOT TO BE BIG PAINTINGS. AND I ABANDONED OIL WITH THE PROMISE, ALWAYS WITH THE PROMISE OF GOING BACK TO OIL BECAUSE THAT WAS THE REAL MEDIUM.

Acrylic was his preferred medium. He never went back to oil, and when he moved to 182 Fifth Avenue, he found a big space to work in. The super-sizing of paintings in the 1950s and 1960s was not only part of an American ethos, but compelled viewers toward a new relationship with the art. The scale was disorienting, making viewers realize the transformative power of art through its sheer physical force. Interview of Al Held conducted by Paul Cummings for the Archives of American Art, session 3, 19 December 1975.

Al Held in his studio at 182 Fifth Avenue, New York City, in 1966, with his painting *Greek Garden*, 1966, a panorama of circles, squares, and triangles that was 56 feet by 12 feet. Photograph by André Emmerich. André Emmerich Gallery records and André Emmerich papers, ca. 1954-1999.

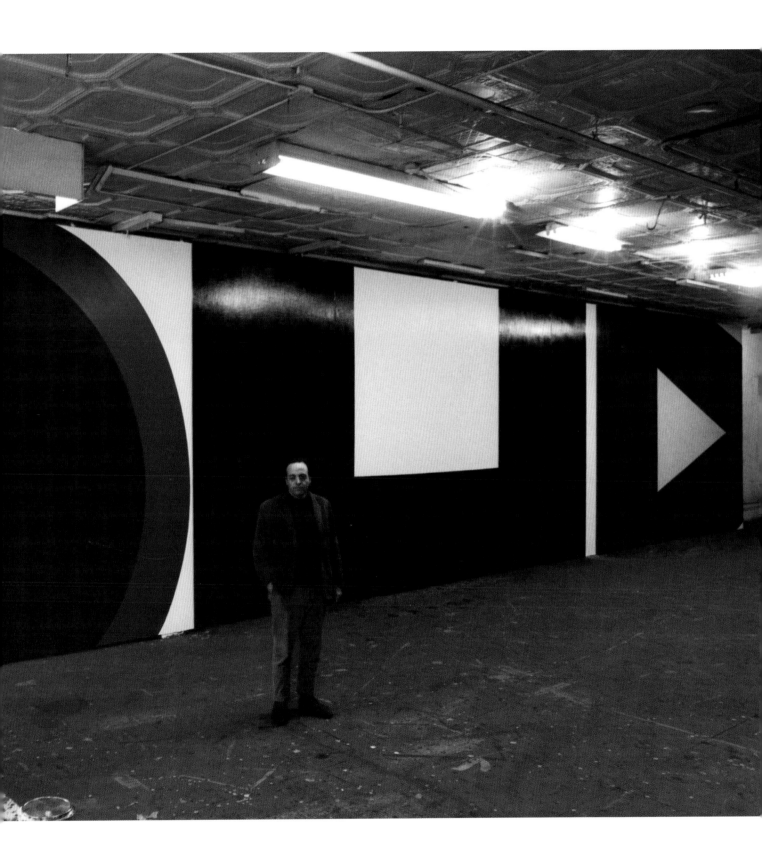

LOUISE NEVELSON

(1899–1988)

In the photograph at right, sculptor Louise Nevelson, left, in her "black" studio at 29 Spring Street, New York City, in 1966, works with her assistant, Diana MacKowan, on *Homage to the World*, a massive semicircle of prefabricated wood boxes and found objects, 8½ feet high by 28 feet long, painted matte black (now in the collection of the Detroit Institute of Arts). Photograph by Ugo Mulas. © Ugo Mulas Estate. All rights reserved.

Louise Nevelson papers, ca. 1903–1979. Nevelson also had a "white" studio so that she could be immersed in the color while painting white elements.

In 1961, Nevelson wrote a poem about the power of black:

QUEEN OF THE BLACK BLACK
IN T[HE] VALLEY OF ALL ALL
WITH ONE GLANCE SEES
 T[HE] KING.
MOUNTAIN TOP
T[HE] CLIMB
T[HE] WAY
RESTLESS WINDS
MIDNIGHT BLOOMS
TONS OF COLORS
TONES OF WATERDROPS
CRYSTAL REFLECTIONS
PAINTING MIRAGES
CELESTIAL SPLENDOR
HIGHTEST GRANDEUR
QUEEN OF T[HE] BLACK BLACK
KING OF T[HE] ALL.

Her poem was published in an article by painter Philip Pearlstein, "The Private Myth," in the September 1961 issue of *ARTnews*. Louise Nevelson, untitled poem, 1961. 1 page, handwritten. Louise Nevelson papers, ca. 1903–1979.

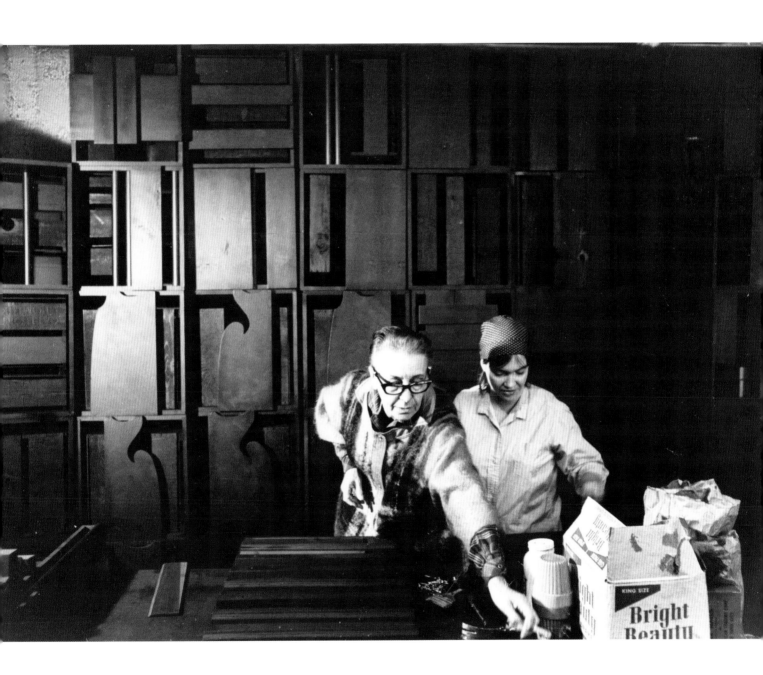

BOB THOMPSON

(1937–1966)

COMMENTS AND INFORMATION RE: BOB THOMPSON

Dates of Acquaintance: From ___1958-8(?)___ To __1965___
Place(s): City __New York__ State __N.Y.__
 City_____ State_____

Relationship to Thompson: __Friend_____

Comment(s): ___I knew Bob Thmpson as a fellowartist living in
___New York's Grenwich Village, and Lower East Side, druing
late 50's and thru to mid sixties. We were very close friends and
used to visit each other, hang out together in various bars, listening
to music and each other, and to the crew of friends we ran with. Painter
friends, writer friends, musician friends. William White another black
painter, also dead before his time. Joe Overstreet, now abstract
and fashionable ny painter, and Bob and I used to be, together with
altosaxophonist, Marion Brown, a close foursome, along with some
other brothers. We ran with each other, bouncing off, the various
white american personalities of the neighborhood. Trying to learn
about art, and all the time needing to learn more about life. Some
of us are still trying to learn more about life, some never got the
chance.
___Bob was a great painter, a fantastic emotionalist, who should
have had wide viewing. He had great influence on us. And his conception
of painting knocked me out. Some of his early works are the strongest
things done during that period Signature [signature]
by anyone I knew or heard of
much stronger than those rich whiteboys we hear so much about. Bob died
Your Name (Please print): because America used him up.
Street Address: __502 High St__
City: __New Ark__ State: __N.J__ Zip: _____
Telephone Number: (201) 624-1011

An African-American artist at the center of the beat scene, Thompson fused abstract expressionism and figuration into intensely emotional paintings, many of which are homages to European masterworks. Thompson lived fast and worked hard, creating more than 1,000 works of art before his death in Rome at age 28 from a drug overdose.

LeRoi Jones's "Comments and Information Re: Bob Thompson," ca. 1966, left. Bob Thompson papers, 1955–2000. Jones, a poet, playwright, and political activist, later changed his name to Amiri Baraka. He wrote, "[Thompson's] conception of painting knocked me out…much stronger than those rich white boys we hear so much about. Bob died because America used him up."

TRANSCRIPTION ON PAGE 189

Bob Thompson painting in his studio at 6 Rivington Street, on the Lower East Side, New York, 1964. 1 page. Photograph by Leroy McLucas. Bob Thompson papers, 1955–2000.

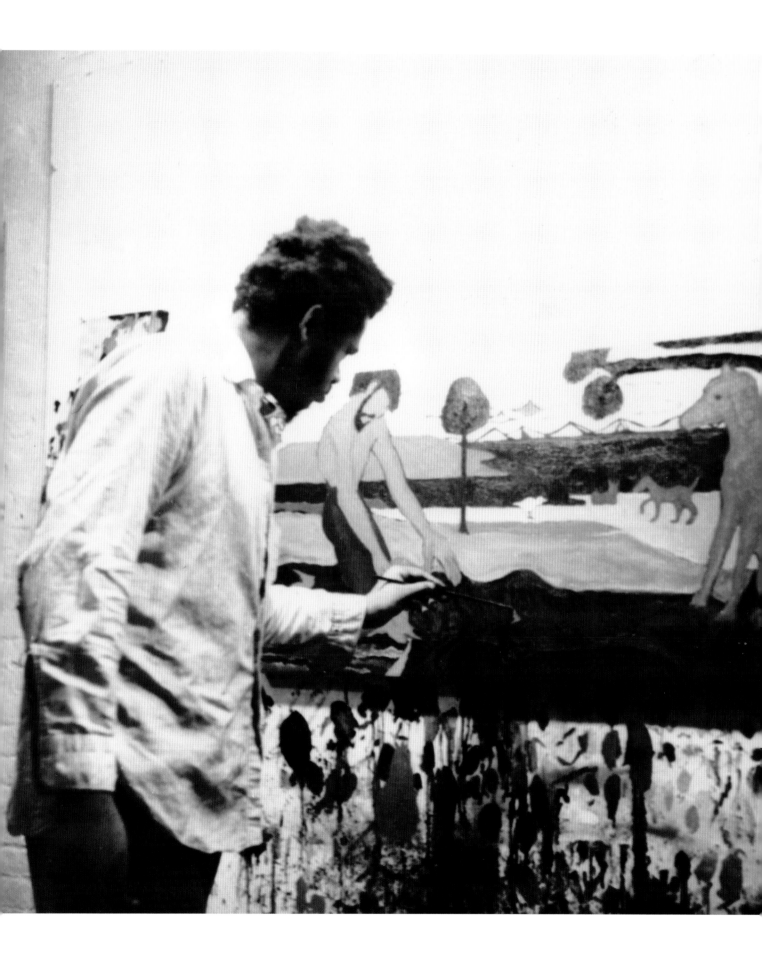

ROBERT RAUSCHENBERG

(B. 1925)

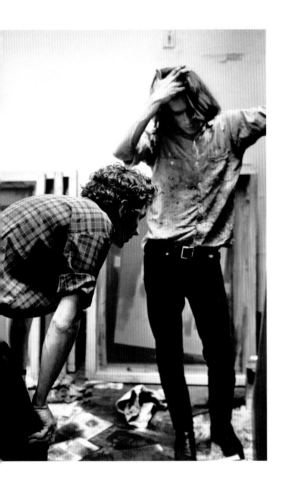

Robert Rauschenberg helped redefine American art in the 1950s and 1960s, first with his "combines"—found objects and paint in a sculptural collage—then with his silkscreen paintings that incorporated found objects and images. Here he has his screens and Plexiglas pieces set up for *Solstice* (1968), an interactive installation that consisted of five pairs of sliding Plexi doors with silkscreen images, which open and close as one walks through.

In 1968, when painter Brice Marden was 20, he worked as Rauschenberg's assistant, mostly ordering Plexiglas and cleaning screens. "I figured," he said, "that my job when he was in the studio was to have everything there for him so that all he had to do was to make art and not be hassled by anything else." Though their aesthetic sensibilities differed, they had a good rapport: "He was very generous, and he was very helpful, and it was a good experience working there, really good." Interview of Brice Marden conducted by Paul Cummings for the Archives of American Art, 3 October 1972, pp. 26-7.

Left: Robert Rauschenberg and Brice Marden (b. 1938) in Rauschenberg's studio, 1968. Photograph by Henri Cartier-Bresson. Henri Cartier-Bresson photographs of artists collection. © Henri Cartier-Bresson/Magnum Photos.

.

Right: Robert Rauschenberg in his studio at 381 Lafayette Street, New York City, in 1968, demonstrating his silkscreen technique for photographer Henri Cartier-Bresson. Henri Cartier-Bresson photographs of artists collection. © Henri Cartier-Bresson/Magnum Photos.

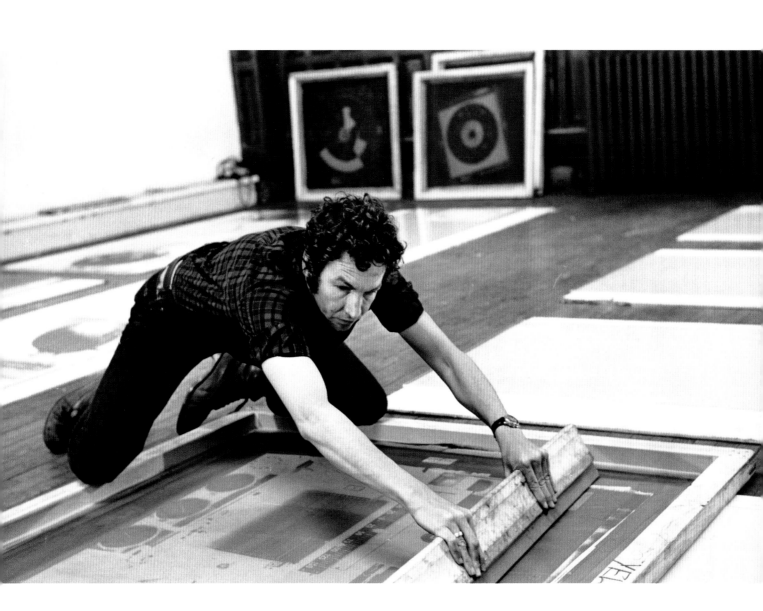

George Sugarman

(1 9 1 2 – 1 9 9 9)

George Sugarman is best known for his brightly painted metal sculptures in playful geometric shapes. At right, he is developing a three-dimensional form using paper.

In his "Thought Book," he wrote:

ABSOLUTE FREEDOM IS MEANINGLESS: IT IS A DENIAL OF STANDARDS & VALUES, WITHOUT WHICH THERE CAN BE NO MEANING. ALONG THESE LINES, NON-OBJECTIVE ART IS MEANINGLESS AND IT ALLOWS THE SPECTATOR ABSOLUTE FREEDOM IN REACTION AND PROVES NO GUIDES OR STANDARDS. . . .

Above: George Sugarman, "Thought Book," Paris, 1951–1955. 31 pages, handwritten. George Sugarman papers, 1912–2001. TRANSCRIPTION ON PAGE 189

.

Right: George Sugarman in his studio at 21 Bond Street, New York City, ca. 1975, possibly working on *#895*. Photograph by James Matthew Auer.

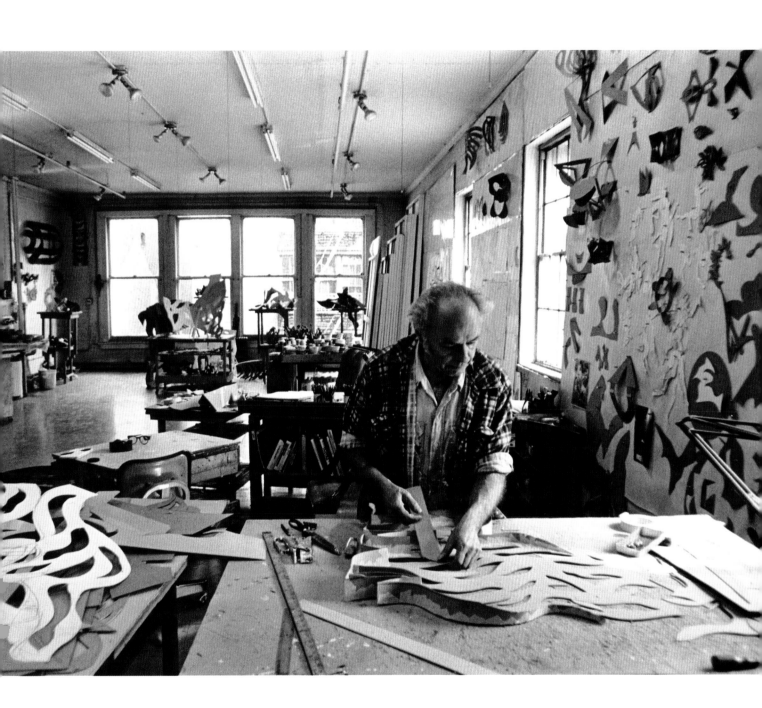

RICHARD DIEBENKORN

(1 9 2 2 – 1 9 9 3)

In 1966, Richard Diebenkorn moved to Southern California to teach at the University of California at Los Angeles, and established a studio in the Ocean Park neighborhood of Santa Monica. Always attuned to his environment, he began his *Ocean Park* series in 1967. He was not so much looking out his window for inspiration, though, but at his win-dow. In an interview he talks about the composition of his *Ocean Park* paintings—blocks of painterly color bound in chromatic and geometric relationships—:

. . . THERE WAS THIS SITUATION OF A LARGE, LIGHTED RECTANGLE, A MORE OF A SQUARE WITHIN IT, AND THEN, SEEN FROM THE SIDE, THE TRANSOM PROVIDED THE DIAGONAL. . . . WELL, THERE'S JUST SO MANY OF THE ELEMENTS THERE, AND I REMEMBER SEVERAL MORE ASTUTE PEOPLE WHO VISITED THAT STUDIO SAID, "WELL, LOOK, YOU'RE PAINTING YOUR TRANSOM WINDOWS."

Interview of Richard Diebenkorn conducted by Susan Larson, for the Archives of American Art, session four, 15 December 1987.

Richard Diebenkorn in his studio in the Ocean Park neighborhood of Santa Monica, California. Photographs by Arnold Chanin, September 1975. Photographs of Southern California artists by Arnold Chanin, photographer, 1969–1978.

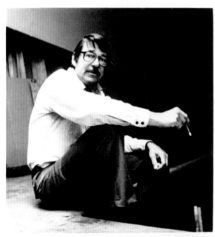
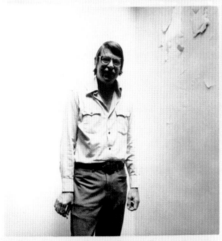
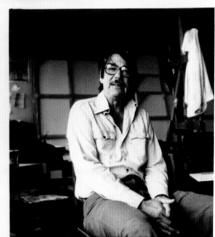
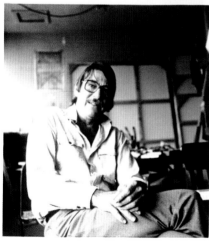
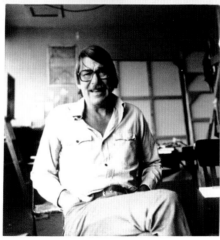
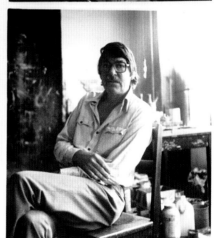

ROY LICHTENSTEIN

(1923 – 1997)

In the 1960s, Lichtenstein gained international fame for his pop art paintings derived from comic strips. In 1971 he moved to Southampton, where he continued to develop his artistic vocabulary of texture, line, and shape and sharpen his social commentary. On the far left of his studio is his painting *Head with Braids* (1979). Directly behind him is the sculpture *Glass V* (1977). *Blue Head* (1979) is on the easel, and a study for the painting *Portrait of a Woman* (1979) is tacked to the top right corner of a large blank canvas, with *Face and Feather* (1979) on the far right.

Left: Roy Lichtenstein's study for his painting *As I Opened Fire*, 1964. Pencil and crayon on paper. Three pieces, each 14.5 × 11 cm. © Estate of Roy Lichtenstein.

.

Right: Lichtenstein stretching in his studio, a converted garage, at his home on Gin Lane in Southampton, Long Island, 1979. Photograph by Lenore Seroka. Lenore Seroka photographs, 1977–1984. © Lenore Seroka, 2006.

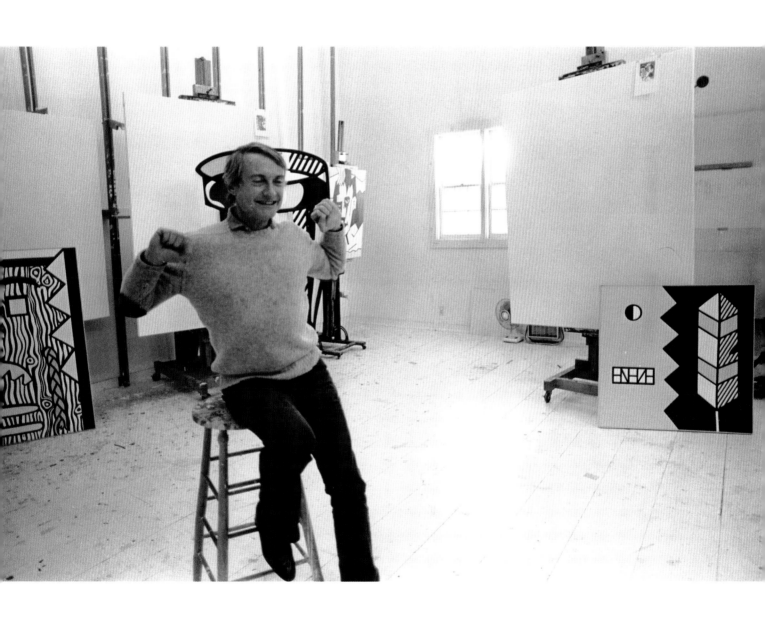

HELEN FRANKENTHALER

(B . 1 9 2 8)

After experimenting with Jackson Pollock's method of painting on the floor, Frankenthaler developed her own soak-stain technique using thinned color pigment on unprimed canvas. Her liquid layers created atmospheric veils of color and helped define a new movement—color field painting—in the 1960s.

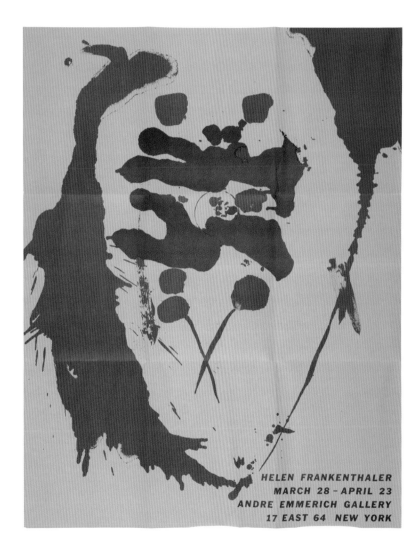

Left: Poster for the one-person exhibition *Helen Frankenthaler* at the André Emmerich Gallery, 28 March through 23 April 1960. Emmerich printed 100 copies of this poster without the text on laid vellum. The prints were individually signed and numbered by Frankenthaler and sold for $10 each. André Emmerich Gallery records and André Emmerich papers, ca. 1954–1999.

. .

Right: Helen Frankenthaler in her studio, a converted garage in Stamford, Connecticut, in 1984. She later tore it down to build a new studio. Photograph by Hans Namuth. Hans Namuth photographs and papers, 1952–ca. 1985. © 2006 Hans Namuth Estate.

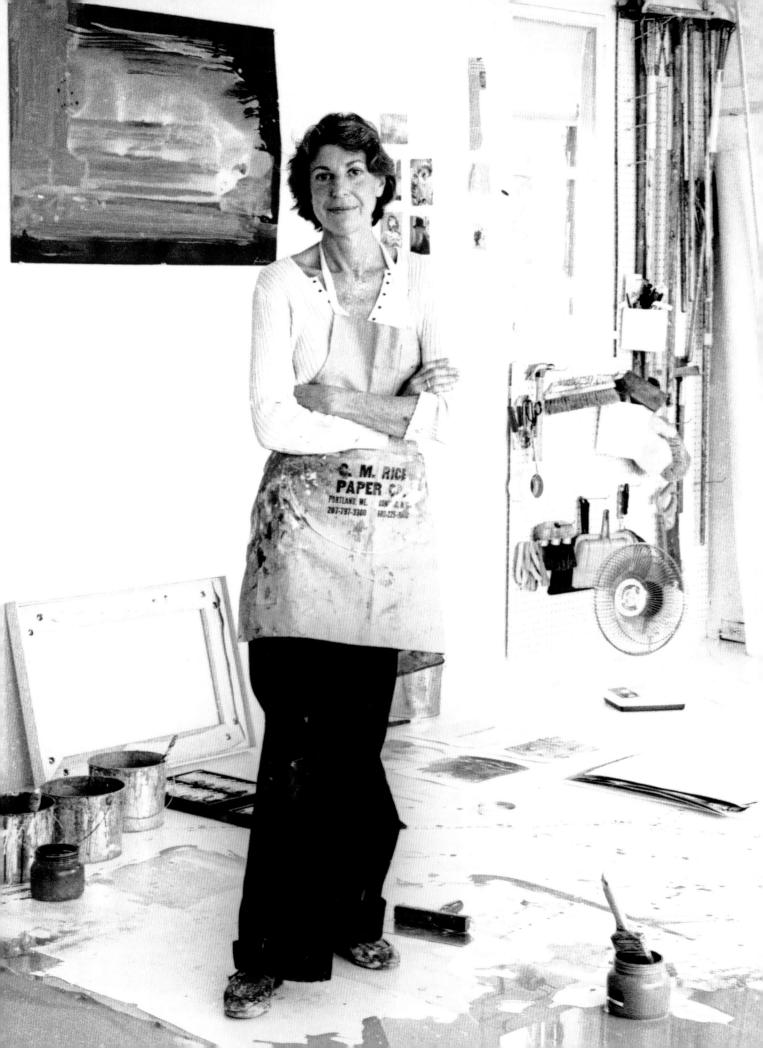

SAM FRANCIS

(1923–1994)

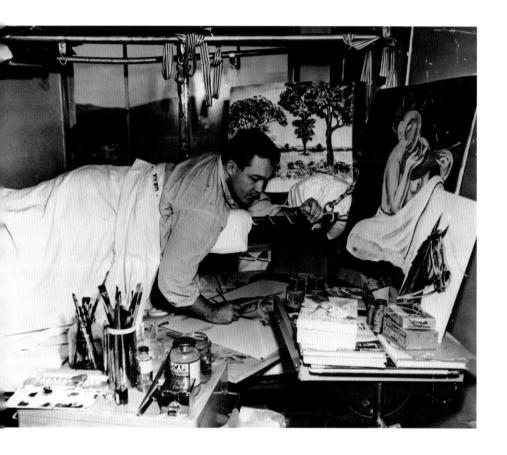

A painter and printmaker, Francis was one of America's leading abstract expressionists. He traveled the world and had studios in Santa Monica, California; New York; Paris; Tokyo; and elsewhere. In his later paintings he explored splattered areas of brilliant color against white canvas or paper.

In 1943, Francis was a student pilot in the U.S. Army Air Corps. He developed spinal tuberculosis from an injury he suffered in a training exercise. Confined to a body cast, he took up painting in an army hospital in 1944. His first studio was the arms-length area surrounding his hospital bed.

Left: Sam Francis painting at the Fitzsimmons Army Hospital in Denver, Colorado, 1944. Photographer unknown. Betty Freeman papers, 1951–1969.

Right: Sam Francis in his Venice, California, studio, November 1989. Photograph by André Emmerich. André Emmerich Gallery records and André Emmerich papers, ca. 1954–1999.

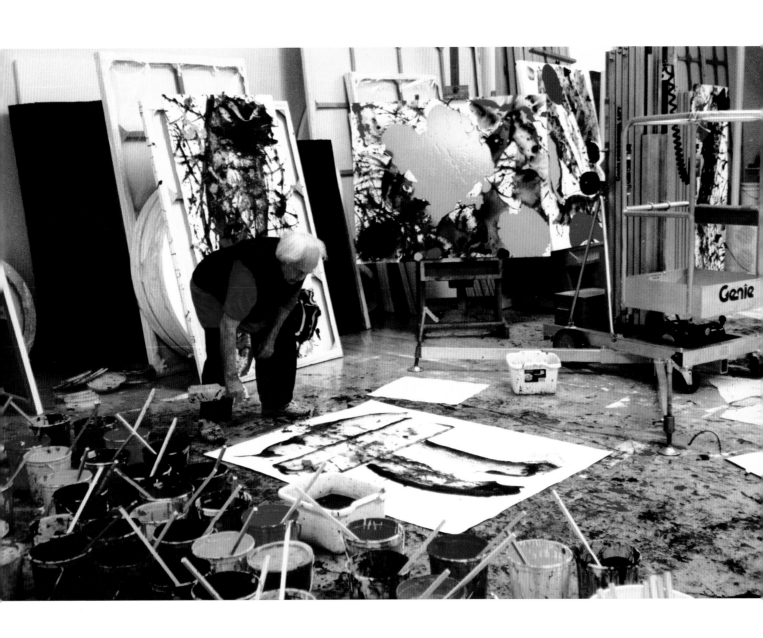

LeRoy Neiman

(B. 1927)

Originally designed as a studio building, the Hotel des Artistes in New York City has had many famous tenants: Norman Rockwell, Isadora Duncan, Noel Coward, Rudolph Valentino, and currently LeRoy Neiman. One of the world's most popular artists, he is known for his colorful and dynamic paintings of sports figures, entertainers, and other celebrities.

He is shown here working on his painting *April in Augusta* (1990), which refers to the Masters Golf Tournament in Augusta, Georgia. He got in the habit of wearing a jump suit in the studio when he was a student at the School of the Art Institute of Chicago. Neiman had stenciled his name across the back of his jump suit in 1980, so that he could be easily recognized while painting the Bing Crosby Golf Tournament at Pebble Beach, California. A celebrity himself, Neiman still has the paint-spattered suit and occasionally wears it.

Left: Wheaties cereal box with portrait of football star Roger Staubach by LeRoy Neiman, 1997. LeRoy Neiman papers, 1921–2005. © General Mills. In 1997, LeRoy Neiman teamed up with the "Breakfast of Champions" to create five box designs, each featuring a National Football League hall of famer.

.

Right: LeRoy Neiman in his studio at the Hotel des Artistes at 1 West Sixty-seventh Street, New York City, in August 1990. Photograph by Steve Friedman. LeRoy Neiman papers, 1921–2005. © Steve Friedman.

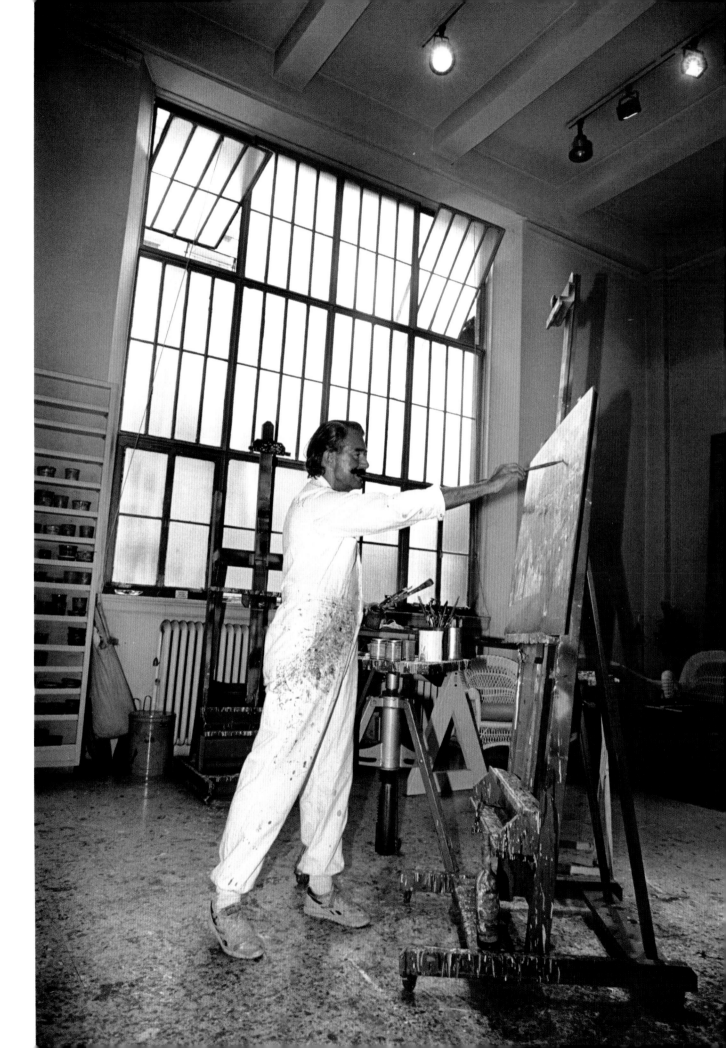

Robert Chapman Turner

(1913 – 2005)

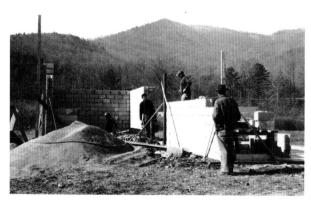

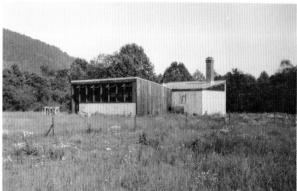

In 1949, after receiving a master's degree in industrial ceramic design from Alfred University, Robert Chapman Turner went to Black Mountain College in North Carolina, then one of the few schools in the country dedicated to educational and artistic experimentation as well as social freedom and communal living. Turner designed and helped build the pottery studio and large high-fire kiln at Black Mountain and taught there for two years before returning to Alfred Station, New York, in 1951 to set up his own studio on a 100-acre farm.

Left, from top to bottom: Building the pottery shop at Black Mountain College (Robert Chapman Turner is at the center of the photograph); the exterior of the shop; and the interior of the pottery studio at Black Mountain College, Black Mountain, North Carolina, 1949. Photographer unknown. Robert Chapman Turner papers, 1948–2003.

.

Right: Robert Chapman Turner inspects one of his pots in his studio on Cook Road in Alfred Station, New York, 1997. Photograph by John Wood and Laurie Snyder. Robert Chapman Turner papers, 1948–2003.

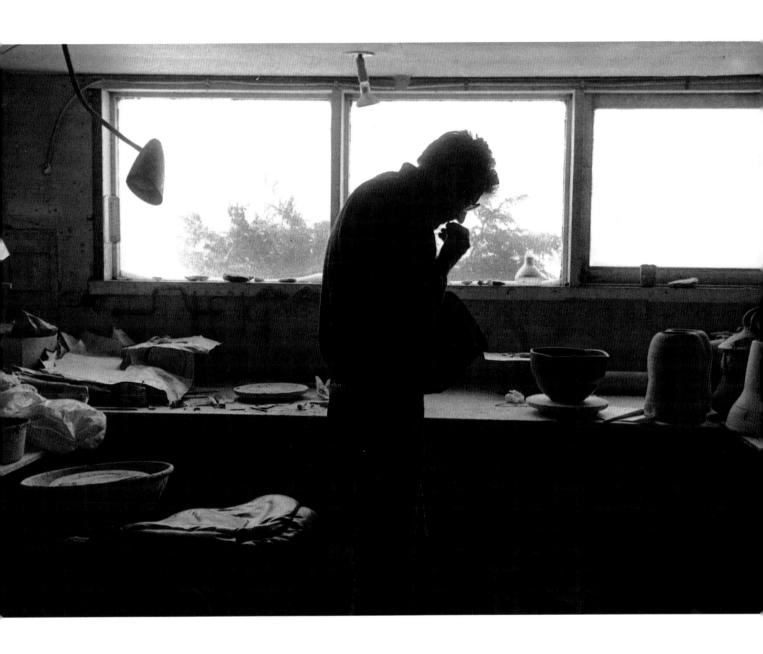

TRANSCRIPTIONS

These verbatim transcriptions preserve the exact spelling and punctuation of the original documents. The format, however, has been standardized according to the modified block style for greater clarity.

Bound volume, 85 pages, handwritten
Hiram Powers and Powers family papers, 1827–1953
Transcription of pages shown

1844 May	7.	Countess Bielinska and her Daughter Polanders	Sat for Daguerreotype likeness at their request. also allowed them to take impressions from the Slave	
		Lord Baltimore	came to my studio the other day	
		Lord Drumlandsig.	also came to see me.	
	11	Gulioni	paid him 6 francni	6
	''	Ghilli	paid him C acct. 8 franni	8
		Everett's Bust.	began it anew on the 5th	
	''	Sancholli.	wrote to him for marble	
		R & M.C.	deposited with them amt. of bill from Gourdin	
	''	''	Drew 100 francesconi	100
	''	Grazzini	Loaned me 200 francesconi at 4½ per ct. must give two months notice before returning it to her, otherwise keep it on same terms for another year.	
		Brooks	engaged a marble duplicated of Proserpine at 300 francesconi. Note* I believe I said dollar—not sure	
	13	Grant.	paid an account of 99 pauls for him	9.9
			took a receipt	
		Brooks	Told me he would advance me money whenever I might want it that he wished me to call on him for it without hesitation and by no means to make any sacrifices—The price of the bust* was stated in francesconi	
1844 May	14	Myself	Should any "mishap" render it necessary for others to attend to my affairs, I wish if possible that my three statues and the bust of Proserpine be finished by Remigio in the best of marble and exhibited in the principal cities of the United States—K will do this for me—I hope that friends ~~may~~ might be found who would be willing to advance the necessary means to accomplish all this. Also to advise my wife as to the best course to be pursued with the children—All of the models should be <u>preserved</u> <u>together</u> as they are, for they may be valuable at some future day—	
	16	Brooks left today	If I have occasion to write to him before June 10th direct to care of Messrs. Hottenguer & Co. Paris – after that time. to care of Messrs Robert Harrison & Co. No. 18 Philpot Lane. London—	
		Charles I. M. Eaton <u>Baltimore</u> James T. Waters <u>Baltimore</u>	Both wish to have Daguerreotype impressions of the Slave – Will pay for them to whomever I may direct (I must send them)	
	16	Grant's bust.	Began drapery today	
		Sloane.	lives in Cara Bouterlin via di Sarvi	
		Eaton	up to October. care of Hooper C. Eaton, No. 7 La Rue Bergère, Paris—	
		Bracebridge– Brooks–Sloane	must not fail to introduce the former to the latter—	

Everett is Edward Everett, a close friend and supporter of Powers. Sancholli is Sancholle, a marble dealer. Gourdin is Henry Gourdin, head of the committee to commission a statue of John C. Calhoun for Charleston, South Carolina. Grazzini is Signora Grazzini, from whom Powers had borrowed money in the past. Brooks is Sidney Brooks, brother-in-law of Edward Everett. Grant is Captain John Grant, a retired British Army officer. Powers made a bust of him. His first sitting was January 1844. Remigio is Romigo Peschi, Powers' marble finisher, who worked with Powers for 33 years. K is most likely painter Minor K. Kellogg (1814–1889), who managed part of the United States tour of the *Greek Slave*, beginning in 1847.

Letter, 1 page, handwritten
John Singer Sargent collection, 1883–1923

Jan. 19th
13, Tite Street,
Chelsea, S.W.

Mr. John S. Sargent sends to Mr. Alden
a photograph of himself, as requested by
Mr. Henry James for the purposes of his
article in Harper's Magazine.

Henry James's article, "John S. Sargent," appeared
in *Harper's Magazine* (October 1887): 683-91.

- - - - - - - - - -

J. J. ABERT TO GEORGE PETER
ALEXANDER HEALY, 30 MAY 1842

Letter, 1 page, handwritten
Research material on George Peter
Alexander Healy, 1811–1966

Washington May 30th 1842
Mr. Healy

Dear Sir,

Anxious to avail ourselves of your
present visit to our City and of your
eminence as an artist, I am authorized
by many subscribers, members of the
Institution, to request that you will
take for the gallery of the National
Institution, the portrait of the President
of the United Sates, and of the
Honorable Mr. Preston of the Senate.
You will please to wait on these
Gentlemen, and arrange with them,
about time and place of sitting.

Believe me to be Sir
Very respectfully
Your ob^{t.} Serv^{t.}
J. J. Abert
Col`Corps T.Eng^{rs} [Colonel Corps
Topographical Engineers]

- - - - - - - - - -

WALTER GAY TO MATILDA
TRAVERS, 1 MARCH 1889

Letter, 4 pages, handwritten
Walter Gay papers, 1870–1980

18 Rue d'Armaillé
March 1, 89

My dear Matilda

I have waited in vain for a letter from
you today. Every time the Facteur comes,
I have met him with a beating heart, only
to be disappointed.

 If you only knew how I depend upon
this letter from Nice. It is the only respite
I have, during the live long day, from
my troubles. I am unhappy the whole day,
until I get your letter, and then everything
is smiling.

 I am so much a prisoner here, shut up
in my studio, with nothing but memories
to live upon. Even one day without hear-
ing from you, is misery. Have I said
anything to offend you, in my wretched
scrawls, or anything which you haven't
quite understood?

 Really, you know me well enough
now, to know that if I have, it hasn't been
intentional, the Lord knows.

———————

Your letter of Feb. 27 has just arrived.
Pardon the above complaints. It is all
right again, and I am so happy! How far
we are apart though. You speak of my
London letters still, & your letter was
written three days ago. All that I have
written since was not received at the time
you mailed your letter.

 There is no question about it, we
cannot be separated again. I couldn't bear
it, & I don't believe you could. It is a
terrible trial, & for what use.

 Just as I have won you, to have you
torn away from me. If you only knew
how I want you, my darling, my darling!
You will know when we are together and
I can prove it.

 The telegram from your sister Susan
was charming. I have kept it, with the very
precious things in the little pocket book
that belonged to my family. Mr Wm. Dana
has just called to congratulate me in per-
son. I am to dine there, on Sunday, to tell
them all about it.

 Many people think we would avoid
trouble in the wedding by going to
London, but of that we can tell nothing
until we meet. I dare say the Minister
would be able to do wonders for us here.

 I have got a copy of the French law of
Marriage and Conflict of Laws therefrom
by Edmond Kelly [New York: Baker,
Voorhis, 1885]. It is complicated, but I dare
say, the Minister could smooth it over.

Yours affectionately,
Walter

[P.S.] I am glad DeCourcy Forbes
approves of me. I hardly know him, but
I know his family.

Wm. Dana is painter William Parsons Winchester
Dana (1833–1927). DeCourcy Forbes is Henry
DeCourcy Forbes.

- - - - - - - - - -

HENRY OSSAWA TANNER TO
EUNICE TIETJENS, 25 MAY 1914

Draft letter, 3 pages (incomplete), handwritten
Henry Ossawa Tanner papers, 1850–1978

May 25 –
1914

Dear Mrs. Tietjens –

Your good note & very appriciative article
to hand I have read it & except it is more
than I deserve, it is exceptionally good.
What you say, is what I am trying to do, &
in a smaller way doing. (I hope.)

 The only thing I take exception to is the
inference given in your last paragraph—&
while I know it is the dictum in the States,
it is not any more true for that reason—

 You say "In his personal life Mr. T. has
had many things to contend with. Ill
health, poverty, race prejudice, always
strong against a negro"—Now am I a
Negro.? Does not the ¾ of English blood in
my veins—which when it flowed in "pure"
Anglo-Saxon veins & which has done in
the past, effective & distinguished work in
the U.S.—does not this count for any
thing? Does the ¼ or ⅛ of "pure" Negro
blood in my veins count for all? I believe it
(the Negro blood) counts & counts to my
advantage—though it has caused me at
times a life of great humliation & sorrow—
unlimited "kicks" & "cuffs" but that is the
source of all my talents. (if I have any). I do
not believe, any more than I believe it all
comes from my English ancestors.

I suppose according to the distorted way
things are seen in the States my ~~curly~~
blond curly headed little boy would also
be a "negro"

 True—this condition has driven me
out of the country but still the best friends
I have are "white" Americans & while I
cannot sing our National Hyme, "Land of
Liberty" etc. etc. still deep down in my
heart I love it. & am some times very sad
that I cannot live where my heart is. You
know many of us have still animal qualities

strongly developed I had a chicken yard once with 20 or 30 hens & cocks. when we bought a new hen she was chased around the yard & abused for 3 or 4 days, & then finally taken in the circle & herself became a tormentor to all new comers. One day I thought I would buy a turkey or two – now certainly a turkey is as worthy a bird as a chicken, but, no—my 30 chickens refused to divide the yard with turkeys— They were chased from corner to corner & back again, not for a week, but for months, finally one became ill & refused to eat & to end their torture I gave them away.

Please dont imagine, that any of this criticism of American ways applies <u>in the least</u>, to you or yours. <u>It absolutely does not</u> & there are many others also. But the last paragraph made me want to tell you what I think of myself – that I am glad I am what I am. for the same reason that a Swede hates to be called a Norwegian, ~~a Southerner to be called~~ & Danes to be called a Swede, a Scotchman to be called an Englishman & etc—He is no better than the other, but sometimes he thinks he is as my chickens thought the earth was made for chickens & not for turkeys—Of course I shall not write Mr. Lane but, should the article be accepted if you would recommend that your

[page missing]

"It might be like what happened when my Lazarus" was bought by the French Government. It was telegraphed to the States "A Negro sells picture to French Government." Now a paper in Baltimore wanted a photo of this "Negro" of course they had none, so out they go & photograph the first dock hand they came across & it looked like maybe some of my distant ancestors when they were come from Africa.

- - - - - - - - - - - - - - - - - -

HERBERT HASELTINE TO
MARTIN BIRNBAUM, UNDATED

Letter, 2 pages, handwritten
Martin Birnbaum papers, 1862–1970

4 RUE DU DR. BLANCHE
PARIS XVI^E
TELEPHONE AUTEUIL 40•03
TELGRAMS HASELTINE PARIS 53.

[Afterthoughts at top of letter:]
Did I ever send you photographs of the bronze equestrian monument? I sent you some of the plaster?

My dear Birnbaum

I really feel very much ashamed of myself for not having answered your kind letter before—I have no excuse except that I haven't written to anyone—the financial depression, I suppose has got me at last—People come to my studio, admire and admire but don't buy—not their fault of course but it cannot be helped—For the present I do not intend moving as the roof over my empty head does not cost anything and I have a few francs left to eat! My accident has taken it out of me and I should have liked to have gone to Bad Gastein [Austria] for a cure but I cannot afford it. Do you think it would be wise (or unwise) to write to T Cochran and offer him the Hereford bull he liked so much for ½ or a ⅓ of the price? What about the Brooklyn Museum and the Stone Indian Bullocks they have? Would it be good policy to suggest their buying them? Give me some advice—Again all my apologies for not writing before—Yours in poverty

H.H.

T Cochran is Thomas Cochran, founder of the Addison Gallery of American Art in Andover, Massachusetts. While there were three sculptures by Haseltine included in Thomas Cochran's founding collection, the Hereford bull was not one of them.

- - - - - - - - - - - - - - - - - -

ALLEN TUPPER TRUE TO
HIS MOTHER, 5 SEPTEMBER [1904]

Letter, 5 pages, handwritten
Allen Tupper True and True family papers,
1841–1987

Monday Sept. 5th

My Dear Mother,

First I want to say how proud I am of the way Jamie stuck the summer and of the letters he writes too. They are <u>bully</u> and I took a great pleasure in showing them to my roommates. It is good news to hear that he will go to DU in the Fall and I hope with his extra six inches and the grit that he used to have he can make the football team. I'm banking on it.

Margaret and Harry are probably both on their ways by now and I am feeling better already to know that Mag is not accross the whole country from me. The dirth of all kinds of letters helps me to suspect that you are all busy.

And Hazel Married! That's the stuff even if they did precipitate things somewhat.

There is a very fine young fellow coming to room with Green and I next week and he has been up here enough already to let me know how much I shall like him. He is one of the first fellows I have met in the East who does not drink smoke or play cards. Saturday afternoon I went down the state to Middletown— his home—with him to enjoy a house party his sister was giving. They are fine people and <u>Live</u> all for the sister. Only got about ten hours sleep since last Friday but just the same I did one of the best days work to day that I have done since I began this series.

The cuffs came all right and are very fine ones. Let those people know that I shall pay for the puncher costumes if necessary but to make them good and a bit complete.

I shall probably be at night work very soon if I am to get out the two more pictures, I have still undone, by the 10th· Haven't seen the Doc yet as he is out of town but shall do so soon.

Saw a fine book for Harry to read.— "Irrigation Institutions" by Elwood Mead—MacMillan Pub. Being a "Discussion of Economic and legal questions created by the growth of Irrigated Agriculture in the West. Mead is a Gov't official & Harry should see the book.

One more favor. Wyeth is coming out to the West (Colo) to study cowboy and Indian life for a month. Can Mrs. Church give him a job on the K◊ ranch or can you help him to a place where he could see the puncher life of N.W. Colo. or Wyoming? When are the round ups & Indian dances? Wyeth expects to start soon and is the kind of fellow one wants to help—self-made & reliant— Well Goodnight Mother,

Love to all,
Allen

"Rush Work" excuses a lot of fussing "regrets" and its <u>fine</u>!

Wyeth is painter and illustrator N. C. Wyeth (1882–1945). Wyeth and True were classmates at the Howard Pyle School of Art.

- - - - - - - - - - - - - - - - - -

Contract, 3 pages, typescript
Adolph A. Weinman papers, 1890–1959

THIS AGREEMENT for the erection of a monument of Abraham Lincoln, made in the year one thousand, nine hundred and seven by and between Adolph A. Weinman of 97-Sixth Avenue, New York City, party of the first part (thereinafter called the sculptor): and the KENTUCKY TABLET COMMISSION of the State of Kentucky, party of the second part (hereinafter called the Commission), w i t n e s s e t h :–

That the parties hereto in consideration of the payment hereinafter provided to be made and for the faithful fulfillment of the reciprocal promises and agreements hereinafter contained, mutuall agree as follows:–

THAT the sculptor doth herby for himself, his heirs, executors and administrators, covenant, promise, and agree to and with the Commission and their successors, that he shall and will complete, and finish in every respect a Memorial to Abraham Lincoln, consisting of a Statue in bronze of the said Lincoln with a pedestal of granite and marble set complete on proper foundations on a plot in the town of Hodgenville, Larue County, Kentucky, hereinafter designated by the Commission, and in accordance with a model submitted by the sculptor and approved by the Commission;

That any approaches, grass plots, grading, etc., adjacent to the Memorial will be executed by the Commission in accordance with the drawings provided therefor by the sculptor:

That the sculptor shall and will find and provide such good, proper and sufficient materials and labor of all kinds, whatsoever, as shall be proper and sufficient for the completion and finishing of the said Memorial to the entire satisfaction of the COMMISSION for the sum of ~~fourteen~~ thirteen thousand dollars to be paid as follows:–

1. The first payment of one thousand three hundred ($1300) dollars shall be paid by the Commission to the sculptor immediately upon the signing of this agreement. This sum to be regarded as a retainer and, compensation for time and labor involved in producing the design, and is not to be forfeited under any circumstances by the sculptor.

2. The second payment of two thousand six hundred ($2600) dollars to be paid by the Commission to the sculptor when the working model of the statue shall have been completed and approved by the Commission.

3. The third payment of three thousand two hundred and fifty dollars shall be paid by the Commission to the sculptor when the full size model of the statue shall have been completed in clay, ready to be cast in plaster and in all respects satisfactory to the Commission.

4. The fourth payment of three thousand two hundred and fifty dollars shall be paid by the Commission to the sculptor when the statue shall be cast in bronze and approved and accepted by the Commission.

5. The fifth and final payment of two thousand six hundred dollars shall be paid by the Commission to the sculptor when the statue in bronze and the pedestal are completed by the sculptor and in place to the entire satisfaction of and in all particulars acceptable and accepted by, the Commission.

That the sculptor shall at his own proper cost and expense provide all manner of materials and labor, implements, models, and cartage of every description for the performance of this contract.

In case of dissent by either party hereto the subject of such dissension shall be referred to three (3) disinterested arbitrators one to be appointed by each of the parties to this agreement, and the third by the two thus chosen: the decision of any two of whom shall be final and binding; and each of the parties hereto shall pay one half of the expenses of such reference.

That the work under this contract shall be begun, without delay, on the signing of this agreement and be carried on as rapidly as possible to completion, and said memorial shall be wholly completed and erected to the entire satisfaction of the Commission on or before February, 10" 1909.

Witness our hands this the 19" day of Sept., 1909.
[signed] Adolph A. Weinman
Party of the first part.

By [signed] Robt Elielaw
Chairman and Treasurer of the Commission

By [signed] Jon B. Nall
Secretary.

[signed] Richard Lloyd Jones
[signed] Chas. J. Hubbard
[signed] Chas. C. Beard

. .

Letter, 1 page, typescript
Janet De Coux papers, 1927–1998

"ELEVEN O'CLOCK ROADS"
WESTPORT, CONN.

December 17, 1940

Dear Janet;

I am a funny sort of a guy not to have written at once to thank you and your family for being so nice as to give me dinner and such a pleasant evening! But, my thanks, though late, are very much from the heart.

Seeing your studio and its grand light and very good proportions makes me feel like building one like it here. I particularly like the fact that you had only a few things in it. You really can see and walk around each piece.

Your light seems to me perfect. Some day, you must make your little leanto shed permanently enclosed, so that you can keep the things you are not working on outside. That is what I would like to do, anyway, if I had it.

I suppose by this time, your little stone figure must be nearly complete. I think it is a fine piece of work, and should be much appreciated. You probably will go in the Pittsburgh Museum. I just heard from Homer Saint Gaudens, asking for something, but I have nothing particularly prepared to send.

We are hoping to see you around Christmas time. You must try out your new road, it should bring you here in no time. Laura sends her best to you, and we all hope you will be able to make it at Christmas time.

Thanks again to you all,

Faithfully
[signed] J. Fraser

. .

1 page, typed, annotated typescript
Nickolas Muray papers, 1911–1978

GARBO

Very late decolte Eve dress
assigned stage not in use
Set construction going on.
couldn't find evening dress
to get bare shoulders, she
slipped off blouse—
all noise stopped
Howard Strickling yelled
for drape

. .

WILLIAM ZORACH TO
DAHLOV IPCAR, 5 FEBRUARY 1949

Letter, 2 pages, handwritten
Dahlov Ipcar papers, 1906–1997

Sat Feb 5 '49

Dear Dahlov—

The Madamoiselle article & picture was
fine—dignified & diplomatic. Keep up
the good work—you positively look
ethereal—& about 18 years old too
young to have two large boys—

 Let us know what fan mail if any.
Articles like that sell books—Lets hope
pictures too—I got about $1,500.00
Royalties on my book for 1938—So I
suppose they sold 2,000 books which
is OK by me but not very many it seems
to me in view of the publicity & adver-
tisers—Life gave me $10,000.00 worth
of publicity at least thats what they
could have received for the space if they
sold it for advertisement and Im sure 3
or 4 thousand was spent by the pub-
lisher. Shows how little interest there is
in Sculpture—I should have stuck to
painting—Im discusted with the
trend—I told Marguerite I should adver-
tise—this idea—

ABSTRACT AND NONE
OBJECTIVE—SCULPTURE
TAUGHT. IN 6 EASY—
LESSONS—RESULTS
GUARENTEED ORIT'S
YOUR OWN FAULT
COURSE OF 6 LESSONS
$100.00 NO REFUNDS
WM ZORACH

I bet I'd get a flock of morons that would
be perfectly willing & could I show
them!—How!—It would be a switch.
Well that nut who bought 30 watercolors
& 1 piece of sculpture—for $11,000.00
Reniged Edith Halpert sewed him up for
seven watercolors for $2,100.00. He took
one home wrote me a perfectly sane let-
ter—said he would pay 500 down & 300
a month—But has not paid anything
yet. He told Edith he would put
$100,000.00 in her business & she said
she told him to pay for the watercolors
first—lots of love

Dad—

P.S. Marguerite has a cold—we went to
Max Webers opening at the Whitney
everybody that's nobody was there—
mostly artists–

The *Mademoiselle* article is "Going Places at
Home," by Vivian C. Cadden (February 1949). It
included a photograph of Zorach's daughter
Dahlov Ipcar. According to Ipcar, the date 1938 is a
mistake; her father meant to write 1948 when he
refers to the royalties for his book *Zorach explains
sculpture, what it means and how it is made*,
published in 1947. Marguerite is Zorach's wife and
Ipcar's mother. Edith Halpert, owner of The
Downtown Gallery, is Zorach's dealer. The Max
Weber opening that the Zorachs attended for
Weber's retrospective exhibition was held at the
Whitney Museum of American Art, New York,
5 February to 27 March, 1949.

. .

DENNIS MILLER BUNKER TO
ELEANOR HARDY, 1890

Letter, 8 pages, handwritten
Dennis Miller Bunker papers, 1882–1943

My darling Nell,

Instead of no letter Friday, I got two and
it was lovely. I thought at first I would be
very wise and keep one to read in the
evening and after much debate as to
which one to keep—I couldn't make up
my mind and I finally read them both
together. Dear old Nell I do love you so
much and I love so to read your letters—
I have been passing a perfectly useless
day—my models' grandmother with
that lack of style that distinguishes such
people has taken this opportunity to
die and so my model won't be able to
work before next Thursday, which leaves
me unprovided for Monday Tuesday
and Wednesday. You don't know [how]

disgusting it is to be dependent on such
people. This afternoon I've been looking
at a studio that I think very strongly
of taking for next winter—but I've put
off deciding until you come on for the
wedding and then we'll go up and look
at it. A friend of mine has it now—
Mr. Reginald Coxe. I think all things
considered it [is] about the best and
cheapest thing for us I've yet seen. It is in
the Sherwood studio building on the
corner of 57th St. and 6th Ave. on the
fourth floor. (there is an elevator) and
the studio has an excellent side light.
The plan of the thing is like this [draw-
ing]. It would be just the place for us.
I think the rooms are just what we need.
Everything is all together as you see. A
good studio—and in the bedroom a jolly
big bath-tub—The rent is sixty-five
dollars a month—a lot of money for us
to pay but I think the cheapest we can
do. The only thing is that I will have
to rent it from the first of May when
Coxe goes out and pay for it all summer
long when he's not using it—but that
would be the same in any summer.
However when you come we'll go look
at it and decide together what is to be
done. We would be awfully happy there
though, and would not have to go out-
side the door if we didn't want to. I think
you'll like it tremendously. I don't like
the crowd of painters who inhabit that
quarter of the globe, Beckwith and so
forth, tho' I suppose there'd be no need
of seeing them. There is a very good
restaurant in the house.

 There's a jolly great big bedstead
there with four tall posts that would be
the very thing for you and me, and a
few other things that Coxe wants to
store or that we could hire of him that
would be uncommonly useful. It made
me laugh to look around and see how
snug you'd be in there—trotting around
from room to room and feeling very
important over your "apartements" and
I tried to imagine your golden head and
your sweet little face making the place
gay. I think it's the place for us—and we
won't have to decide until you come
on—then when we take it—if you like
it—the only thing is to get married as
soon as we can and go and live in it.
Coxe and Rice are both à sec as it were
and have got to go to the country—to
live for a while until they get some cash.
It's a wild life! I was out at Garden City

yesterday and everyone was much delighted and excited over your present of plates—they seem to me very charming—what a magnificent person you are—I've just been ruining myself for them too—by buying a small dressing table for Jack. I spent 30 dollars for it and ought to be thanked—it was all I could get though. Everything costs such an infernal lot of money—there seems to be nothing but that out of one's mind all the time—how to get some more money—I'm awfully tired of it all—Darling I want to see you so much—my precious Nell—I think and dream of you and of our love—and it makes me forget all the horrid things and the struggle and fight. My sweet I kiss you a thousand times and will you please kiss some little places for me tomorrow night—please—

Dennis

Beckwith is painter J. Carroll Beckwith (1852–1917). Beckwith was the doyen of the Sherwood Studio Building. John W. Sherwood, the proprietor of the building, was Beckwith's great-uncle; Rice is painter William Morton Jackson Rice (1854–1922).

Painter Reginald Coxe (1855–1927) lived in the Sherwood Studio Building from 1886 to 1891 and again from 1893 to 1894. The Bunkers did not take Coxe's studio as planned, but another smaller studio in the building.

. .

LORRAINE MAYNARD, "33 W. 67TH STREET STUDIO" VERSE, CA. 1910

1 page, annotated typescript
Richard Field Maynard papers, 1895–1979

East Side is east; West Side is west;
And ne'er the twain shall meet;
Save when they come together on
Old Sixty-Seventh Street.
We don't pretend we're swanky
Nor even very neat,
Yet there's a certain oomph about
Old Sixty-Seventh Street.

We have a livery stable,
It's called a "Riding Club,"
And 'cross the street at Number one
A restaurant and pub,
A place where H.C. Christy
Drew ladies in the nude
I don't advice your going there
In case you are a prude.

We also have a laundry
To wash your little shirts;
A drug store on the corner
With things to cure your hurts.
A tailor shop to make your cloths
Or just to press your pants,
And several of the buildings
Have places for the Dance.

Bessie Potter Vonnoh
Will mold your little head
So we can talk about you
Long after you are dead.
Or if you do not like the face
Bequeathed you by your mother,
Just see our Mr. Benda,
And get yourself another.
Who'll help you get another [handwritten]

You cannot get too deep for us,
E'en in the deep blue sea,
For we can go a half-mile down
With Dr. Willie B.
But we prefer to scale the heights,
And when we leave for Heaven,
We hope we'll make the take-off
From good old Sixty-Seven.

(Verse by Lorraine (Mrs. Richard F.) Maynard of 33 W. 67th St.—Might have been written for a big party in the studio.)

Sculptor
Bessie Potter Vonnoh
N.B. lived on 12 mezz.
at 33.
"Dr. Willie B" =
Wm. Beebe
undersea explorer.
W. Benda made masks
in #27

. .

CHARLES KECK, NOTES FOR A DINNER PARTY, 23 FEBRUARY 1933

1 page, handwritten
Charles Keck papers, 1905–1954

Dinner- February 23, 1933.

Studio- 40 W. 10 St.
 Table Cloths—Blue & white check paper.
 Napkins—Red and white check linen.
 Flowers—White narcissus—mignonette—sweet peas—freesia—anemones—asparagus fern in Red and white scheme.

Centre piece—Red paper boat "Good Cheer" with golden sail filled with white sweet peas—fern and anemone.

Menu:
 Cocktails and appetizers.
 Clear soup.
 Steaks.
 Noodles with mushroom sauce
 Peas and carrots
 Italian white & whole wheat bread-bread sticks
 Spumoni
 Coffee
 Steins of beer

Entertainment—Mr. Walsh—violin
 Mr. Kelly—song
 Two pianists
 Theo Alban, Tenor

Guests—Hon. Wm. J. Egan
 Hon. Edw. J. Quigley
 Col. Hugh Kelly
 Col. Wm. Freiday
 Mr. James W. Costello
 Mr. Charles Edison
 Mr. Arthur Walsh
 Mr. B. J. Cummings
 Mr. John B. Peterkin
 Mr. Bob Crowder
 Mr. John J. Raskob
 Mr. Schuyler Knox
 Mr. Dan McAllister
 Mr. Robt. W. Maloney
 Mr. Camillus Christian
 Mr. Carlos Fetterolf
 Dr. Raymond P. Sullivan
 Mr. Con Dykeman, Jr.
 Mr. Barrett Bowne
 Mr. Mark Fenderson

. .

JOHN SLOAN TO WALTER PACH, 9 JUNE 1920

Letter, 2 pages, handwritten, illustrated
Walter Pach papers, 1883–1980

[Notations on artist's drawing:]

 big moths very common

 "you want me pose?"

105 Johnson St
Santa Fe N.M.
June 9–1920

Dear Pach—
Well! here we are again in the old town—

it looks just the same we feel the altitude more this year than last I suppose because we climbed more slowly by automobile last year We took three days to get here and were delayed 5 miles east of Lamy for 3 hoursvery provoking, for we would have arrived on the dot of schedule time if a freight wreck in Apache canyon had not occurred ahead of us.

Dr. Hewett I have seen just once for a few minutes—he seemed glad to welcome me back

We walked out to the "Casa de [Randall] Davey" last Sunday—He is going to have a beautiful place when his alterations are completed They're well under way. He has three horses one a piece for self wife & boy—Three miles up the Santa Fe Canyon—wants me to buy a place near him $900 is the price but I guess I wont indulge myself in real estate purchases.

I have started painting nearly a week went by before I felt ready— a Corpus Christi procession through the roads and over the bridge Sunday— gave me a theme.

By the way I got in to the Metropolitan Anniversary Ex before I left N.Y. and Thank you for reminding me of its importance I enjoyed the special additions very much. Suppose you read Coomaraswami's article in the Dial "Art & Craftsmanship" I thought it very concise and true didnt you?

I hope that Raymond is quite well by now remember us both to Mrs Pach and if you have some time to kill drop us a line—we feel far away out here. Regards to "Bayley" if you see him. Good luck and good health to you.

Yours sincerely
John Sloan

Dr. Hewett is Edgar L. Hewett, the founder of the New Mexico Museum. The article Sloan mentions is by Ananda Coomaraswamy: "Art and Craftsmanship," *Dial*, 68 (June 1920): 744-6. Raymond is Pach's son, born in 1914.

GERARD MALANGA, POETRY READING ANNOUNCEMENT, DECEMBER 16 [POSTMARKED 1964]

1 page, photocopy, addressed to
David Bourdon
David Bourdon papers, 1953–1998

Poem Visuals by Andy Warhol and Gerard Malanga [drawing of a snake] The New Realism, Yeah Yeah, Fashion, and Disaster series read by Gerard Malanga [three stars] Introduced by Ivan Karp Wed. Dec 16th 3:15 P.M. Leo Castelli Gallery 4E. 77th St, Free

FRANCIS DAVIS MILLET TO AUGUSTO FLORIANO JACCACI, 22 MAY [1908]

Letter, 2 pages, handwritten
August Jaccaci papers, 1903–1914

Washington
May 22

Dear Joe,

Almost every life of Fulton has a reproduction of a portrait and there are some excellent ones. I packed up all my material about the Clermont etc. sometime ago but I will dig it out again and tell you when I come to N.Y. next week more about the portraits. I am just finishing today the Baltimore work (vicariously) having sent two men to Baltimore to tone down one or two details.

The governors conference here last week was most interesting and a powerful lot of interesting things are going on. How about the new or the proposed new Art Commission here? Have you heard anything about it. The report is that Mr. Parsons is slated as a substitute for Olmsted.

Yours faithfully
F. D. M.

Fulton is inventor Robert Fulton (1765–1815). The Clermont or the North River Steamer was Fulton's first steamboat. Mr. Parsons is Samuel Parsons, Jr. (1844–1923), landscape architect for the New York City Department of Parks. Olmsted is Frederick Law Olmsted (1822–1903), the founder of American landscape architecture.

HARRIET BLACKSTONE, NOTEBOOK, 1912

Bound volume, 25 pages, handwritten
Harriet Blackstone papers, 1864–1984
Transcription of pages shown

[William Merritt] Chase—
Don't try to finish anything
Paint spots here and there
as you see them. It will carry steady along
Play with it.
Enjoy putting spots of color down. Don't be afraid. If you find yourself
niggling make a bold dash at the
canvas—Don't be afraid of it
Never let doubt creep in.
Paint raggedly.
Keep plane of face & eye nearly the same
See that plane of brow shows
the eyes and mouth as ornamentations
Paint in spots of color of eyes & mouth
& then trim to shape—it makes
things softer—truer—as if they
were a part of the whole.

Note how Rembrandt painted edges. Difference in "nearly edges" like rounding of nose—face etc. to the round edges— such as ribbon edges lapel edges etc.

GRANT WOOD TO ZENOBIA B. NESS, 28 OCTOBER 1930

Letter, 4 pages, handwritten
Grant Wood papers, 1930–1983

Cedar Rapids Ia. Oct 28–1930

[exclamation surrounded by hand-drawn squiggly box:]

Hurray!

Two paintings of mine in the American Show – "Stone City" and "American Gothic"!

Two is the maximum and only a few make it each year

I am having photos of the two made in the Art Institute and will get them when I go in next week. Intend to have newspaper matrixes made of the best photo and have an article written about it by a professional press agent I know in Chicago. In it the credit for my luck will be put just where it belongs—much you and the State Fair.

Will have her (the press agent) bombard the State papers with it (especially the Des Moines Register and the Davenport, where they are holding the "All Iowa" show) If I discover that other Iowa people got in I will, of course, have them played up, too, in the write up. Am holding off on the Corey

letter till this is published so that I can include a clipping.

Am enclosing a page torn from the Art section of the Chicago post which includes a write up of the Colorado State Fair awards. If they get mentioned, why cant we? I think it would be very nice for all concerned if you could get something in.

Did you know that Cedar Falls art teacher at the N.E.I.T.A. [National Excellence in Teaching Awards] convention here railroaded Ed Rowan in as head of this section—electing him over Ed Bruns who was also nominated. Rowan is not, of course, a public school art teacher and the local teachers are very indignant. We are all hoping that there is something in the constitution which will block this new move of his. If there is any-thing you can do please do it.

The Iowa Artists Club was very insistent that I send in this year—even elected me to an active membership without my having sent them any paintings. But, as long as Rowan dominates the jury again, I refused. Will enclose my letter to Miss Orwig. When you write me again please tell me the cost of getting an out-of-the-state judge to come.

Am delighted over the idea of your coming here for a visit. By all means let me know in advance.

Sincerely,
Grant Wood

.

John Storrs to Marguerite Storrs, 30 March 1930

Letter, 4 pages, handwritten
John Henry Bradley Storrs papers,
1847–1987

HOTEL BREVOORT
Fifth Avenue
AT EIGHTH STREET
NEW YORK
CABLE ADDRESS: LAFBREVORT, N.Y.

Dearest Lady, Well, this Sunday morning & beautifully sunny. I have just returned from a plate of waffles & a cup of coffee—at the same time running quickly throu the Sunday paper—all in good American style!

I spent most of Friday afternoon with Stieglitz in his new gallery. I just happened to have my photos with me which he asked to see. He was very enthusiastic & we had a fine talk. He told me that Lachaise had gotten to be impossible & that he no longer had any of his things & said that he would like to have some things of mine in his gallery!

We are going [to] talk about it again when I return to N.Y. in May.

At five I had an appointment to show my photos to Corbett the architect.

He liked all my things—said the B of Trade statue would be the finest thing of its kind & for the world's fair in Chicago he would see that I had all I could do—now that he knew that there was someone in Chicago that could do that sort of thing—the sort of thing he would like to see done! We talked for a long time about the future of American arch.

At seven, I had Dudensing for dinner at the Salmagundi Club—just one block from here & where I am an affiliated member (very old hat). Afterwards he came to my room & I showed him my photos & silver points & we talked American painting till after one o'clock. He wants very much togive me a one man show & a show of silver points any time I like—but I made no promises. He is a very nice boybut surprising poor taste as a dealer.

Saturday morning I stoped in to see Cunningham at Knoedlers—very sweet—asked me to lunch—showed me all the new French things they have.

Afterwards had a charming hour or so with Miss Green of Rhineharts's & then went to see Germaine Carpenter who is now the secretary of the new Modern Museum. She also was very sweet & introduced me to the director of the museum. He seemed very well acquainted with my work & asked to see my photos some day next week. He now has a large show out of Miole [wooden African masks] & the modern German sculptor. After looking it over I felt that my things could make just as important a showing & perhaps even more alive.

At one—had lunch alone with B[illegible]. I took the occasion to talk to him about himself (about his health & his moral attitude towards his work). He seemed very much touched and insisted I have lunch again with him next week—He has a charm for me that is hard to explain.

Afterwards I visited some shows—called on Mrs. Porter & "Crowny"—both out—& walked down to see the new Crysler Blg. & others in that section.

At seven Mlle de la Chas[illegible] came to dinner—took her to a small place on 8th St. & to the movies.

It is understood for Nov. 15th she is going to write you.

Going to lunch now at the club then to the Metropolitan & dinner with MacMonnies. So long—my love—you see I am pretty busy—but still find time to think of you and M[illegible]—love to Philis—John. 30-3-30

Dearest Lady is Storrs's wife, Marguerite. Stieglitz is American photographer Alfred Stieglitz (1864–1946); his gallery in 1930 was An American Place on the 17th floor of 509 Madison Avenue. Stieglitz was one of the first art dealers to introduce European and American avant-garde art to the American public. Lachaise is Gaston Lachaise (1882–1935), a French-born American sculptor. Corbett is Harvey Wiley Corbett (1873–1954), an influential designer of sky-scrapers in New York. The B of Trade statue is Storrs's 31-foot-high aluminum statue *Ceres*, 1929, for the top of the Chicago Board of Trade Building. Dudensing is Valentine Dudensing, owner of the Valentine Gallery in New York. Cunningham is John Cunningham, a dealer at Knoedler's Gallery in New York. "Crowny" is Frank Crowninshield, editor of *Vanity Fair* magazine. MacMonnies is Frederick W. MacMonnies (1863–1937), American sculptor and painter.

.

Robert Boardman Howard, statement, ca. 1953

1 page, handwritten
Robert Boardman Howard papers,
1916–1975

Pellegrini & Cudahy
American Art & Artists 1953

———————

The irresistible urge to make sculpture seems to come from sources that have always been mysterious to me.

I know only this; that I must make shapes with tools, and find a great satisfaction in overcoming the innumerable problems of materials, physics, mechanics—and realizing the idea.

[stamped]
ROBERT B. HOWARD
521 Francisco St. San Francisco

.

EUGENIE GERSHOY, "FANTASY
AND HUMOR IN SCULPTURE,"
CA. 1936

*Essay, 1 page, edited carbon copy
typescript*
Eugenie Gershoy papers, 1914–1983

FANTASY AND HUMOR
IN SCULPTURE

Generally, it may be said that all art
forms exist within two categories: one,
that art form which is concerned with a
faithful transcription of visual percep-
tions—representational art; the other
is a subjective conception made up
of lyrical expression, mystical and reli-
gious experiences—in short, an inner
emotional interpretation of the outside
world.* However, out of these two
expressions arises still another form
which combines these elements, rein-
terprets and extends them into a realm
beyond the purely objective and the
purely subjective and condenses them
into an imaginative or a caustic com-
ment creating a world at once poetical
and critical—the world of fantastic
humorous or satirical art.

All three traditions have always
existed side by side, but in certain his-
torical periods one form or another has
assumed preeminence. In primitive
times exaggeration was necessary ~~to~~
for the comprehension of rudimentary
peoples, and since the subjective sig-
nificance of their art was not obscured
by methods of expression, we ~~have~~
find a resultant form, grotesque and
distorted, that was an intensification
of life.

In classical antiquity, in Greek
sculpture for example, balance of body
and mind predominates; idealized
external forms express the harmonized
inner life. The ideal is no individual
fancy, but a rational intelligence, recre-
ating perfection from that which can
be actually seen. In contrast to this art
which defines concrete objects, there
developed in Gothic sculpture, sugges-
tive art: the Christian ideal of spiritual
purity, which removed man from the
contemplation of the material and per-
suaded him of unseen realities.

With the loss of faith and religious
fervor, there was a corresponding loss of
collective effort in art—a loss of the
united effort coming from a popular
religious movement and a more indi-
vidualized approach took shape.* And
as industrial development advanced
with the growth of invention, we mark
a more intellectual attitude toward art,
more and more a critical observance of
human action and human action in
social conditions.

Before the XVI Century, caricature
as a form of art was still bound up
with religion, confined to the presen-
tation of good and evil; after the
reformation, it became the weapon of
warring political sects.* Since then,
its main function is the expression of
revolt against subjection to authority
in every walk of life, by reducing might
and power to absurdity.

Out of the urge to destroy the
sham grandiose, the soft sentimental,
manifestations of the degenerate tradi-
tionalism of the middle XIX Century,
arose new types of art forms.* Modern
Psychology has led the sculptor and
the painter to depart even further from
the realistic and traditional forms.
*Likewise, the chaos in the economic
and social circumstances of our times
has emphasized in art the fantastics,
the satirical and the humorous.

*Today the artisti's revolt against
conditions of life at once prosaic and
sordid, jaded and over-sophisticated,
serve to free his art from rigid canons.
There results a release of the imagina-
tion towards enhanced expressional
values. In sculpture particularly, a
fantastic conception can use a sculp-
tural form that is pure, not needing to
describe organic structures. A form
released from such restrictions creates
dynamic effects. The idea is exploded
that fancies, vagaries and impressions
are not suitable to the sculptor's
medium. On the contrary, lightness
and gaiety are as much in his realm
as in the most capricious ravings of
the dadaists and sureralists, et als. Color
too, in sculpture, serves a delightful
and important means to intensify the

individual and the typical. Finally, then,
the function of fantasy and humor in
sculpture as in all other art forms, is of
prime importance today, as an echo,
varied, and universal, of our changing,
fantastic world. It takes the role of
commentator; as satire it becomes a
propaganda; as humor and fantasy it
laughs with or at human beings,—a
rapier against boredom and deceit.

By –
EUGENIE GERSHOY,
145 West 14th Street,
New York City.

.

YASUO KUNIYOSHI TO
GEORGE BIDDLE
11 DECEMBER 1941

Draft letter, 3 pages, handwritten
Yasuo Kuniyoshi papers, 1921–1993

Biddle
Dec11 – 41

Dear George—

As you probably realize, the world con-
dition as it is today, has in my particular
case, produced a very awkward and try-
ing situation

─────────────

A few short days has changed the status
in this country, although I myself have
not changed at all. Friends and art
organizations I am connected with have
gone a long way, trying to remedy this.
Artists, art executives, museums, and the
press have been contacted affirming my
loyalty to this country and its war effort.
This has been very reassuring to me.

I am also trying to straighten out this
situation with the proper local authori-
ties. This is being done now.

Could you help get me this to the
attention of your brother; I have hesi-
tated in writing him directly. A letter
or statement from him to the effect that
I am a loyal American would make it
easier for me to continue my work as a
painter and teacher.

Holiday greetings to you & your
family

.

*Letter with map, 2 pages, handwritten,
illustrated*
Ben Shahn papers, 1879–1990
© 2006 Estate of Alexander Calder/
Artists Rights Society (ARS), New York

24 Feb./49

Dear Shahn

Apparently I "decommanded" the Sobys
that evening when I met you—so I dont
know what I may have said to you. I
hope it wasnt too bad.

 In any case I would like very much to
have you come here sometime, for a
weekend, or the middle of the week,
which ever would suit you better.

 We put our guests in the attic, to
sleep, and I trust you won't mind that.

Cordially
Sandy Calder

The Sobys are James Thrall Soby (1906–1979)
and his wife, Eleanor Howland. Soby was a
writer, collector, and intermittent chair of the
department of painting and sculpture at the
Museum of Modern Art.

[map]

Washington

R. 47

1½

3½

North Woodbury

R. 6

Newtown

R. 25

Stepney

R. 59

Easton

Exit 46

Merritt Pkwy

N.Y.

2 pages, annotated typescript
Elaine and Willem de Kooning financial records, 1951–1969

Joint Return—Willem and Elaine de Kooning—1953 Siegel

INCOME

A. from sale of pictures (Janis Gallery) ✓$9632.00
 minus commission to gallery ✓3429.98
 actual income from gallery 6202.76 *

B. from service on painting jury (Chic.) $100.00 W
 articles for Art News 270.00 E
 " " New Mex. Quarterly 25.00 E
 sale of drawings from studio 66.50 E
 461.50 *

 $6202 plus 461 equals Total Income $6664.26 *

EXPENSES

 Exemptions $ 1200.00 *
 Rent for studios ✓1700.00 *
 $50 per mo. 88E. 10 St. W
 50 per mo. 132 E. 28th St. E
 500 for summer studios (Easthampton) W+E

 Charity:
 $65 American Cancer Society
 50 American Red Cross
 50 March of Dimes
 25 Cerebral Palsy
 25 Tuberculosis Society
 10 Salvation Army
 50 Heart Fund
 100 Catholic Church charities
 total: $375.00 *

 Telephone (studio and outside business calls) W+E ✓150.00
 Heat (88 E. 10th St.) W ✓320.00
 electric (88e. 10th St. and 132 E. 28th St.) W+E ✓120.00
 cleaning of the studios W+E ✓260.00
 maintenance, repair of studios ✓88.00
 total: $938.00 *

 Travel to and from N.Y.C., Chic., Montauk,
 Easthampton, Phila. in connection with
 lectures, serving on painting juries,
 interviews for articles $350.00 W
 Taxis to formal events, openings, lectures, etc. 250.00
 Telegrams 50.00
 total: $650.00 *

 Photographs of paintings for publicity
 (releases to Museum of Modern Art,
 Time Mag. Harpers Bazaar, Janis
 Gallery, etc.) newspapers, mags. $150.00 *
 Art books, magazines, prints, art club
 fees, etc. $208.00 *
 Entertainment $450.00 *

Joint Return Willem and Elaine de Kooning—page two '53 Siegal

EXPENSES

Models: Gandy Brodie $112
 Milton Resnick $96
 Giorgio Spaventa $80
 Alfred Leslie $108
 Total ✓$396.00 * W item 4

Art Materials: paint, canvas, brushes,
 stretchers, turpentine,
 linseed oil, varnish,
 paint remover, paper, charcoal,
 pastels, crayons, homosote
 boards, pads, etc. $986.00 * W item 5

Hardware: Lumber, frames, staples, nails,
 miscellaneous, $149.00 * W item 5

Capital loss – repurchase of painting
 (constitutes short sale because
 option exhibited to repurchase
 same at higher price) sold in 1944
 for $50 to John Graham. Repurchased
 1953 for $500 $450.00 * item 2

Capital loss –
 return of payment on painting
 sold elsewhere and paid for in
 taxes of that year ('52) Attic $1000.00 * item 2

 Total Expenses $8652.00 *

 Minus Income $6664.26

 Loss $1987.74

 [signed] Elaine de Kooning

· ·

HANS HOFMANN, "ABOUT MYSELF,
MY WORK, MY SCHOOL," UNDATED

Draft essay, 3 pages, handwritten
Hans Hofmann papers, ca. 1904–1978

First Concept

About myself, my work, and my
school—

I never considered myself "the
Founder" of any particular school. I
would consider it a limitation in a world
of unexhaustible creativ possibilities.—

As an artist I never have belonged to any
group. I am not a teacher in the usual
sense either. I am a painter which had to
teach for his livelyhood to assure artistic
indepence. In this function I became the
imitator and disseminator of certain cre-
ativ ideas that have contributed to the
cultural evolution of our time. My very
in most thoughts hold in my opinion
the key to many schools, past, present
and of the future.—I enjoy the wrong
reputation that I love to teach. What I
really love in the function as a teacher is

the steady contact with new possibilities
in the future—with new generation.
Because teaching is not really 1 vocation
on my part, I have made the beste ~~part~~
of it in making it the greatest pleasur for
myself by giving myself completely as an
artist and as human beeing. It explains
the success of my school. Its psychologi-
cal reasons are:

1.) I handle every student from the
beginning as the individual he really is

2.) by establishing what is in the
man his very own I cultivate his creativ
instincts and keep them alive in the spark
that must enflame his entire artistic future.

3.) As teacher I respect the smalest
talent – A pearl is a pearl great or smal A
talent is a talent great and smal – the
sume total of it makes the cultural assess-
ment of a nation:

A teacher must investigate and
clarify the mysteries of the creativ
process. This is a very hart task and con-
trary to an artistic temperament, because
it ask from him to explain the inexplan-
able. The artist works with the full
register of all his senses and need no
theories and explanations. He is con-
stantely ask to explain his work. I excuse
myself always in stating: my work as a
total represents a chain development
from work to work toward an end that
I only vaguely sense.

All creativ utterance is in its final
analysis of reflection of nature since we
are part of nature. All means of creation
have a very distinctiv Life of its own.

All that is comunicated with the help
of it to be really thru must respect the
aesthetical demands of the inherent
nature of the means.

Life is the expression of cosmic forces
as distinguished from physical forces
through which it exsist. As a living entity
nature stimulates in us the urge to create.

My own work is initiated by inner
vision in the capacity to sense the myster-
ies in nature and reveal it through the act
of creation. There is no end in both and
therefor no end in conceptional growth.
I hate to repeat myself, I hate manirism
and false styles and I detest eclecticism. I
know only one things for certain:

Art starts where construction ends.
"Only visionary experience transformed
into visionary pictorial expression will
produce a masterwork."

· ·

2 pages, handwritten
Downtown Gallery records, 1824–1974

The good picture—
No one wonders at more than the one
who created it—

Made—with an inborn instinct—
which in time begets an awareness—and
these periods of awareness are—the red
letter-days in the Creators life

Made—by an instinctive recognition
of the—Basic—The great horizontal—
the culmination of rest The great
upright—the culmination of activity—
for all things sway away from or toward
these two—A recognition of the back
bones—as it were—of movement—all
objects within the picture obeying the
magnetic pull of these back bones—

Having not—these back bones of
movement—in the mind's eye—there
can be no real creation.

Having—one goes not far astray—
pulled back by an awareness of these—

The other night—I saw the full
moon arising suspended over out City—
It gave me a—thrill—of a verity should
not our picture embrace a—thrill—
based on a life experience—"Try with
all that is within you" For—the thrill
begotten—looking at the good picture—
hearing the good piece of music—Ah—
to have had that

How vaporish the comments of most
commentators

John Marin

· ·

ROBERT MOTHERWELL TO JOSEPH
CORNELL, 18 FEBRUARY 1950

Letter, 3 pages, handwritten
Joseph Cornell papers, 1804–1986

c/o Chareau
215 E. 57
18 Feb 50

Dear Joe: For a long time I wanted to
write you about the marvelous "box"
that you made for me—but when I con-
template it, & think of the grace of your
gesture, I am moved on a much deeper
level than those for which I have words,
& irritated at my inadequacy.

I will have to make you something
wordless, though it may originate in

something verbal, perhaps un coup de
Dès [a roll of the dice]—but you know
how long it takes for a complete con-
ception to develop, I know you know
because you are the only complete artist
this country has, & it fills me with rage
to read the triviality with which your
radiant show was received. But the effect
of it on other artists was deep & perma-
nent. The past confronts the present in
your work—to the enhancement of
both—with love & perfection. I guess
what it has cost you, but work of that
felt quality could not have come easily.

Give my best regards to Robert.
Your friend & admirer
Bob M.

The red faded, can I have a sample
of the original hue? I want to make it
permanent.

Motherwell wrote to Cornell c/o Pierre Chareau,
a French architect who ran the "Free French
Canteen," a meeting place for Francophile
Americans. Robert is Cornell's brother.

· ·

Draft letter, 3 pages, handwritten
Hananiah Harari papers, 1939–1983

Jun 28, 1961

Dear Dan,

Your thoughtfulness through the years of
your exile in providing Freda and me
with the notices of your exhibitions is
enormously appreciated. It is evidence of
your loyalty and ~~kindness~~ constancy.
Thank you for remembering us and for
keeping in touch.

It was so good to see Gertrude when
she was here accompanying your show at
the Peter Deitch Gallery. She was either
shy or busy—we could not get her to
come out here for a visit with us, and I
am sorry not to have seen more of her.
Of course, I am sorry too that you are
gone so long, are not a part of our life
here. But I am sure that the life you have
chosen in Europe is congenial and con-
structive for you. The beautiful works in
your show gave ample evidence of that.
They manifested a mature integrity of
personality, a liberation of imagination,
a masterful command of means, an élan

and vitality. ~~How~~ Your love of your
work shows through, and it is obvious
you are a hard worker. I thought all
your works were of consistently high
quality—some, quite inspired—except
two or three of the large canvases.
Perhaps the scale impeded your concep-
tion. But as a whole, I was overjoyed
by your obvious mastery.

Through the years, I have been able
to pursue my own work at a ~~disappoint-
ing~~ pace that has almost unbearably tried
my patience. The problem of earning a
living, of ~~live~~ managing one's affairs in
this environment, ~~tends~~ interferes to a
monumental degree with creative possi-
bilities. Yet I have tried to hold on in
my painting—sometimes, just barely
succeeding. Now conditions are a little
better, though still beset with ~~plenty of~~
frustrations. During all this time, as
mood and views shifted in a kind of
slow-paced dialogue—reflection of my
life experience—I have alternated
between abstractions and figures. Now
I am deeply in figures, doing them in a
way I like. They are of the impatient
distortion, unadorned I hope of cliché
of means and being, sometimes funny,
elemental in concept, psychologically
involved, committed to color. But every-
thing proceeds slow, slow in the face of
inexorable and inharmonious demands.

USA has flowered in painting. The
development since your early days and
mine is amazing and exciting. ~~There
is so much good work done~~. But at
the same time an ~~ironic~~ academy has
ironically formed around a self-pro-
claimed vanguard of impulse-schmearers
and preciositeurs; we are ridden with
cliquism, great snobbish barriers have
been fixed against an ~~free-and-easy~~
unprejudiced acceptance of non-groove
work. Sensationalism and amateurism
are weeds crowding out of the quieter
flowers. I suppose much of the same
goes on where you are. Yet is seems there
are ~~ears to listen to your voice~~ eyes for
your images. You ~~seem~~ appear to flour-
ish, to judge by ~~your~~ the universal ~~habits
of~~ habitats of your work. Some day I
want to ~~listen to~~ hear your ~~recount~~
account of your European life, the why,
how, what, where, and when of it. This
would be best done in ~~a~~ European stu-
dios and cafés, but in lieu of that hope it
will someday at least be experienced
here, over some savory food and drink.

Do you know, Dan, as ~~time goes~~ my experience deepens, my admiration for ~~the~~ your significance ~~of your~~ as a soul grows larger. Underneath its self-imposed crusts of hardship, my own soul, is kin to ~~a lot like~~ yours. One of the hardships was that for a long time I ~~denied~~ succumbed to a denial of my soul, I was afraid to admire it and believe in it. I ~~saw too rea~~ was fool enough to surrender to certain 20th century ugli-nesses in politics, architecture, and philosophy. You were always steadfastly right in affirming your individualism. I now understand and revel in the revolt of fantasy and poetry, of gentleness and fun. For me you are the embodiment of true freedom. I hope that we shall be ~~and a~~ able in the sometime future ~~where we may~~ to enjoy a fruitful discourse.

Affectionately
Dick [Hananiah Harari]

. .

CLAES OLDENBURG,
STATEMENT FOR "ENVIRONMENTS,
SITUATIONS, SPACES," AT THE
MARTHA JACKSON GALLERY
MAY–JUNE 1961

4 pages, edited carbon copy typescript
Ellen Hulda Johnson papers, 1939–1980

Statement for the catalogue of an exhibition at Martha Jackson Gallery, "Environments, Situations, Spaces", May–June 1961, in which the first form of the Store was presented.

I am for an art that does something other than sit on its ass in a museum. I am for an art that grows up not knowing it is art at all, an art given the chance of having a starting point of zero. I am for an art that involves itself with the every-day crap and still comes out on top. I am for an art that imitates the human, that is comic if neccesary, or violent, or what-ever is necessary. I am for an art that takes its form from the lines of life, that twists and extends impossibly & accu-mulates and spits and drips, and is sweet and stupid as life itself. I am for an artist who vanishes, turning up in a white cap, painting signs or hallways.

I am for an art that comes out of a chimney like a black hair and scatters in the sky. I am for an art that spills out of an old man's purse when he is bounced off a passing fender. I am for the art out of a doggy's mouth, falling five floors from the roof. I am for the art that a kid licks, after peeling away the wrapper. I am for an art that joggles like everyone's knees on a bus. I am for an art that is smoked, like a cigarette, smells, like a pair of shoes. I am for art that flaps like a flag, or helps blow noses, like a handker-chief. I am for art that is put on and taken off, like pants, which develops holes, like socks, which is eaten, like a piece of pie, or abandoned with great contempt, like a piece of shit.

I am for art you can sit on. I am for an art you can pick your nose with or stub your toes on. I am for an art from the pocket, from the edge of a knife, from the corners of the mouth, stuck in the eye or worn on the wrist. I am for an art under the skirts. I am for the art of conversation between a blind man's metal rod and the sidewalk. I am for art that is flipped on and off with a switch. I am for art that unfolds like a map, that you can squeeze, like your sweety's arm, or kiss, like a pet dog. Which expands and squeaks, like an accordion, which you can spill your dinner on, like an old tablecloth. I am for an art you can ham-mer with, stitch with, sew with, paste with, file with. I am for an art that tells you the time of day and which helps old ladies across the street.

I am for the art of red and white gasoline pumps and blinking biscuit signs. I am for the art of old plaster and new enamel. I am for the art of slag and black coal and dead birds. I am for the art of scratchings in the asphalt. I am for the art of bendig and kicking things and breaking them and by pulling on them making them fall down. I am for the art of sat-on bananas. I am for the art of mama-babble, and bar-and-grill-babble, toothpicking and oggaaltin. I am for the art of falling off a barstool.

I am for the art of underwear and the art of taxicabs. I am for the art of icecream cones dropped on concrete. I am for the majestic art of dogturds, riging like cathedrals. I am for the blink-ing arts, lighting up the night. I am for art falling, splashing, wiggling, jumping, going on and off. I am for the art of fat truck-tires and black eyes. I am for Kool-Art, 7-UP Art, Pepsi Art, Sunkist Art, Dro-bomb Art, Vam Art, Pamryl Art, San-O-Med Art, 39 cents Art and 9.99 Art.

I am for the white art of refrigerators and their muscular openings and closings. I am for the art of funeral hearts and sweet hearts full of nougat. I am for the art of meat-hooks and singing barrels of red, [note in margin with arrow pointing here: Rest is not in M. Jackson] white, blue and yellow meat. I am for the art of weak grey pencil-lead and grainy wash, and the noise of rectangles coming home from school. I am for the art of wind-shield wipers and the art of fingers on dusty steel or in the bubbles on the side of the bathtub. I am for the art of decapi-tated teddy-bears, exploded umbrellas, chairs with their brown bones broken, burning X-mas trees, firecracker ends, pigeon bones, and boxes with men sleep-ing in them. I am for the art of hung, bloody rabbits and wrinkly chickens, tambourines and plastic phonographs, and abandoned boxes tied like pharaohs,

May 1961

. .

WILLIAM P. DALEY,
"ON DRAWING," CA. 1982

Essay, 6 pages, edited typescript
William P. Daley papers, 1905–2003

I begin making a pot by drawing past successes. It is a way to ease past the fear that there may not be "anything in there." Recapitulation suggests alterna-tives and the variations multiply for review. When ~~in~~ possibilities emerge which seem to merit further develop-ment, I shift from typing paper to drawing directly on my pre-prepared studio walls. There I draw in elevation and plan view at full size. This shift in scale helps me to adjust the proportions of forms to imagined volumes. When completed they become ~~the~~ working drawings for templates and support forms necessary for me to work in clay.

Drawing as a way of examining options and recording findings for future use, is a standard design practice. It is related to written language, as a loose visual symbol system. ~~Drawing is a way of using images to nurture thought.~~ By differentiating possibilities and describ-ing their form, drawing is a way of using images to nurture thought.

This cursery account of work procedure and the above school definition do not account for the feelings I have about ~~the way~~ drawing and making pots as reciprocal aspects of my work. For me drawing is notational. As you can see by the ~~accompanying reproductions~~ enclosed work, I use a number of conventions. Plan, Elevation and Sections; Axanometric and orthographic projections are combined with perspective as Parts and Fragments or complete views are ~~needed~~ useful. For me, drawing is ~~notational~~ schematic rather than pictorial. ~~The primary means of exposition are these~~ I use conventions which use lines to note information. Line itself is a convention of ~~our own~~ visual perception. One which assumes the presence of light. It is ~~part~~ one of our learned visual cues to percieve form. As such, it is the primary ~~description~~ descriptor of mass, space and volume. To me, the way line can be manipulated as a pot, encompasses ~~the most~~ compelling reasons for making their drawings. First line is the elemental boundry. It is the means by which we sense the illusion of edge in space (silhouette). As boundary it supports our sense of inclusion and habitation. As edge, line qualifies our sense of inside/outside which can describe the location of the alien and the intimate. As cross section (the slice), line describes the boundaries of volumes and the axis of symmetries. Through the connection of points, line suggests movement – as such line is the main cue to our perception of closure. Closure to me is the implication of continuance and completion. For me drawing and making are ways to use ~~lines~~ these elemental properties of line to articulate form.

Drawn lines ~~permit~~ allow gravity free investigation ~~which~~ to ~~permits~~ escape from the tyranny of making clay "stand up by itself." In a way, drawing is a way to make a model without the constraints of a physical objects' ultimate requirements. For example, as drawings the bivalent nature of line permits transparency—inside/outside can be viewed through walls. The relativity of location can be manipulated at will. Near, far, part and whole can coexist; boundaries and numbers can be illusions and more than one thing can exist in the same space at the same time. The axis of

volumes and the auras of shapes which are invisible can ~~become visable~~ be seen. Drawing permits me to play with the inverse; the dual of a pot. It encourages ~~me to respond to~~ the logic of caprice.

For me, drawing confounding possibilities is an important way to make things clear. Drawing ~~a~~ is a kind of indirection which lets the ~~trivial~~ ugly and the awkward temper habitual convictions. Sometimes ~~when things~~ drawing confirms recognitions of structure which allude to the way things were always arranged. Such openings are "Luck Outs" and part of the drawing as a kind of reverie. The awareness of a sense of correspondence not thought for—a way to be at once productively connected and disengaged. It is a state to be sought when ~~though~~ I am drawing during faculty meetings.

In primary school, I drew as a way to avoid learning. I made the same drawing over and over. Usually they were "aerial combats" of Fokers and Spads. These flights of near microscopic biplanes offered the pleasure of making millions of finely dotted lines. Lines ~~are~~ as trajectories which connected all protagonists and completed all possibilities. As I did them, amazing spaces emerged which filled up everything. On vacations and holidays I now draw farm houses, flowers and birds. The rest of the time I draw the lines of pots on typing paper with a ball point pen. In many ways I am still making the same drawings ~~perhaps to deter the present~~ I made in 1930 at St. Matthews School.

Drawing on typing paper is tentative and exploratory. Drawing on the studio walls is reductive and concrete. I use a level to draw right angels and account for gravity. The measurement of lines allow for the shrinkage of clay. Full scale adjustments in ~~line~~ configuration and proportion are made with latex wall paint to paint out what doesn't work. Broad carpenter's pencils are used to redraw my ~~most precise~~ best guess judgement of what will work later as a physical volume. I say guess because the final decisions are made working in clay.

The physical presence of a pot speaks through a more primal sense—touch—which precludes light and visual line. Touch confirms form as material – ~~touch confirms~~ its texture, its temperature, and

its hardness or softness of surface and edge. There is a tactile sense in drawing— ~~the tracing out of configuration the drawn~~ lines have the capacity to emphatically describe hardness and softness. To me, my drawing is neutral to touch but the burnished and brushed passages of my pots are another matter. To me they are a rather sober ~~and mute~~ but powerful expression of clays' ability to hold touch inflections ~~of touch, to me~~ the compressed or open surfaces of burnishing or brushing invite satisfactions on a preconscious level. I see such marks on the clay as ~~important~~ drawing.

- -

LEE KRASNER TO JACKSON POLLOCK, 21 JULY 1956

Letter, 1 page, handwritten
Jackson Pollock and Lee Krasner papers,
ca. 1905–1984

Sat—

Dear Jackson—

I'm staying at the Hôtel Quai Voltaire, Quai Voltaire Paris, until Sat the 28 then going to the South of France to visit with the Gimpel's & I hope to get to Venice about the ~~2nd~~ early part of August—It all seems like a dream—The Jenkins, Paul & Esther were very kind; in fact I don't think I'd have had a chance without them. Thursday nite ended up in a Latin quarter dive, with Betty Parsons, David, who works at Sindney's Helen Frankenthaler, The Jenkins, Sidney Gist & I don't remember who else, all dancing like mad—Went to the flea market with John Graham yesterday—saw all the left-bank galleries, met Druin and several other dealers (Tapie, Stadler etc). Am going to do the right bank galleries next week—& entered the Louvre which is just ~~on~~ across the Seine outside my balcony which opens on it—About the "Louvre" I can say anything—It is over whelming—beyond belief—I miss you & wish you were ~~shari~~ sharing this with me— The roses were the most beautiful deep red—kiss Gyp & Ahab for me—It would be wonderful to get a note from you. Love Lee—
The painting hear is unbelievably bad (How are you Jackson?)

The Gimpels are possibly art dealer brothers Charles and Peter Gimpel who founded Gimpel Fils in London in 1946. The Jenkins refers to painter Paul Jenkins and his wife, Esther. Betty Parsons (1900–1982) was Pollock's dealer in the late 1940s and early 1950s. Sidney's is most likely the Sidney Janis Gallery in New York. Gist is Sidney Geist (1914–2005), sculptor, teacher, and art writer. Drouin is art dealer with René Drouin. Tapié is an artist and art critic Michel Tapié (1909–1987). Stadler is art dealer Rudolphe Stadler. Gyp and Ahab are Pollock and Krasner's dogs.

Krasner stayed with Paul and Esther Jenkins in Paris. That is where Clement Greenberg reached her by telephone to tell her that Pollock had died on August 11, 1956.

. .

ABE AJAY TO AD REINHARDT,
GROUNDHOG DAY
[FEBRUARY 2], 1963 AND
REINHARDT'S RESPONSE
[5 FEBRUARY 1963]

Letter, 1 page, typescript (Ajay) and handwritten (Reinhardt)
Ad Reinhardt papers, 1930–1967

groundhog day 1963

Dear Ad:

God knows, old friend, I don't begrudge you the money or the prize or anything like that. It's just the principle of the thing.

Corruption is like peanuts. It takes an uncommon kind of inner strength to know when to stop. Next thing you know you'll be sneaking in just a tiny dab of flake white on those 'dark (lightless) non-contrasting (colorless) colors, brushwork brushed out to remove brushwork, mat, flat, freehand painted surfaces.'

I have to confess that the prize notice in our local Danbury paper hit me with all the force of, let's say, Albert Schweitzer coming on full screen in a Crest commercial shouting 'Look Ma No Cavities!' I felt terrible.

While I haven't removed that nice picture of your bent over bald head from my bulletin wall I have stopped burning the two candles which flanked it during 1962. I am sorry for that but it's the way I feel.

No, Virginia, there is no Ad Reinhardt,

Alas and alack,
Ajay

cc: Art News
 The London Times
 Pravda
 Playboy
 The Des Moines Register

[Ad Reinhardt's response]

Dear Abe:

Why are you hammering them nails in my hands and toes so hard for? They hurt! Keep up the good candlework! Why should that prize notice hit you in the paper with all the force? Don't stop the wax-burning! Why fight it? Isn't that life? Isn't the air we breathe in corrupt? Why can't I be like all the other fellows? Don't let the lights go out! What do I have to do with that prize? I didn't award it to myself. Can I help it if I'm loved, prized, worshipped? God, I didn't belch (Who said I belch in their faces and they applaud my fine tenor voice!?) Hold on! Don't give up the ship! Don't take that baldy picture down! Don't be sorry for the way you feel! Don't lose faith! Think it over! Truth will rise again! You can't keep a good man down! It'll be all right in the end! Don't jump! Take it easy! Pull yourself together! That's not a real Damocles sword hanging over your head or any prick of conscious-ness! Who's Virginia? Why should I be Santy Claus? Did I ask to be born? Did I make this world? What we got to lose except our gains? Don't alas and alack! Isn't virtue its own reward? A normal person has to eat! Think I'm some kind of a ground-down-hog? Every dog has his day! Chin up, old man, people love you, people love me! Things will turn out! Don't let the lights go out! Keep the frame! Keep the studio fires burning! Don't let the heat on let you go out! Keep up! Keep!

AD

. .

ELLEN HULDA JOHNSON,
NOTES ON HER VISIT TO
JAMES ROSENQUIST'S STUDIO
3 APRIL 1964

9 pages, handwritten
Ellen Hulda Johnson papers, 1939–1980

April 3—1964 Jim R. Home: Ha7-0340 Studio 429 Broome St. (Entrance on Crosby)

Described amusement park in Texas where he was last summer. (his parents have moved there from Minn.—or something he has on his knee the name of his hometown in Minn.) A kind of Luna Park terribly artificial. On boat ride thing—turn your head—click alliga-tor popping up, vulgar, obscene things, etc. Came out Breeze along legs, couldn't find what making it. Looked up more trees they had, murdered (?) & put elec-tric kind of fans (?) in to blow breeze. So he couldnt help killing ~~splattering~~ slicing a tree & filling it with electricity. Got it at friend's place in Cozan (?). "Not art, not nature." Makes the point clear.

His talking & movements are abrupt, diving changes & rhythms like his ptg

[Lucy] Lippard art hist. at MOMA did piece should be in Metro (last summer's, still not appeared.) Later: in 1965 came out in ArtForum.

Would like to do hard edge

Would like to do blank canvas from ceil-ing and suspend something perhaps just string (Idea I think would take up & enliven all the space.)

Said was in Biennale for few minutes—Now plan is to have the 4 (J.J. [Jasper Johns]/ RR [Robert Rauschenberg]/ [Morris] Louis/ [Kenneth] Noland) in regular pavilion – then extra one C.O. [Claes Oldenburg /[Jim] Dine / [John] Chamberlain / [Frank] Stella ? or who? – anyway he thinks OK, because they ~~got~~ come from JJ and RR.

Going to Paris May 14.

He says except for Allan Solomon (& me) no one really done anything on (the new artists.)

I asked how he liked [Lawrence] Alloway's 6 Ptrs [illegible][*Six Painters and the Object*, Solomon R. Guggenheim Museum, 1963] cat. [catalog]. Obviously thought too art historical. Reminded him of once when he heard [Erwin] Panofsky on icon sources of Rolls Royce emblems [illegible] I saw [illegible] and another complex one going to Ileana [Sonnabend].

Did some window displays for same person that JJ & RR did. Fine. But when he left, had to explain things to new person so much. Use up energy getting things across to people.

———

Not sure Sculls [Robert and Ethel] are happy about him anymore. (Everybody seems to feel they're pretty possessive) Scull has 10 of his

Paint in papercups

Jim Rosenquist
Full of ideas. Lot of artists tired of object – either ptg flat or making sculpture but he thinks still many possibilities. But time. Would like do neon in 4 different colors, 4 layers but would cost minimum 1000 – even with friend doing it cheap. Has balloons in studio. Would do picture with 2 canvases, & on one side one balloon up, one down – put paint on string, snap it ag. canvas Balloon at bottom heavier – get diff. diagonals.

Ph. [Philip] Johnson wanted him do outside mural for Lincoln Center. Got lots of ideas then Johnson called said couldn't get money more than ca. 1000 for expenses. And Jim got too busy – getting ready for Ileana show, etc. Was going to do parking lot after theatre. Showed EJ [Ellen Johnson] drawings – plastic brick but – office, etc. Woman coming out, figure drawn in neon, blank, numb (way people should come from theatre, not babbling & knowing all about it right away.)

Had learning French records on vic. Getting ready for summer. Will travel around. Also go Sweden (relations in Malmö). May poss. to Sep.

Capillary Action [1963]

Jim Rosenquist
Apr. 3–64
Would like to have in forest. show if goes to Sweden—belongs there.

Would like to have someone do a serious article on him.

———

Jim Rosenquist says sometimes [Roy] Lichtenstein came off – sometimes not. But has ideas (Roy says same about him – didn't much like or understand the things at James's but glad to see he has ideas. Roy thinks Jim Dine—good ptr.)

———

Ileana was there at 4:00 today. Leaving tomorrow.

RE Andy's [Warhol] film sleep – saw 3 hrs. as it just the face, Thought he was dead till a tear formed, then knew he was alive.

Has motorcycle – blue, fusses with it. Boy of his time. When things pile up, likes to get on it, click & sail away.

There is in his work that kind of abrupt movement, quick changes in tempo & scale & place.

Leaving Green [Gallery] – going Castelli in the fall. Secret. Didn't say why exactly, but among other things, said thinks Dick B. [Bellamy] puts too high prices on things. Hultin [Pontus Hulten] wants Capillary Action II. Dick wants 4000; Jim thinks 3000 more reasonable (EJ thinks both too much)

Has sense of responsibility about his work; doesn't want to do bad Rosenquists. "Lots of ptgs fast, lots of fast ptgs"

———

EJ – if he's going Castelli, you can always get photos

One I thought a stencil was not. Is photo enlarged [so dots show] & paper attached to the board and painting.

Often does collages. Had some and lost them. Prob. When moved.

Means to do some more & frame them up

———

Told him about JJs going to Japan. He would love to do that. Wonderful things happen in Japan—Place where east & west meet.

Is going teach Yale ev. 6 weeks Sept–Oct. only 1 day week

Div. photo engraving printing idea—color films grey, red, etc. in single colors—first De[illegible] put together—then RR did it with colored ~~stencils~~ silk screen. RR stencils his own in color. That's what happens with idea. Just get ready to take your next step and someone else does it. The big one with brush was that.

———

Savoy Hilton, New York
Was going to bring me his scrapbook, etc. Aft. 5–64 but got bad cold

Asked Scull to lend us a Rosenquist but said all 10 of his out (Jim had said they still have 2)

· ·

GEORGE SEGAL TO ELLEN HULDA
JOHNSON, 7 NOVEMBER 1963

Letter, 2 pages, handwritten
Ellen Hulda Johnson papers, 1939–1980

Nov 7, 1963

Dear Ellen,

The strange thing is, I haven't heard from Ileana since my show opened, which was two weeks ago. Ileana and I flew back to the States together about Sept 11. One person whose judgment I trust told me of the extremely hostile reaction of American expatriate painters and poets. French reaction seems to range from hostility to enthusiasm.

I made a sculpture in Paris of Michael Sonnabend tensely playing an American pinball machine and it was extremely difficult to work there. Incredible complications getting the simplest materials and hand tools, working publicly and living in an atmosphere incredibly and minutely sprung to life from the memory of French art & writing, complete even to expected clichés.

The Sonnabends were marvelously gracious to us, anxious to reveal the essential nature of the French to us, took us touring, spent endless hours translating questions from curious novelists, artists, critics, really working very hard to persuade the logical & verbal French of American stance & attitude.

Yet the French don't have the American situation and enviornment & have powerful conservative feelings. I was pained to disturb the nostalgic withdrawal into a dream of the past I found in some American friends. But I was swamped and staggered by the soaring greatness of Chartres and the late Titians I saw in Venice. I came away strongly aware of petty niggling and intricate political maneuvering over minor matters in the Parisian art world. I was unwilling to stay on for my opening.

Withdrawal to my studio has been marvelous. Working on art fulltime encourages my compulsive working habits. Concentration is simpler. I'm

currently involved in a gas station 25'
long and a movie marquee which is a
wall of cold fluorescent light 8' square
with a figure removing the last letter
from the blank, blazing sign.

I am very pleased with your article.
It arrived in Paris when Michael was
busily conferring with various French
writers. Michael thought your article
would have more relevance published in
Metro or Art International rather than
the catalogue. While I was there with
them I saw the endless hours of writing
and talking they put in. I'm baffled at
the wall of silence since I'm home. And
rather than let my normal paranoia
come out, I'm going about my business
and wait for their report. When I hear
more, I'll let you know.

With warm regards,
George

*Segal discusses his exhibition at the Galérie Ileana
Sonnabend in Paris in 1963. Perhaps taking
Michael Sonnabend's advice, the following year
Ellen Hulda Johnson published "The Sculpture of
George Segal," in Art International, VII, 2 (March
20): 46-9. Segal was working on The Gas Station,
1963, now in the Collection of the National Gallery
of Canada, and Cinema, 1963, now in the collection
of the Albright-Know Art Gallery, Buffalo, New York.*

.

"LeRoi Jones, Comments
and Information Re: Bob
Thompson," ca. 1966

1 page, various media
Bob Thompson papers, 1955–2000

COMMENTS AND INFORMATION
RE: BOB THOMPSON

Dates of Acquaintance:
From __1958–8(?)__ To __1965__
Place (s): City _New York_ State _N.Y_
 City _____ State _____
Relationship to Thompson: __Friend__

Comment (s): I knew Bob Thompson
as a fellowartist living in New York's
Greenwich Village, and Lower East Side,
druing late 50's and thru mid sixties. We
were very close friends and used to visit
each other, hang out together in various
bars, listening to music and each other,
and to the crew of friends we ran with.
Painter friends, writer friends, musician
friends. William White another black

painter, also dead before his time, Joe
Overstreet, now abstract and fashionable
ny painter, Bob and I used to be, together
with altosaxophonist, Marion Brown, a
close foursome, along with some other
brothers. We ran with each other,
bouncing off, the various white american
personalities of the neighborhood.
Trying to learn about art, and all the
time needing to learn more about life.
Some of us are still trying to learn more
about life, some never got the chance.

Bob was a great painter, a fantastic
emotionalist, who should have had wide
viewing. He had great influence on us.
And his conception of painting knocked
me out. Some of his early works are the
strongest things done during that period
by anyone I knew or heard of much
stronger than those rich whiteboys we
hear so much about. Bob died because
America used him up.

[signed] LeRoi Jones
Signature

Your Name (Please print): _____
Street Address: _502 High St_____
City: _NewArk_ State: _N.J._ Zip: _____
Telephone Number: __(201) 624-1011__

*The J.B. Speed Art Museum sent this question-
naire to Thompson's friends and associates in
preparation for their exhibition, "Bob Thompson,
1937–1966, Memorial Exhibit," held at the J.B. Speed
Art Museum in Louisville, Kentucky (Thompson's
hometown), 2 to 21 February, 1971. While com-
ments were published in the catalogue, Jones'
arrived too late to be included in the publication.
Thompson died one month before his twenty-
ninth birthday.*

.

George Sugarman, "Thought
Book," Paris, 1951–1955

Bound volume, 31 pages, handwritten
George Sugarman papers, 1912–2001

of sculptural organization:
1) space surrounded
2) space surrounding.

Of all these, the 4th pictorial is unsatis-
factory: it deals with tensions existing
between the various elements of the
space, but without regard or reference to
the totality or unity of the whole space
in which they operate. It can create pat-

terns but not structure. From a philo-
sophical point of view it is equally
objectionable—to have no structure is
basically the same as to have no purpose-
ful meaning. It is the equivalent of living
a life in terms of isolated acts.

The structure or construction of a
work of art is one of the basic tools
whereby an artist communicates. In
plastic terms, along with the other tools
of form, color, line, etc, ~~In~~ it is his mean-
ing. In general terms, I like to think of
an artist's structure as his universe which
he peoples with individual instances in
terms of form, color, etc. He builds a
unified universe when form, color, etc
are actually individual instances of this
universe and not contradictions of it.

Absolute freedom is meaningless: it is
a denial of standards & values, without
which there can be no meaning. Along
these lines, non-objective art is meaning-
less and it allows the spectator absolute
freedom in reaction and provides no
guides or standards

INDEX

HarperCollins books may be purchased for educational, business, or sales promotional use.
For information, please write: Special Markets Department, HarperCollins Publishers,
10 East 53rd Street, New York, NY 10022.

First Edition

First published in 2007 by:
Collins Design,
An Imprint of HarperCollins*Publishers*
10 East 53rd Street
New York, NY 10022
Tel: (212) 207-7000
Fax: (212) 207-7654
collinsdesign@harpercollins.com
www.harpercollins.com

Distributed throughout the world by:
HarperCollins*Publishers*
10 East 53rd Street
New York, NY 10022
Fax: (212) 207-7654

Designed by Susi Oberhelman

Library of Congress Cataloging-in-Publication Data

Kirwin, Liza.
 Artists in their studios : images from the Smithsonian's Archives
of American Art / Liza Kirwin and Joan Lord.
 p. cm.
 Includes index.
 ISBN-13: 978-0-06-115012-8 (hardcover)
 ISBN-10: 0-06-115012-6 (hardcover)
 1. Portrait photography. 2. Artists—United States—Portraits.
3. Artists' studios—Pictorial works. 4. Archives of American Art.
I. Lord, Joan. II. Title.

TR681.A7K57 2007
779'.0922—dc22 2006037850

Printed in China
First Printing, 2007